499

6. -

Creative Seascape Painting

Creative Seascape Painting

BY EDWARD BETTS, N.A., A.W.S.

WATSON-GUPTILL PUBLICATIONS/NEW YORK

For Jane, again

First published 1981 in the United States and Canada by Watson-Guptill Publications,
a division of Billboard Publications, Inc.,
1515 Broadway, New York, N.Y. 10036

Library of Congress Cataloging in Publication Data
Betts, Edward H 1920–
 Creative seascape painting.
 Bibliography: p.
 Includes index.
 1. Marine Painting—Technique. I. Title.
ND1370.B47 1981 751.4 80-24929
ISBN 0-8230-1113-5

Manufactured in Japan

First Printing, 1981

ACKNOWLEDGMENTS

My very deepest thanks to all the excellent painters whose work is reproduced in these pages. Whatever merit this book may have is due far more to their presence here than to any words of mine. This book is really theirs, for it could not have been put together without their unfailing friendliness, enthusiasm, and cooperation.

I am grateful to all the art galleries who were so generous in supplying photographic material, and to all the art collectors who graciously agreed to allow work in their collections to be reproduced here.

Once again, I am eternally grateful to Donald Holden of Watson-Guptill Publications, who conceived this sequel to my *Creative Landscape Painting* and served as my working editor. Whenever I had questions or problems, his insights were invariably helpful. I am also indebted to Bonnie Silverstein for her keen eye and painstaking care in dealing with the nitty-gritty of shaping up my prose. She was a joy to work with. And, as always, I appreciate Bob Fillie's expert and imaginative design, a contribution that too seldom receives the recognition it deserves.

CONTENTS

INTRODUCTION

The sea has always been a source of fascination. It can be soothing and it can be terrifying. It can be hypnotic and awe-inspiring. And it is virtually limitless in its variety of color, light, and texture and its constantly shifting form and movement. From the painter's point of view, it is also an unending source of picture material.

The visual aspects of the sea are indeed so varied and appealing, so picturesque and downright beautiful, that they can become a deadly trap. The unwary painter who succumbs only to the ocean's most obvious attractions will produce pictures that are equally obvious and cliché-ridden, more akin to picture postcards than to profoundly felt emotional and aesthetic responses. Seascapes, like paintings of any other subject, above all should be an experience in paint, and only secondarily should they be views of water or shoreline.

Many of the greatest masters in the history of painting have at one time or another felt the strong attraction of ocean and shore and have produced superb seascapes—not just renderings of pretty scenery, but first-rate works of art—because they interpreted the sea in *painterly* terms. When you examine the work of master artists of many eras and cultures, you can see the tremendous variety of approaches that are possible. Among the masters of Chinese and Japanese ink paintings, there are the splashy breadth and freedom of Yosa Buson and Sesshu Toyo; the wildly abandoned, juicy washes of Chu Ta; the brevity and lyricism of Tao-Chi; the shorthand styles of Sesson and Shih-t'ao; and the elegance and expressiveness of Wen Cheng-ming. Among European artists, there is the concentration on light or atmosphere of J. M. W. Turner, John Constable, Claude Monet, and James Abbott McNeill Whistler; the sharp-focus romanticism of Caspar David Friedrich; the interpretation of the sea by the colorists Eugène Delacroix, Edouard Vuillard, and Pierre Bonnard; the search for color as space, volume, and structure of Paul Cézanne; and the simplified slabs and bold masses of color of Nicolas de Staël. Among the Americans, we have the panoramic vistas of Albert Bierstadt and Frederick Church; the brooding, eerie lighting effects of Martin J. Heade; the preoccupation with sharp-focus treatment of forms and reflections of Fitz Hugh Lane; the haunted, visionary seascapes of Albert Pinkham Ryder; the vigorous brushwork of Rockwell Kent and George Bellows; the excited splashiness of John Marin; the lyrical, delicate combinations of wash and line in Lyonel Feininger; the somber starkness of Marsden Hartley; the severe simplifications of Georgia O'Keeffe and Milton Avery; and the rigorous but expressive design evocations of Monhegan Island (Maine) surf, cliffs, and pines of Morris Kantor. All these artists, and others, brought individual concerns, attitudes, and styles to their paintings of shore and sea.

As I write these lines in my summer studio in Maine, I am watching a group of painters, possibly in art class, perched on the rocks, painting the drama of the smashing white surf, and the thought occurs to me that sea paintings are among the very best and the very worst in American painting. More depressingly, still another thought occurs to me: painters of seascapes are, as they say, a dime a dozen.

This is not meant to be a harsh criticism of the state of seascape painting, especially since that art has long been my passion and my obsession. It is simply that too few seascapists are making the most of their material. It strikes me that all too many marine painters work at the level of what I call the "tourist snapshot." Yet the finest seascapes come from artists who disdain the quick visit and the documentary snapshots in favor of an intense, prolonged, contemplative contact with the sea and its neighboring areas. It is this difference in attitude that separates the true seascape artist from the mass of minor painters of seascapes.

Thus, knowing the vast range of approaches—historical, cultural, and individual—possible in painting the sea, and yet finding myself increasingly aware of the limited variety in seascapes today, I have undertaken the writing of this book in an effort to change this fact by encouraging artists to deal with the seascape in other than standard, conventional ways.

WHAT IS A SEASCAPE?

Perhaps at this point I should define what I mean by "seascape." Seascape falls under the larger heading of "landscape." In fact, many of our most eminent sea painters were equally at home painting both subjects. When I speak of a seascape, I don't only mean a painting of rocks and foam; I use the term in its broadest sense to include cliffs, dunes, tide pools, tide flats, salt marshes, driftwood, storms, boats, regattas, harbors, boat yards, lighthouses, fishing gear, fishing shacks, underwaterscapes, seaweed, mussels, and periwinkles. In fact, the term "coastal painting" might be even more accurate, since it is the whole coastal environment, where ocean and continent mix and come together, that is the fundamental source for the seascapist's art.

Here I should repeat what I have written elsewhere: that no matter what the medium, most of the best contemporary seascape paintings are done in the studio. Although paintings done on location have a spontaneity and an immediacy often lacking in paintings from the studio, they lack the sense of considered order, the adjustments of color, space, and design, and the controlled orchestration of all the pictorial elements that are expected of a painting destined to be shown in a major gallery or a national exhibition. A painting may be started outdoors and later completed in the studio, but the most common practice, and the one I strongly recommend, is to just sketch on location and do the actual painting in the studio.

There are plenty of excellent instructional books on how to paint water, surf, waves, and rocks in a representational manner. But the major concerns in

such books are usually a specific medium (oil, acrylic, watercolor) or technique (the mechanics of applying paint). That is not my concern here. I am more interested in *process*, and by that I mean the creative process, the internal means by which an artist creates a pictorial organization out of his or her response to the raw material in nature. I am much less interested in teaching specific techniques than I am in helping my students to develop personal methods of employing those techniques toward purposes that transcend mere description, skill, or virtuosity. How, then, can we go about all this?

From my own experience in painting and teaching, I have come to believe, though this is undoubtedly a generalization and a simplification, that the painter's creative process breaks down into a sequence of four phases: observation, assimilation, synthesis, and revelation.

OBSERVATION
Observation is where it all begins. For the painter, perception and contemplation open the door to the entire creative process. Since we are dealing with a visual medium, everything hinges on what the eye perceives in nature. Thus, continual study of the sea and its environs are an absolute necessity to a marine painter. We know, for instance, that many Oriental masters studied their subjects for a long time, absorbing them through contemplation rather than sketches or studies, and only after they had thoroughly understood the essence of the subject did they finally start the painting. As the painter Max Beckmann put it, "To grasp the invisible, one must penetrate as deeply as possible into the visible."

We know, too, of seascapists, such as Winslow Homer and Charles Woodbury, who built their studios on rocks at the very edge of the ocean in order to observe better the action of waves and surf, atmospheric effects, patterns, color, and light as daily recurring phenomena under all possible conditions of weather and season. Those painters not lucky enough to live right at the water's edge were inveterate beach walkers and cliff sitters, either studying rock and beach forms at close vantage or contemplating the vast panorama of the ocean rolling in ceaselessly toward the land. Then, of course, there was J. M. W. Turner, who at the age of sixty had himself lashed to a ship's mast so that he could observe at first hand a raging tempest out at sea. While this was carrying the idea a bit far, it did indeed provide the sort of information that imbued Turner's sea paintings with a sense of direct personal involvement with nature's forces.

Painters who have watched the sea over a long period of time are bound to produce pictures that possess a conviction, an authority, and a sense of design or poetry, that cannot be matched by someone who has relied on the information contained on a dozen rolls of color film. Constant observation leads to an intimate knowledge impossible to obtain in any other way.

I am reminded here of a passage from D. W. Prall's *Aesthetic Judgment* (Apollo Editions paperback, New York, 1967): "The use of wave forms in Japanese prints serves as a reminder to those who would forget man's dependence on nature for even the beauties of expressive design in art, that the vigor and richness of design itself draws upon natural sources, from which by long and patient observation the greatest artists have extracted beauties from obscuring contexts, to give fresh life and meaning to design itself."

You should keep in mind that at this stage the act of observing is just that and nothing more: no drawings or sketches, simply a soaking up of the look of nature through the eyes alone. For one thing, this absorption enables you to memorize the visual specifics of the way the coast looks in all lights and seasons. But aside from the documentary aspects of looking at nature in order to paint it convincingly, this is also a means of accumulating a rich and varied mental repertoire of shapes, colors, and textures to be later dipped into and used as a painting may require.

Finally, observation can spark your mind into suddenly imagining pictorial possibilities—that mysterious moment of intensity or inspiration in which a new painting is conceived. Even painters who arrive at their sea imagery by improvisational methods or accidental manipulations of their medium tend to identify those emerging images through their associations with things they have observed and known. So, when all is said and done, it is what passes through your eyes that is ultimately the basic stimulus for embarking on a creative adventure in paint.

ASSIMILATION
The next stage, assimilation, is one of digesting what has been seen. It is usually a period in which on-location drawings are made, followed by color sketches done on location or from memory in the studio. On-location drawings are factual and representational, documenting the scene pretty much as it actually looks, with a minimum of rearrangement or distortion. This is a way to become further acquainted with the subject, to get deeper into it, to understand how the forms are constructed and how they relate to each other.

Depending on the subject, each artist assimilates the material in his own way. Some artists make rather careful, objective, detailed drawings that record all the information they might possibly need as reference. Other artists make highly emotional, spirited sketches that do no more than suggest the motif while capturing its essential qualities. They don't wish to be hindered or distracted by details but want only to preserve—or even intensify—the aspects that first attracted them to that motif.

The drawing medium used is also a personal choice. Some seascapists like to use a pencil or pen and ink, both of which are fundamentally linear in character. Other artists take a more painterly approach and sketch with a fluid medium, such as ink and wash or monochrome watercolor washes. Such media, they believe, are considerably closer to the look and spirit of a marine painting and so are a clearer indication of how the final painting might actually appear.

Whatever drawing medium you select, drawing brings you closer to your subject, forcing you to look

more carefully and specifically at the scene before you. It forces you to put down on paper some sort of visual statement, which means that you must find a way to describe or suggest the subject in purely graphic terms. In other words, you are beginning to explore your subject matter on a level different from that of just passive observation.

You might follow these drawings by color studies in oil, gouache, watercolor, or pastel, also done on the spot. Again, these studies are usually representational, primarily informational, to be used later in the studio as reminders. In them you would note colors, edges, transitions, passing effects of light or clouds, and other pertinent details that would not likely remain long in your memory, amplified perhaps by written notes in the margins. The main point is to become as familiar as possible with every aspect of your subject, studying the motif from several angles or viewpoints and perhaps trying out varying lighting conditions and sources so that in the end, in preparation for the next phase, you feel you have really absorbed your subjects and made it a part of you.

SYNTHESIS

The next stage, synthesis, is the bringing together of all that you already know about your subject to coordinate the content of your painting with the formal means of expression. This means exploring your subject on still another level and involves a number of new considerations. First, you must identify exactly what it was that first attracted you to the scene. You must never lose sight of that first response. If you can't remember what stimulated you to paint the picture, you'll never be able to communicate it to someone else. Also, your reason for doing the picture will strongly influence your choice of color, mood, pattern, design and any distortions or other departures from reality you will make in the final painting.

This is also the time to experiment. You might want to explore light and dark patterns, shape relationships, line versus mass, simplification and condensation of the design, and so on. This might then be carried further into reversing light and dark relationships and positive and negative shapes, playing with size and scale, trying both horizontal and vertical formats and compositional variations, imagining different light sources, or substituting invented colors for those that actually existed in nature. All of these are ways to extend your knowledge of the subject matter and to seek out its full potentialities as a painting.

Although studio studies may be a great help in making major decisions and in minimizing unnecessary fumbling later, you may prefer to save some of your problem solving for the actual painting. Many professionals do this because they feel that too many studies carried too far may lessen their enthusiasm for tackling the painting itself. Instead, they hold themselves partially in reserve, so that there will still be some problems to be solved and challenges to be met during work on the actual painting. Nothing can be more unexciting than having all your problems

solved too neatly and completely beforehand, reducing the act of painting to little more than a rendering process, a mechanical chore.

The synthesis of subjectivity and objectivity, of emotional response and the formal aspects of picture-making, is an essential step, and most of your really creative decisions will be made then. If you are not an experienced painter, try to explore and assimilate your material in a thorough, orderly fashion before beginning a painting, coordinating and interrelating your responses, memories, thoughts, and feelings with the esthetic considerations of medium, design, color, pattern, space, and texture. You may later be surprised to find that most or even all of the synthesis will take place not in sketches but in your mind.

The whole thrust of the synthesis phase is to work toward a complete integration of subject, expression, pictorial structure, and technique, all wrought into a unified whole. Although such an ideal balance of those various elements may not always be possible, it is most certainly worth a try. At any rate, if most of the synthesis can be even tentatively worked out at this stage, everything will proceed a lot more smoothly in the final phase.

REVELATION

The culmination of the three preceding phases is found in the final phase, that of revelation in the form of a painting. The picture that is the outcome of all the preparatory work is a summation of all that you have observed, known, and felt about your motif, presented to the viewer in essentially painterly terms. It is a matter of your communicating to an audience, of revealing essences by translating external appearances into either an emotional or intellectual experience in paint.

You may or may not refer to your preliminary sketches and studies as you work. Sometimes they may furnish a clear indication of the path to be followed in developing your painting. Other times, if followed too slavishly, they might hinder your ability to flow with the painting and inhibit your willingness to accept unexpected alternatives, even when the picture itself may seem to require them. Some painters, having done the studies, put them out of sight and rely on their memory of the scene and the spirit of their sketches to sustain and guide them through the actual painting process. You will have to find out which method works best for you.

The main thing to remember is that the picture you paint should be more important than the subject that inspired it. A truly fine painting is a *painting* above all else. It does not merely copy or reproduce nature, but it is a self-contained pictorial statement that might refer to nature but does not compete with it. Obviously, if resemblance were all we asked of painting, photography would probably do a much better job.

But we do ask more than that, and you as a painter should be less interested in factual accuracy than in revealing your innermost responses, emotional or cerebral, to what you have seen and experienced. You should do this through brushstrokes, color, impasto, glazes, and washes and an application ranging from

delicacy to muscularity and from tight control to wild abandon. The intention is not to record the surface appearance of a particular scene but to search deeper for more universal aspects: timeless fundamental shapes, rhythms, movements, and forces.

In this phase, revelation, you utilize your powers of invention and imagination to their fullest, sharing with others your personal vision of nature—in this case, the seascape. This means you must make every effort to avoid clichés and conventionality and to shun any subject that is too obvious or picturesque. To be sure, subject matter is important; without it there would be no seascape painting. But whether you paint realistically or abstractly, your subject is only a point of departure. It is your interpretation or transformation of that subject that creates a work of art.

ABOUT THIS BOOK
This book is directed primarily to the person who has already had considerable discipline and experience in painting the coastal environment, especially in the traditional modes of painting representationally directly from nature. If you are thoroughly familiar with the seashore and have reached a certain level of technical competence, then you are probably ready to press on to the next level of interpreting it more creatively.

Perhaps you have reached a point at which you can sense that your pictures are painted reasonably well, but you feel that they are somewhat bland and predictable, too similar to a great many other realistic seascapes. Or you may not have fared well with art juries and are wondering where to turn next to discover ways to push your ideas further and to add freshness and vitality or a more personal slant to your work. If this is so, then this book is for you.

Above all else, this is a book of ideas and concepts aimed at suggesting a wide variety of approaches to seascapes, including unusual viewpoints, compositional alternatives, various ways to use color, to expand your range of marine subjects and to view the coastal scene more creatively and on a more advanced and less banal level. In short, this book is an attempt to help you improve your seascapes in as many ways as possible.

The format of this book is based closely on that of my previous book, *Creative Landscape Painting*. I have assembled here fifty different approaches to coastal painting. Some are compositional, others are concerned with viewpoint, lighting, unusual subjects, or design in nature, while still others concern various aesthetic attitudes in contemporary American seascape painting. After describing each concept, I suggest ways to apply it to your own paintings. In addition, to stimulate your pictorial inventiveness, each of these fifty concepts is illustrated by the work of a contemporary artist that demonstrates a striking or innovative approach to the seascape.

The color section contains thirty-two full-page reproductions of some of the best representational and abstract seascapes by American painters of our time. In the caption accompanying each plate, I discuss the use of color and other pertinent aspects of each painting. The final section, "Studio Notes," contains the most frequent remarks I find myself making to my students in classes and workshops.

When you find yourself in a rut, a glance through this book will remind you of alternatives to ways in which you have become too secure, stale, and accustomed. Through this book, I hope to stimulate and encourage you to reevaluate your current seascapes in the light of new ideas and to open up fresh avenues for exploration. I also hope to shake you up a bit and put you in a state of mind in which you gain courage and become more willing to take risks and surprise yourself now and then. Perhaps you will find a means of solving a seascape problem that has long eluded you. Or perhaps you will be stimulated to try something you've never thought of doing before. And if *that* should happen, I would consider the writing of this book to have been worthwhile.

1. PANORAMIC VIEW

CONCEPT The panorama is an all-encompassing view of enormous expanses in nature. It has long been used for Alpine landscapes, prairie scenes, and such overwhelming natural wonders as Niagara, Yellowstone and Yosemite Falls, and in the nineteenth century, it became a favorite way in which to depict the vastness of the American western wilderness. Because enormous areas of sky, vast spaces, and limitless distances are often involved, it is only natural to assume that the panorama may be used with equal effectiveness in paintings of the ocean and seacoast.

A panoramic composition offers the best way to arouse the feeling of large coastal expanses by creating paintings that dramatically evoke nature's own size and grandeur. It is only through sheer size that a picture can begin to rival, or at least attempt to suggest, the tremendous breadth and vastness of ocean and shore. Precisely because the panorama is unusual and unconventional enough to strike the eye immediately with a sense of space, its heroic proportions and long vistas are bound to give a painting considerably more visual impact and scope than the conventionally sized seascape.

Of course, panoramic views do not have to be painted only on large canvases. They can be done on a more modest scale by compressing all the areas into a smaller format, although the result may lack the breadth and shock value of a huge painted surface.

Some marine painters interpret their subjects through an exceptionally wide format—an elongated horizontal proportion—to give a strong impression of the expanse of ocean as seen across great distances of water. Others work from a high vantage point and look directly into the distance down the coastline. Still other painters give the sky unusual prominence, thus reducing the sea and its shore to a tiny strip that traverses the very bottom edge of the painting. The way in which the panorama is handled depends a great deal on the subject itself and the viewpoint selected and indeed on whether or not painters really require this view to most effectively put across their responses to that particular subject.

PLAN When you want to capture a sweeping view of a large section of a coast, think of your composition as being seen through a very wide-angle camera lens that includes a greater amount of the scene than your range of vision would normally include. (If you were to paint a smaller section of the shore in a more conventional seascape treatment, your picture would lack the sense of immense stretches of distance and space.) To get a panoramic effect, don't look just straight ahead of you but turn to both sides to depict the entire sweep of shoreline much in the manner of the old banquet cameras. As a matter of fact, if you are using a camera to supply detailed information not included in your sketch or drawing, you can photograph the entire spread of the scene in a sequence of three, four, or five separate shots of continuous sections of the seascape. You can then piece the prints together into a single elongated image by taping them together on the back to form one wide panoramic view of your subject. I once took a series of views through a standard camera lens that, taped together, formed a print over two feet wide!

For variety, instead of viewing the panorama from sea or ground level, you can look down the coast from a higher vantage point such as a high sea cliff, a tree, a rooftop, or a hillside that commands an extensive view of ocean and shore. Sometimes this viewpoint will give your painting a fairly high horizon. This can intensify and reinforce the sense of openness, the feeling of the seascape stretching in all directions, not only on either side of you but also into the deep space directly in front of you. Harbor scenes by Oscar Kokoschka and tidal flats by Leonid (Berman) often use this vantage point to obtain a panoramic spread that is not quite as easily perceived at sea level.

One point to remember when painting a panoramic view is to maintain a constant interest throughout the painting. See to it that there are no dead spots—areas lacking in any sort of visual interest—that would allow the composition to go slack. Every section must have enough in the way of subject matter, detail, pattern, color, or texture to sustain the viewer's interest at all times.

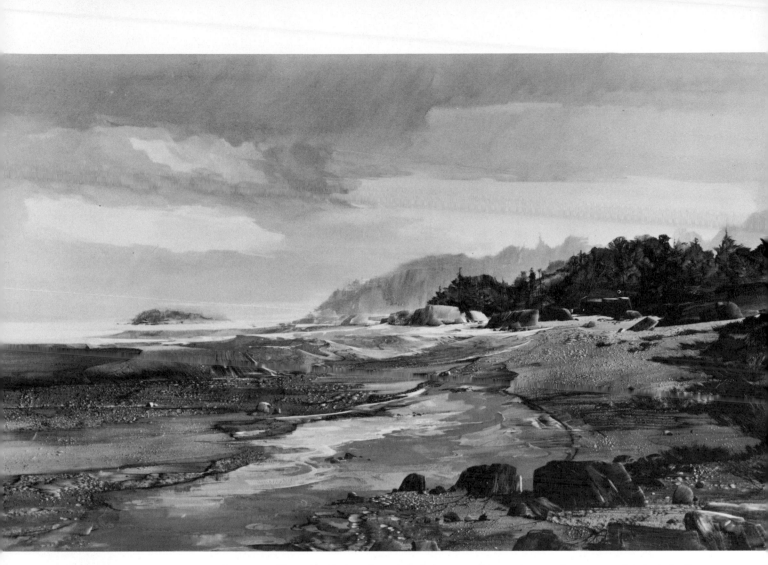

GREAT TIDE
by Laurence Sisson.
Oil on Masonite,
44" × 72" (112 × 183 cm).
Courtesy Dalzell Hatfield Galleries,
Los Angeles, California.

Laurence Sisson's paintings have long been associated with the Maine coast, though he is equally at home in using his personal oil technique to depict the spacious rocky landscapes of the Southwest. In this expansive coastal view, he has chosen a high vantage point in order to see as much as possible of the varying shapes and textures of ocean, tidal flats of sand and stones, beach, rocks, pines, and the headland and offshore island in the distance. A scene that might in some hands look rather ordinary has been made exciting by Sisson's intense interest in textures that include flat, washy passages, scumbling, spatter, and drifting paint. Note that he has used aerial perspective to enhance the feeling of depth, progressing from clarity and detail in the foreground and middle distance to grayer, softer, misted areas in the far distance. Observe, too, his handling of the sky in simple masses and broad strokes that serve as a foil for the intricate, detailed treatment of the lower section of the painting.

2. SELECTIVE VISION

CONCEPT One of the first lessons beginning painters are taught is to select and simplify their subject matter, a process that is less a choice than an obligation. The opportunity to select, to retain only those elements that are really important to the painting, is an advantage the painter has over the photographer. Although a photographer can move about to get a different view of his subject to eliminate or at least minimize what he considers unimportant or distracting, the painter can work from his chosen viewpoint and simply omit any elements that are not necessary to his composition.

In spite of the fact that selective vision is assumed to be part of an artist's equipment, too many paintings are overburdened with superfluous details that contribute little or nothing to their overall impact. Merely because an object is present doesn't mean it must be included in the painting. One of the aims of art is to see with how *little* a picture can be made, not with how much.

If the artist is not selective, the finished painting is apt to have distracting areas that weaken the main idea. But selectivity and simplification will enable the painter to direct the viewer's eye and to lessen the risk of having a spectator get tangled up in areas of the work that are not essential to the main statement.

John Sell Cotman was one of the greatest of the English watercolorists. Yet his true greatness lay not so much in his technique as in his extraordinary ability to select and simplify. Many of his seascapes, such as *The Needles* and *The Dismasted Brig*, are rigorously simplified into powerful flat shapes and masses strongly and compactly designed within a severely limited range of values. Detail is virtually nonexistent, and every touch counts for something. Indeed, in his own time, Cotman was known as "the master of the art of leaving out." Of course, there are other marine painters whose work is characterized by their ability to say much with little, who painted, when they chose to, with economy and brevity: Turner, Jean-Baptiste-Camille Corot, Delacroix, Louis-Eugène Boudin, Whistler, Homer, Emile Nolde, Marin, and Avery.

Selectivity is not a moral issue—like a form of censorship—but a pictorial necessity. It is in painters' own best interests to edit their subject matter because, by paring away the unnecessary, artists can project their responses more directly. It is certainly not the job of a viewer to weed out distracting material. Rather it is not only the artists' prerogative but it is also their responsibility to clear out the mess and offer an uncluttered vision of nature.

PLAN The first step in pictorial selectivity usually takes place in the sketchbook. When you sketch, you probably won't take the time or trouble to include things that don't interest you but will probably jot down only those shapes and areas that mean something and seem to be most pertinent to the fundamental aspects of your motif. This kind of selective vision, which is an integral part of the process of sketching and drawing, should be continued into the painting stage, right up to the finish.

If you are in the habit of relying on photographs as the only source for your paintings, this business of simplification and selection is a more conscious and more difficult task (and it probably serves you right!). You must constantly ask yourself how much in that print or slide you *really* need in order to put across your idea in the painting.

As you do preliminary drawings based on photographs, draw at first only the absolute essentials that interest you most, and if you can't omit all the details, at least try to reduce them to masses wherever possible. Strive constantly for economy of means, for ridding the composition of distractions that get between you and the clearest expression of your subject matter. Be brutal. Be hard on yourself. Try leaving out much more than you think you need to, and then add it later if you see you really need it. Don't put anything into the composition thoughtlessly, and take nothing for granted.

Be just as tough when the painting is finished. Don't kid yourself, but look at it coldly and analytically, condensing and simplifying whenever possible. If there are areas in the picture that you are pleased with, eliminate any passages that might distract a spectator from seeing and enjoying those areas. Think about the architectural maxim that "less is more," and keep in mind that development of your selective vision is crucial to your success in learning to translate nature into art.

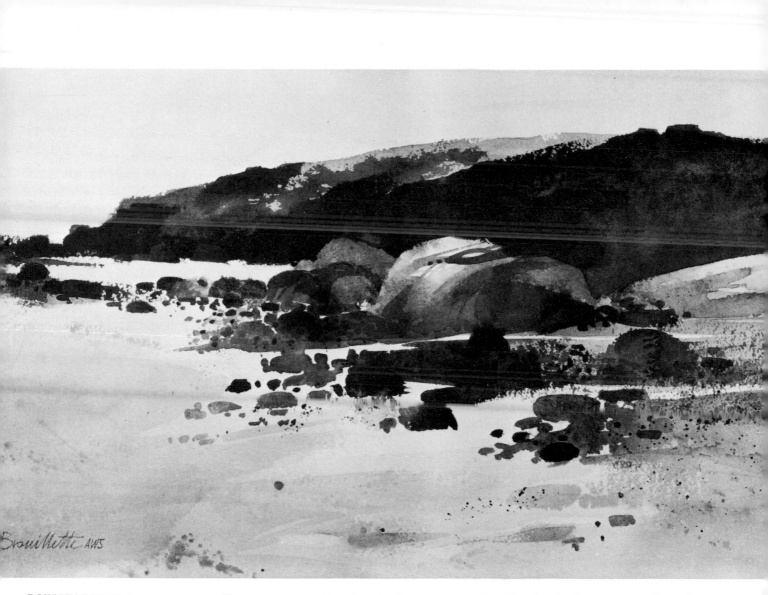

DOWN TO THE SEA
by Al Brouillette, A.W.S.
Acrylic watercolor on paper,
14" × 21" (36 × 53 cm).

There are no wasted brushstrokes in this painting. The subject here is simplicity itself. Closing in on a small section of coastline, Al Brouillette's selective eye has seen to it that no distracting textures or details interfere with the enjoyment of his almost Oriental brushwork. There are three simple masses—sky, rocks, and beach—accented by a few deft jabs of the brush to suggest the smaller stones at the water's edge. That's all there is, and that's all that is needed. It was not necessary to include a boat, a lighthouse, or a boy and his dog, since

Brouillette's sole aim was to translate a few basic coastal forms into a series of direct washes and touches of color. The values are clearly separated into lights, middle tones, and darks. The treatment is spontaneous but straightforward and unselfconscious, and the only suggestion of texture is an occasional spatter. The painting verges on abstraction, since detail and description are suppressed in favor of allowing the marks of the brush and paint to carry all of the pictorial interest. This is brevity and economy of means at its best.

3. THE CLOSEUP

CONCEPT "Avoid distant views; paint objects close up," Charles Hawthorne told his classes at Provincetown on Cape Cod. The great teacher had a point. A view that includes too much can, in the wrong hands, become a disorganized hodgepodge, in which too many unrelated things are happening. The best antidote for too busy or too complex a view is to narrow down the range to smaller fragments of sea and shore—in other words, to paint a closeup.

Although the term "closeup" comes from photography and film-making, it actually offers more leeway to the painter than to the photographer. In painting we speak of a closeup as being a view of something anywhere from ten feet to ten inches away. Of course, pushed to an extreme, a closeup could be an almost microscopic view of substances and textures barely visible to the human eye—"seeing the world in a grain of sand" as it were.

But generally, the closeup is an intimate, concentrated view of seascape or landscape, an investigation of particulars rather than an all-inclusive panoramic spread. To the painter, this means far greater attention to exact placement and composition than might otherwise be expected in the more traditional broad view of an entire scene. In the distant view or the panorama, details play only a minor part in the large, general scheme; in the closeup, a single detail can become the entire picture. Such a view is often more striking, more unpredictable, and more personal than that of the conventional composition, which is based on large masses of background, middleground, and foreground.

A final point to keep in mind is that the occasional closeup lends variety to a painter's total output of paintings, so that, in a one-man show, for example, the same distant viewpoint does not recur again and again with monotonous regularity. I always think of an artist who uses the closeup as having a more sensitive awareness to all the possibilities of the subject matter than the painter who is less willing to depart now and then from standard, conventional ways of seeing and composing seascapes.

PLAN Close in on your subject. Forget for the time being the ordinary ways of seeing the coastal environment in a large context. Perhaps in your selected scene, there are two painting views available to you, the long view and the closeup. So much the better. But for now, be selective. Narrow down and zero in on a more intimate view of your material. Instead of taking in the whole scene, concentrate, for example, on a group of worn, textured lobster buoys hanging against weathered shingles. Or on a pile of bright buoys on top of a rock or an overturned dory. Or on a bait barrel and dory half in shadow against the steps of a fishing shack, with a harbor in the background. Or on the patterns of lobster traps stacked on a wharf. Or on the interlacing of dune grasses blowing in the sea wind, against eroded rock textures and sand. The list is unlimited. Just keep your eyes open and your mind alert to all possibilities.

A closeup for its own sake is usually not enough. It helps to have some reason for choosing a closeup viewpoint, such as the play of light and shadow, interesting textures or patterns, or a study in design or shape relationships. You may even find that, as time goes by, the closeup will claim more and more of your interest as an offbeat pictorial viewpoint, and you will realize, too, that it is just as applicable to abstract treatment as it is to realism.

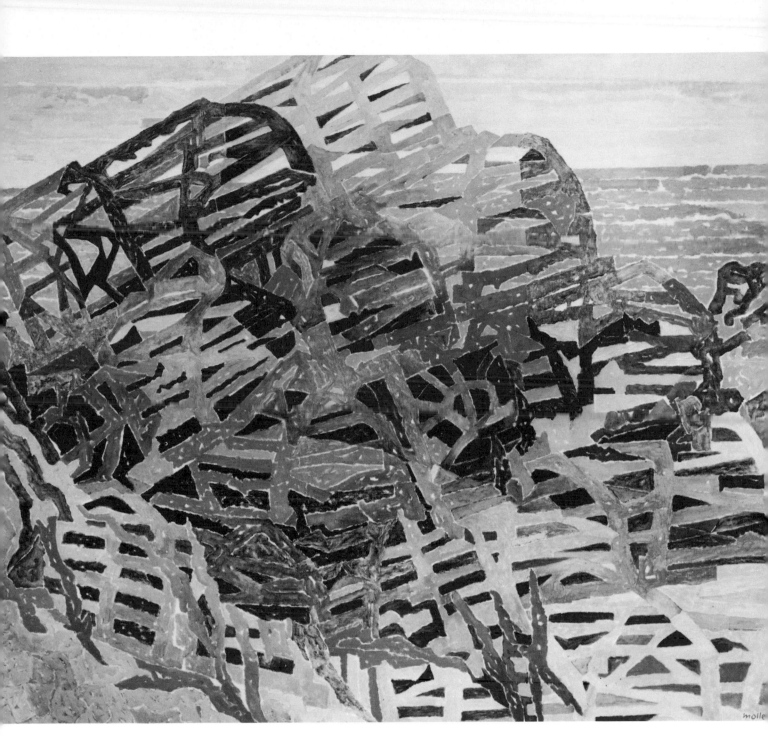

LOBSTER TRAPS
by Hans Moller, N.A.
Oil on canvas,
40" × 50" (102 × 127 cm).
Courtesy Midtown Galleries,
New York City.

Rather than present a more comprehensive view of the shore where the lobster traps would be a relatively minor element, Hans Moller has closed in tightly on his subject. This closeup view was the most natural one in order to compress his material, eliminate extras, and to reveal and explore those design aspects that most excited him. Moller has conceived the pile of lobster traps as an ordered jumble, an intricate interweaving of many linear elements. The sky has been kept very simple and unobtrusive in closely related values, and the horizontal strips of waves in the ocean effectively echo the basic linearity of the compositional structure. Even the grasses and weeds have become involved in the complex network of positive and negative shapes created by the casual disorder of the lobster traps. By using the closeup, Moller has achieved an effect of intense concentration in which the main subject fills the picture surface and the ocean acts only as a background for the interplay of color, line, and shape that constitutes the real drama of the painting.

4. SEASCAPE AS BACKGROUND

CONCEPT Although the most forthright way to present a seascape is to have the ocean occupy the entire picture, other forms can sometimes be put in the foreground that more or less frame this view of the ocean, which is then purposely kept in the background. It is a sort of reverse way of composing a picture: to place other dominant elements in the foreground and relegate the real reason for the painting to a minor position some distance away. The most flagrant use of this concept is in a delightful painting by Howard Chandler Christy that I saw many years ago. The picture was easily dominated by two undressed young ladies cavorting at the edge of the shore. A skiff was barely noticeable in the distance and off to the right. The picture was titled *Harrison Fisher's Boat*.

To use the seascape as a secondary interest in the painting is indeed something of a compositional twist and just a little offbeat, which is a good reason for doing it. Aside from that, however, a concentration on the foreground often gives the painter a chance to put greater emphasis on the environment—shore, meadows, forests, or architecture—that is close by the sea.

If the ocean is partially hidden behind branches or trees, or framed by a doorway, window, or posts on a porch, or glimpsed between two foreground buildings, then for some reason it is made all the more interesting, and the viewer is impelled to look harder and try to see it more clearly than if the same motif occupied the entire picture area. In other words, the very fact that it is compositionally slightly out of reach makes it that much more intriguing, visually speaking.

To put the seascape in a secondary position is to exercise some restraint, to make the picture a little less obvious by purposely refraining from showing the subject all at once as the principal element in the composition. A beginner would probably depict the scene just as he first sees it. The experienced painter often looks for other ways to present it, ways that are more consciously arranged or thought out in regard to methods of relating the sea most interestingly to nearby land forms.

PLAN One thing you have to keep in mind as a practicing painter is to maintain some degree of compositional variety. If all your seascapes are based on too similar a view, your work may give others the impression that you are more limited or less resourceful than you really are. Just as you would not use the same color scheme over and over again in a series of paintings, so your composition or point of view also needs some variety now and then, for your sake as well as that of your audience.

Therefore, as I've suggested earlier, you should look at your subject from more than one viewpoint. Examine it close up and at some distance. Check out possibilities for placing the subject in the middle-ground or distance. Frame the scene as seen through a doorway in a house or through the large doors of a barn that open up to a vista of the sea beyond. Keep a sharp eye out for foreground interest: flowers, a rock wall, a meadow sloping toward the shore, a grove of trees, or a pair of dories. Or use a fishing shack on either side of the picture, and a pile of fishing gear or lobster traps, with the ocean glimpsed in the background. It is still a seascape, but you are leading your viewer into your seascape in a more interesting way, with more happening in the picture than just the seascape itself.

In short, be imaginative and daring. Try to set off your subject by the context in which you arrange to surround or frame it. Do the obvious view, by all means, but then do another version showing the same subject in a different or more unexpected relationship to its environment. And never forget the lesson of *Harrison Fisher's Boat*!

SURF AND WINTER PINES
by William Thomson.
Opaque watercolor on paper,
20″ × 30″ (51 × 76 cm).
Courtesy Ps Gallery,
Ogunquit, Maine.

Although ''surf'' is listed first in the title of this painting, it reveals itself only after the first impression of the total picture has been made. At first glance it looks more like a snowscape than a seascape. Closer examination discloses the fact that it is indeed a seascape filled with great breakers, tumbling surf, and churning white water. While this might at first sound like a Frederick Waugh composition, what makes it special is that Thomson has chosen to place this vast, active seascape in a secondary place in his picture by setting it beyond a grove of trees that serves as a framing device for the sea and provides foreground interest. Because of the detailed delineation of the textures and branches in the pine trees, with each area— water and trees—acting as a foil for the other, the mass of white water seems more of an elemental force. Note that the tree trunks are carefully arranged and spaced, with considerable attention given to the distances between them and to their recession into the picture space.

5. VIEW FROM OCEAN TOWARD LAND

CONCEPT The customary vantage point for painting a seascape is from the land. The painter situates himself on beach or rocks, on dunes or dockside, and paints the ocean spread out before him. It is also the safest place to be when painting the coastal scene, especially when stormy surf comes crashing and pounding in on the rocks at the ocean's edge. But as dramatic and varied as such paintings may be in terms of composition, movement, light, or expressiveness, they all have one thing in common: the landlubber artist has limited himself to studying the sea only from the land.

Now, if this situation is reversed, so that ocean and land are seen as if from the sailor's or fisherman's viewpoint (looking back toward the coast from some distance out in the water), a fresh viewpoint for a seascape can be achieved. No longer are beaches, dunes, and rocks in the foreground, with the ocean serving as middleground and background. The ocean now occupies a major foreground position in the picture space, and land forms are relegated to the background. This concept is not to be looked on as being entirely unconventional, since it has been used by Oriental masters as well as by Corot, Boudin, Turner, Cotman, Monet, Homer, Childe Hassam, Bellows, Kent, Edward Hopper, Marin, William Thon, Reuben Tam, and Max Ernst, among others.

Whether an artist is painting realistically or abstractly, a greater variety of forms are possible with the ocean in the foreground than there are with the land as the foreground. For example, atmospheric effects of sunlight, sunsets, color, mist, haze, and fog are seen in relation to the land in a way that is possible to observe only from a viewpoint out in the water. Also, the action of waves and surf, the patterns of flow and turbulence, and the textures of flowing liquid masses and frothy foam often help to create more visual interest and more unusual forms and textures than those of the more familiar rocks and beaches.

And, of course, the element of unexpectedness, of perceiving both land as well as sea in a transposed relationship—just the fact that it *is* a reversal of the standard situation—is bound to give the painting a special, fresh quality that sets it apart from the average seascape treatment. It puts the spectator right out there in the water to participate directly in a view of sea and coast ordinarily familiar only to the seafarer.

PLAN Get out on the water by whatever means you can, on anything from a rowboat or sailboat to a yacht (if you have the right friends). The main thing is to find a way to get the viewpoint from the water while looking back toward shore. Quite often, as long as you keep out of their way, fishermen or lobstermen are glad to have you along. Some boats are for hire to take out fishing parties for most of a day, while other boats take tourists on short coastal cruises near the shore. Another alternative is to sketch the mainland from a nearby island.

However you manage it, make the most of your opportunity. Try painting an ocean view of a lighthouse. Or paint the geometry of harbors with docks, wharves, moored boats, pilings, ladders, nets, ropes, and fishing gear. Or picture the white houses of a fishing village clustered on a slope leading down to the docks where boats are moored, being built, or repaired. Or record the look of meadows, mountains, or cliffs as they tumble toward you to meet the ocean, often with exciting atmospheric effects of light breaking through fog or surf. Even the sensation of seeing waves rolling away from you, moving relentlessly toward their point of impact against the rocks and beaches, is an altogether new visual experience when seen from the ocean. Sketch these scenes, photograph them, or simply memorize them, but try to find ways to use the mariner's view later in the studio to add extra interest to your seascapes.

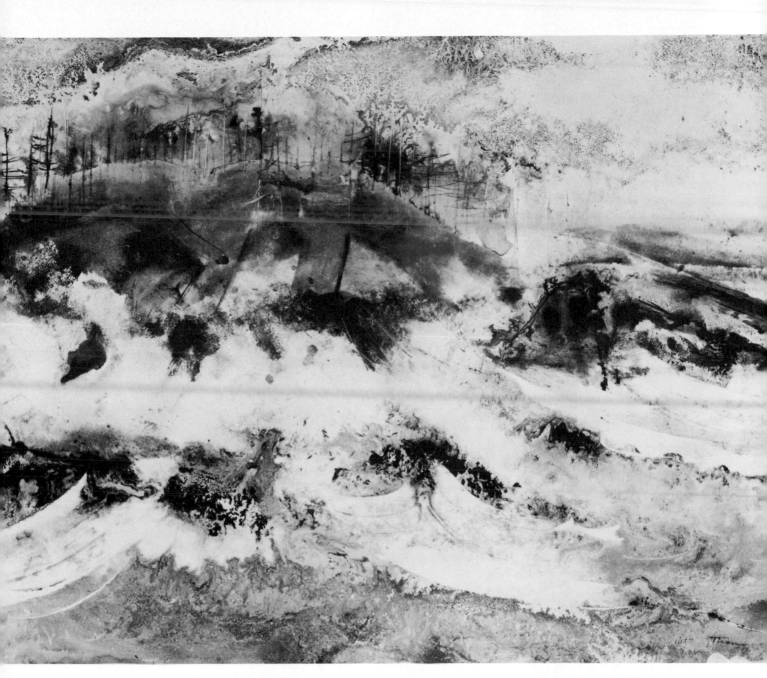

ISLAND SURF
by William Thon, N.A., A.W.S.
Watercolor on paper,
20½" × 27" (52 × 69 cm).
Courtesy Midtown Galleries,
New York City.

William Thon's work has long been associated with the sea. An ardent sailor and the owner of several boats, Thon has had ample opportunity to build up a repertoire of memories and impressions of the rocky coast of Maine as seen from the vantage point of the water. In this painting the surf occupies the major part of the picture surface. The focus is on the white spray and foam boiling over and around the rocks at the base of the cliff, and the land mass has been subordinated to the ocean's activity. The picture's most unusual quality is its viewpoint. Thon has placed us in the midst of the surf, and we share his experience of observing the energetic sweep of waves smashing against the coast. Instead of a routine description of the scene, Thon has treated it in thoroughly painterly terms, especially revelling in rich, yet subtle paint textures to heighten and intensify the visual effects in this dramatic subject.

6. MID-OCEAN VIEW

CONCEPT If the preceding suggestion of picturing the ocean scene from the ocean itself were pushed to its extreme, the artist would have a seascape where no land at all would be visible—that is, a pure seascape. Anyone who has made a transoceanic voyage has experienced the awesome vastness of the only two great spaces there—sea and sky. There, the ocean seems so infinitely deep and the continent so distant that it is not only completely out of sight but indeed may as well not exist at all. Being surrounded by water—if not in the middle of the ocean, at least for many miles around—brings with it also a certain sense of timelessness (and possibly fearsomeness?) somehow lacking under more ordinary living conditions on terra firma.

Painters like Turner, Ryder, and Homer have used the midst-of-the-ocean viewpoint to evoke as eloquently as possible the immensity of the forces of nature. Their paintings are not just tranquil views of ocean subjects seen from the safety of the shore, but they are scenes involving ocean snowstorms, raging seas, opposing turbulent water masses, and misty atmospheric effects far out at sea. Paintings of this sort are meant to suggest aspects of elemental power, violence, mystery, or poetry. Choosing the mid-ocean viewpoint enables the artist to communicate most directly and powerfully the deepest responses of the human mind and emotions to the sea.

Admittedly, the viewpoint from the midst of the ocean is not always easily accessible to every painter. Nevertheless, considering how much it has to offer in the way of drama and emotional impact, it should not be ignored as a serious alternative for a painting.

PLAN From the midst of the ocean? It is not really an impossibility, and there is much to be gained pictorially. To place your spectator right in the middle of things is to have that person experience most intimately and directly the color, light, movement, patterns, and textures of the seas observed close at hand. For the traditionalist painter, it means that the usual foreground or background planes, and often the horizon, may not be present. The action of the water itself is the total concern of the painting.

Of course, the most obvious way to get material for this viewpoint is to get out into the ocean in any kind of boat and do a number of sketches or take snapshots of the water in action. For purposes of painting seascapes, the most desirable situations would be those in which the ocean is somewhat in movement, times when waves, crests, swells, and sea-foam patterns are most in evidence. But if these conditions seem too risky to you, try sketching the same sea forms from rocks or ledges that jut well out into the water, simply omitting anything in the composition that would refer to rocks or land forms of any kind, near or far. Some painters have been known to wade knee-deep into the oncoming waves and record with a camera the look of surf and foam, so that water forms fill the entire composition in their lens and the impression is given of being surrounded by the swirling, rushing water. This method often produces some exciting pictorial arrangements, but I have a feeling it is likely to be pretty hard on a camera. Still, if you are willing to take chances. . . .

Rejecting all the above, you can always use photographic sources, particularly *Oceans* magazine or some of the surfing magazines, which often contain some spectacular shots of waves in action. Remember, these photographs are only general source material and are not to be copied literally as the basis for a sea painting. On the other hand, they do supply necessary information on the action of surf and waves, splashes and sea spray or spindrift, and the fundamental surge and rhythm of moving water. You can then use this information creatively to imagine and invent ocean compositions that represent your personal interpretation of what it must feel like to be in the midst of the ocean.

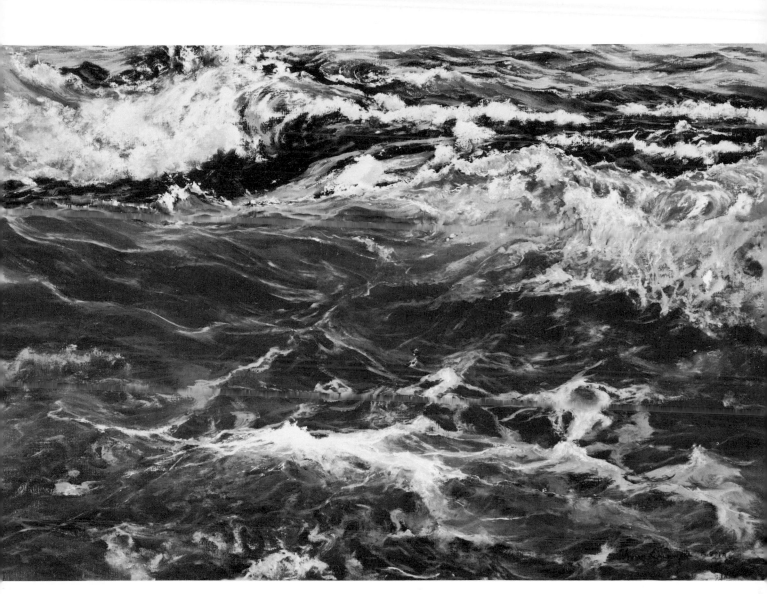

CROSSCURRENTS
by Vivian Caldwell.
Oil on canvas, 24" × 36" (61 × 91 cm).
Private collection.
Courtesy The Back Door Gallery,
Laguna Beach, California.

This painting puts the viewer right into the midst of the water, with no references to beach, rocks or even a horizon. The swirling ocean currents and the water itself are the total content of the picture. There are no distracting or sentimental elements here—just an intense concentration on shape, form, movement, surface, light, and texture. In that sense, despite the free realistic treatment, the painting is just as much an abstraction as it is a description, and it can be enjoyed equally on both levels. Caldwell has captured the infinite variety of the open water, especially its fluidity and constant change, by studying the differences between flowing water at the upper edge, the spill of foamy waves, the conflict of one current against another, the deep swell and surge of ocean, and finally the more complex action of sea foam and choppy movement at the lower edge of the picture. This is not a generalized, clichéd sea painting. It is a vivid and intimate revelation from the very midst of the subject.

7. PLACING THE HORIZON

CONCEPT The most basic division in any seascape painting is the placement of the horizon. Compositionally, this is one of the most important decisions to be made in the beginning stages of the painting, and one the painter usually arrives at in the early preparatory sketches, when deciding whether to compose the painting within a horizontal or vertical format. The establishment of the horizon line determines immediately the principal relationship—or proportion—of sea to sky. Since this relationship is crucial to the overall look of the painting, it demands serious thought.

One of the oldest rules in pictorial design is that the horizon should never, never divide the picture across the middle. To do so, it is said, would be to create a boring symmetry, an equality of parts, that is worse than any of the Seven Deadly Sins. As we shall see, that is a rule that can be broken on occasion without utterly destroying a composition. Nevertheless, in general, it really is best not to divide the picture into two completely equal upper and lower parts.

Most seascapes and landscapes have horizons placed approximately one-third of the distance from the lower edge of the composition or somewhere just above the middle. This is the most natural placement for our customary, eye-level view of nature. However, to better express a particular view of the subject, to alter emphasis on one part of the picture or another, or just to make a more striking division of the picture surface, the painter can always raise or lower the horizon line.

As we have already seen, an unusually high horizon tends to give an effect of tilting the ground plane upward toward the viewer, giving the impression of a gull's-eye view. Conversely, an extremely low horizon tends to create greater depth, a recession into deep space directly outward in front of the viewer, thus placing much greater emphasis on the sky as the major area in the composition.

PLAN Where to place the horizon is entirely up to you. However, I suggest that you vary its placement from one painting to another and not put it at a similar point in all your paintings. Apart from the lack of variety that results, it is a good idea to avoid routine formulas for relating the amount of sky to the amount of sea. The motif of each painting requires its own solution as to how the horizon divides the picture surface.

Use the horizon as a challenge; take some chances. Put the horizon at levels that are new to you and then see how you can use that unusual placement to add interest to the picture. In your sketchbook try several variations of placement—not only the most obvious one—*before* you begin to paint.

The placement of the horizon can also affect your handling of perspective and distortion and thus help to dramatize your subject. Think of the horizon not just as a horizon but as a design device to divide the picture area in an unusual way. For example, try putting it at midpoint, with equal amounts of sea and sky, breaking the rules yet still making the picture succeed by the way you use the upper area as a foil for the lower.

Try a high horizon now and then, looking down on your subject, or drop the horizon almost to the bottom edge of your composition. With sea or shore compressed into a small band that traverses the lower edge, the large mass of sky can be treated either as totally flat area or as a hazy, atmospheric one, serving as a contrast to more active elements below. Or the large area of sky can be handled as a dramatic arrangement of light and dark patterns, cloud forms, storms, and so on, relegating the coastal elements to a very minor role in the composition.

In short, never look at the horizon unquestioningly. Instead, try to use it creatively as an important factor in structuring your compositional arrangements.

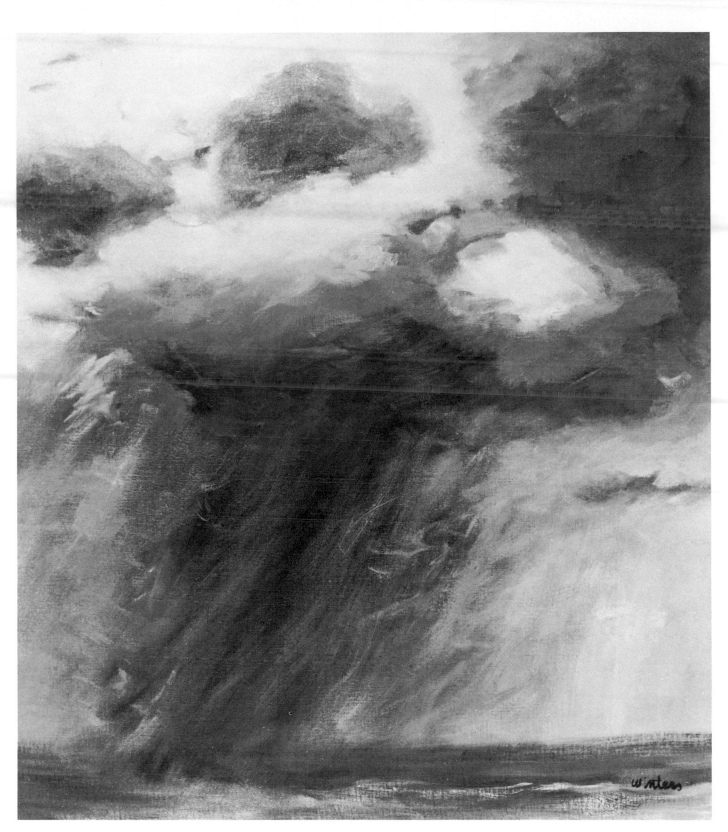

TROPICAL STORM
by Denny Winters.
Oil on canvas,
46" × 40" (116 × 102 cm).
Courtesy Hobe Sound Gallery,
Hobe Sound, Florida.

In this painting Denny Winters has dramatized the storm by dropping the horizon close to the bottom edge of her composition. The turbulent storm clouds, gusting winds, and torrent of falling rain are captured with a loosely brushed treatment that is thoroughly expressive of the subject matter. A higher or more "normal" horizon would have brought about a near-equalization of the areas of sky and sea, but here, the low horizon concentrates the major interest in the upper areas, and by so doing, magnifies the sense of scale and the awesome fury of the tropical storm. Compressing the sea (which is painted as simply and unobtrusively as possible) into a very small zone is not only an offbeat division of the picture surface, but it is an interpretation vital to the heightening of the visual impact inherent in the subject.

8. AERIAL VIEW

CONCEPT One of the most fascinating views of all is the aerial view. By looking directly downward, the artist can observe the coastal forms below as being parallel to the picture plane. It is not an angled or oblique view but a perpendicular one in which a horizon line is not even present.

This view is of particular interest to the seascape painter because it is a wholly new way of perceiving coastal contours, shapes, and textures. Instead of the conventional view of forms receding into depth seen at eye level, the aerial view results in a flat, maplike arrangement of shapes and forms. It is an exciting viewpoint too, since the viewer is made aware of the elemental or geologic character of shoreline, islands, and cliffs, as well as inlets, marshes, incoming waves, dappled water textures, white surf, or the counterpoint of geometric harbor forms to the flat organic forms of the shoreline. A variety of underwater configurations are also visible: shallows, shoals, rocks, reefs, and sandbars, all disclosing an abstract world of shapes, patterns, colors, and textures that are never as clearly seen from any other vantage point.

The aerial view provides a means of seeing and understanding abstract relationships as pure shape and pattern, but in a way that is applicable to both realistic as well as abstract styles, since it lends itself equally well to detailed description, stylization, or abstract interpretation. It probably appeals most to the abstract artist, however, because it tends to obliterate recognizable form in favor of emphasizing the basic formal relationships of abstract design. When seen from a low level in the air, boats, shacks, wharves, beaches, dunes, cliffs, and meadows are still quite recognizable. But from far greater heights, these elements are reduced to lines, masses, and patterns that are often more arresting, intricate, and breathtaking than any that might be invented by a human mind.

Finally, the aerial view offers an opportunity to observe the unusual effects of fog and mist drifting in over ocean and shore, where atmospheric nuances of whites, grays, and neutrals appear as a contrast to the harsh, rugged forms of the coastline. This opposition of hard and soft is, of course, also visible to the shorebound painter. But to the airborne artist, these relationships offer a quite different visual experience, a delicate, evanescent, poetic beauty that, from a more customary viewpoint, remains unseen and unsuspected.

PLAN Ideally, if you want to experience the effects of an aerial view at first hand, it means doing some flying. I have observed the seacoast from aircraft ranging from gliders to small private planes to commercial jetliners, and I can tell you there is no substitute for seeing it in that way. Sketch, take snapshots if you can, or perhaps better yet, observe intently and soak up impressions for future reference. Paintings that result from such experiences are bound to be more personal and evocative just because there was such a direct visual-emotional response to the sea and shore from that particular viewpoint.

Failing that, however, you can get some idea of an aerial view of the coastal environment by examining the group of magnificent photographs of shore and ocean by William Garnett that appear in *Not Man Apart: Photos of the Big Sur, Lines by Robinson Jeffers*, edited by David Brower (Sierra Club, San Francisco, 1965). Also, though not specifically concerned with the seacoast, don't miss Beaumont Newhall's splendidly illustrated book, *Airborne Camera* (Hastings House, New York, 1972), which should open up to you the world of striking forms and patterns as seen from the air. Other sources might be the files of firms that specialize in aerial photography for coastal geological surveys or commercial enterprises.

Understand that such photographic sources are not comparable to firsthand experience and should certainly not be copied literally. The main idea is to enlarge and enrich your personal repertoire of shapes, patterns, and textures as applied to seacoast themes and to use aerial views purely to stimulate your design ideas and compositional inventiveness. A perpendicular look at the coast below can give you a broader and deeper understanding of the varied aesthetic possibilities for coastal configurations in your paintings.

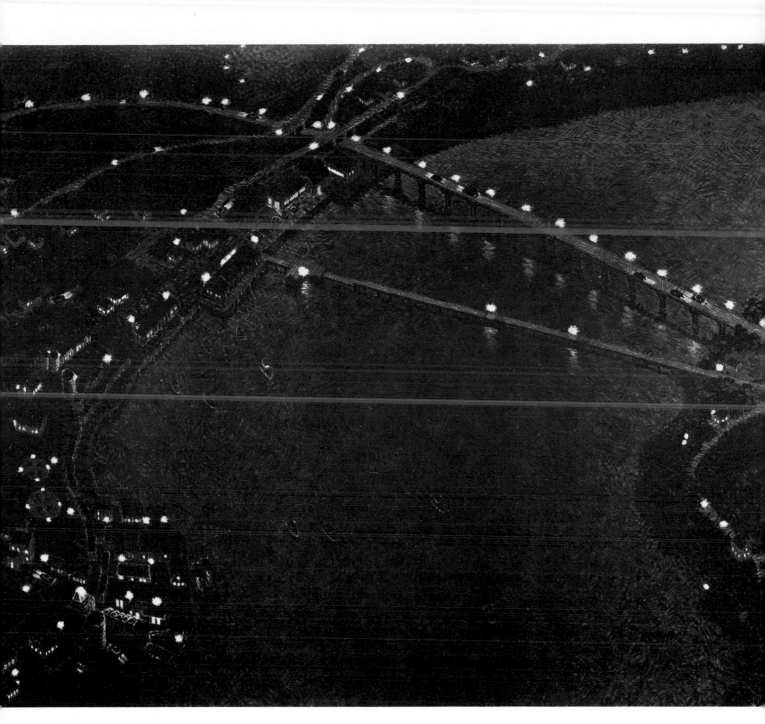

BELFAST HARBOR NIGHT VIEW
by Yvonne Jacquette.
Oil on Canvas,
66¼" × 80¼" (168 × 207 cm).
Courtesy Brooke Alexander, Inc.,
New York City.

Yvonne Jacquette's painting of a harbor at night is a relatively low aerial view in which several houses are easily visible, as well as a number of lobster boats at their moorings. If seen from a greater height, such forms would be less recognizable and far more abstract and generalized as elements in the composition. A former realist-precisionist painter, Jacquette has preferred to remain nearer to her motif and to put more emphasis on the relationship of natural forms (the shoreline) to man-made ones (bridges, wharves, and buildings). The night view has given her the chance to work with deep saturated color and to play with the linear patterns and clusters of lights, painted in a variety of warm and cool touches. Her application of paint is a combination of dots, dabs, and loosely hatched brushstrokes, which keep her surfaces more vivid and varied than if the paint were applied more flatly. Note that the aerial view eliminates a horizon and presents the scene in a maplike format. The fact that she has chosen to paint it as a night scene serves to enhance her personal vision of the coast as an experience in line, mass, pattern, and light, giving her a delicate balance of abstract design within a realistic context.

9. GULL'S-EYE VIEW

CONCEPT In discussing the panoramic view, I mentioned that one of the possibilities was to look downward and outward from a high vantage point. The gull's-eye view is somewhere between that and an aerial view. It is not looking down and outward, nor is it just looking directly downward. It is a kind of angled view of the coast below, with a high horizon line near the top of the painting, sometimes in the upper quarter of the composition and often even nearer to the top of the picture. In fact, it is this high positioning of the horizon that seems to project most clearly the idea of a gull's-eye view.

The advantage of this viewpoint is that the artist is not restricted to observing a subject only at sea or ground level, where forms are perceived in front of and behind each other while receding into space. Instead, in the gull's-eye view forms are seen from a higher vantage point and have a more airy, open, and spacious relationship to each other. It is much like looking at seascape or landscape from an airplane that has just taken off or is about to land. Islands are seen as whole shapes and masses, and the curves of the shoreline are more evident. Land and shore configurations are seen in a way that more truly reveals their natural characteristics than when seen head-on at eye level. It is this fresh revelation of the relationship between land and sea—seeing the shapes and patterns of beaches, rocks, and tide lines from an unaccustomed viewpoint—that appeals to many painters as a way of suggesting a number of different possibilities for presenting a more personal vision of the world around us.

The gull's-eye view is adaptable to both a realistic, representational approach as well as an abstract interpretation of coastal forms. It need not be panoramic in scope, but it can be a composition of only cliffs and surf, or of mist moving in over a harbor or spruce forest. And for the abstractionist who is concerned with composing planes within a controlled or limited depth (as opposed to an infinite deep space of the traditional painting), the gull's-eye view affords an opportunity to use the ground plane as the deepest, or rear, plane to compress the pictorial depth into a far more shallow space.

As soon as a high horizon has been established (and it might even be a tilted horizon), the situation is set for creating the impression of looking downward at a slight angle as a soaring, swooping sea gull might know it, thus suggesting several compositional arrangements to painters that would be less available (or visible) to them at ground level.

PLAN As I mentioned earlier, you can get a gull's-eye view from any elevated vantage point: cliff, mountain, rooftop of barn or seashore inn—any point that will give you a downward view of your motif. Of course, you can also study coastal subjects from the air in a low-flying plane, helicopter, or glider. Under such conditions, it is possible to make sketches or take snapshots for reference, but because time is limited and the aircraft is in motion, I'd recommend memorizing the views and storing up impressions instead. Professional low-level aerial reconnaissance photographs can also suggest shapes, patterns, and designs for your paintings.

If you are reasonably experienced, you can start a painting by simply indicating a horizon line close to the top edge of the picture. This establishes a relationship between sky and sea or land forms that immediately suggests a gull's-eye view. From that point on, a combination of knowledge, memory, and imagination will produce a far more unusual and arresting arrangement of nature than one based on the standard earthbound point of view.

If you want a change from the usual level horizon at the upper edge of your composition, try tilting the horizon for an even more forceful effect of soaring or gliding. Remember, though, you are using this view not as a novelty or gimmick but as an expressive means of revealing various aspects of the appearance, structure, and design of the coastal environment that are less commonly seen in more conventional seascapes. As always, don't abuse or overdo it.

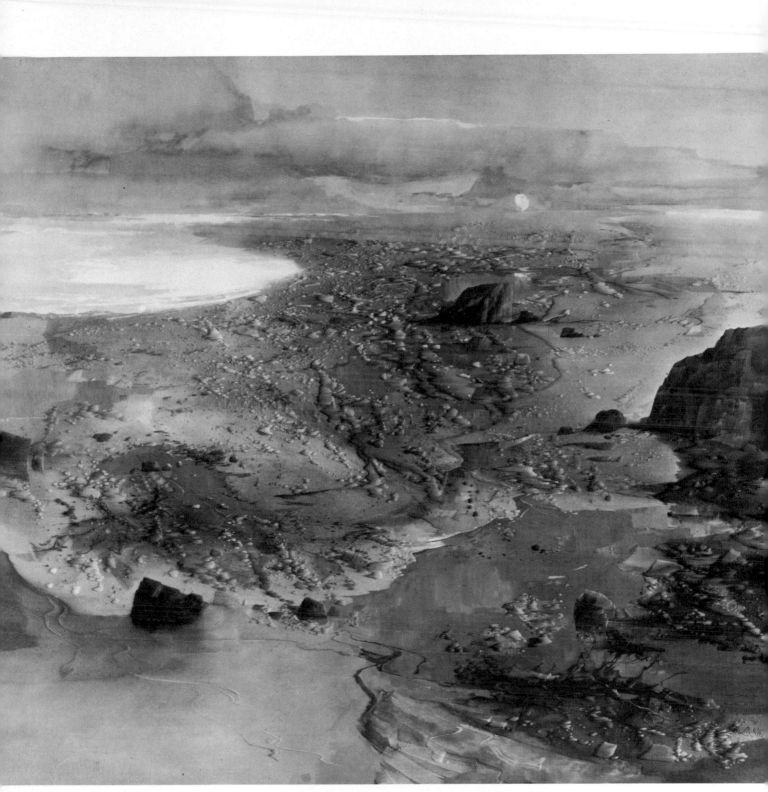

VIEW FROM SOUTHPORT

By Laurence Sisson.
Oil on gesso,
36" × 42" (91 × 107 cm).

Laurence Sisson's painting of tidal flats evokes the spaciousness of the scene and at the same time depicts detailed tidal patterns in the sand, wet sand formations, pools of shallow water, and all the rocks, stones, pebbles, shells, and flotsam and jetsam that pertain to this area between sea and rocky shore. By selecting a gull's-eye position, Sisson has been able to get a downward view of the entire expanse and thereby reveal shapes, patterns, and textures that would be barely visible at eye level on that very beach. We have the sensation of being suspended in air, looking outward toward the high horizon, with the foreground almost directly beneath us. This effect is reinforced by the foreground elements, which are more clear, detailed, and specific than distant areas, which are blurred or more generalized. This sense of simultaneously looking downward and into the far distance can be achieved only by painting from a relatively high vantage point or by simply imagining oneself to be floating or flying at some height above the coastline.

10. UNDERWATER VIEW

CONCEPT It is one thing to look at the ocean from land or sky, and it is something else to look at the ocean as you sail on it. But beneath the surface of the water is a whole other world of sea forms that might be said to qualify as seascape in the very truest sense.

Rocky outcroppings, reefs, clefts, sea caves, fishes, underwater vegetation, and the sea floor itself are all part of the underwater scene. The range of color is quite different from what is seen on the shore. There are much richer saturations of color: a range of deep blues, turquoise, olive and moss greens, warm browns, purples, blacks, brilliant golden yellows, hot oranges, and occasional shots of pink or flaming red. Of course, at deep water levels, less light is able to penetrate and the underwater scope is darker and gloomier than nearer the surface. But at shallower depths the variety of forms and brilliance or richness of color is almost unbelievable. It is a world so new, so unknown to us, that it borders on realms of imagination and fantasy.

Many painters respond to underwater forms precisely because of their abstract quality which inspires them to further inventions that combine colors and shapes in this new environment and unusual context. In fact, I know a number of abstractionists who have become addicted to underwater diving and swimming as a means of exploring and experiencing that fascinating world firsthand. This takes special training and gear, of course, but the results shown in their art are well worth it.

Underwaterscapes range widely in style and treatment from Syd Solomon's richly pigmented, glowing hot and cold colored forms based on his own scuba-diving experiences off the Florida Gulf Coast; to Nick Brigante's soft, flowing underwater world of color, line, and washes that relate to the California waters; to Sylvia Glass's delicate, ambiguous fantasies that evoke feelings of the ocean floor. At any rate, the undersea composition, whether observed directly or derived imaginatively from photographs, is a form of seascape painting that has recently produced some of our most interesting imagery.

PLAN I recommend going directly to your sources whenever possible. Actual experience observing underwater geological formations and various forms of marine life—plant or animal—is certainly the best way to achieve authenticity and a firsthand response to the undersea environment. Unfortunately, you will need specialized training and practice for this. You will also require diving equipment, more for scuba diving, obviously, than for snorkeling at shallower depths.

If firsthand underwater experience is not feasible, I would suggest the intensive and extensive study of undersea photographs. *Oceans* magazine is a splendid source for highly professional photographs of all sorts of undersea forms. Another convenient source is *National Geographic* or *Audubon* magazine, both of which feature photographic illustrations of great clarity and artistry. Again, I must warn you that these sources are *not* to be copied. Your job is to use them to get the feel or mood of the underwater world and to absorb those forms fully so that you may later use them freely and inventively. Look for color combinations, patterns, shapes, textures, and design possibilities. Get to know the ways of water currents and how splashes, bubbles, and foam can be used.

Using inks or paint, make improvisational sketches that seem to be the equivalents of undersea forms and forces. Then go on to imagine and invent your own underwaterscapes, coordinating what you know and have absorbed with the manipulation of your chosen medium. Let the fluidity of your paint help create your underwater world. Think of it as being above all an experience in paint that also happens to evoke an undersea environment.

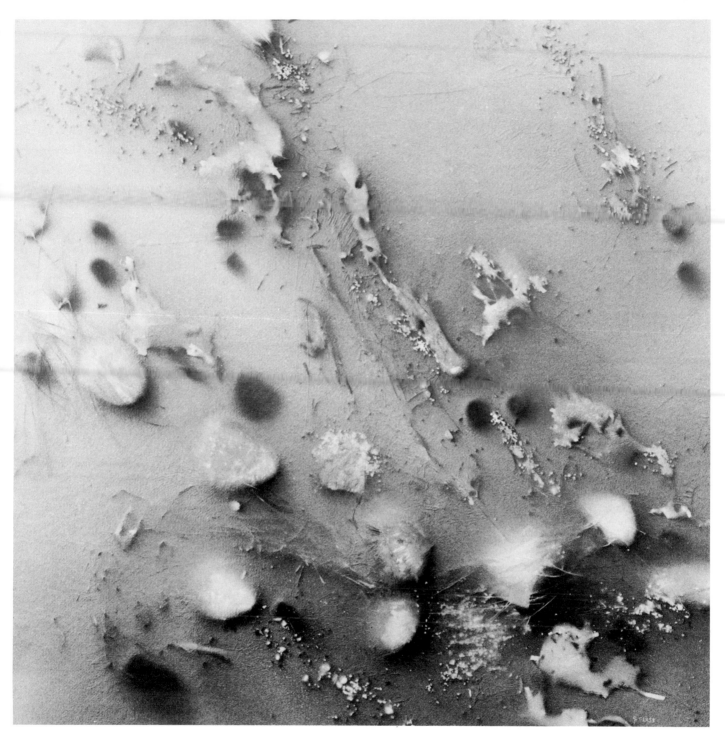

MID-OCEAN DEEP
by Sylvia Glass.
Water media on illustration board,
42" × 42" (107 × 107 cm).

The ocean paintings of Sylvia Glass are unusually felicitious combinations of the real and the unreal. Although her inspiration is the sea, her art reflects inner experiences as well. The surfaces of her pictures evoke the idea of scattered unidentifiable forms on the sandy ocean floor, implying some kind of reality without any attempt at specific description. Her images are partly the result of accident and improvisation (allowing manipulation of the medium to influence the development of her forms and composition) and partly the result of her quite personal use of intuition and fantasy. Applying paint with both a brush and a spray gun, Glass creates luminous, irridescent shapes, textures, and shadows that offer the illusion of three-dimensional forms at the bottom of the ocean.

11. UNDERWATER CLOSEUP

CONCEPT For a less generalized view of the underwater scene, the alternative is the closeup, detailed view. While closeups are still quite possible in deep water, shallow tide pools also offer the artist a unique opportunity. For one thing, they are readily accessible, and secondly, they reveal a complex underwater world.

Some tide pools tucked under large overhanging rocks are relatively deep, but most of them are shallow. They contain a wide variety of forms—rocks, stones, seaweed, sea grasses, crabs, anemones, coral, periwinkles, starfish, barnacles, glittery rock clusters and strata, deep shadows, and crevices—all plainly visible to the artist looking for new forms, designs, and rich color relationships. Frequently, the floor of a tide pool looks less like rock or sand than an open treasure chest heaped with bright jewels, their colors enhanced by the still, clear water of the pool.

Aside from color and design, the tide pool has emotional overtones that are best summed up by Nick Brigante: "The reality of the tide pool in its undulating serene existence among the rocky shores evokes many mental images of quiet depths, mystery in its shifting shadows, images quivering in obscurity." Again, in some catalog notes, Brigante mentions the tide pool's "undulating light, mirrors of moving images above—translucency of water depths below." Such response to the poetic, visual qualities of a tide pool are quite personal but not at all unusual. In fact, it bears out Janet Schneider's comment (in her catalog foreword to *By the Sea*, a 1979 exhibition at the Queens Museum in New York City) that "the unique attributes of the shore have long attracted artists, and we find in their work a bridge between the sensual and the aesthetic."

It is their almost mystical attraction, together with the visual beauty, that makes tide pools such an excellent source of underwater imagery for the artist. The closeup of undersea forms in tide pools offers an intimate, deeply personal view of nature that should not be missed by anyone interested in painting the coastal scene.

PLAN Underwater closeups are most easily undertaken by examining tide pools while the tide is at its lowest ebb. Situated as they are among rock forms, the tide pools themselves are often interesting abstract shapes. But you should also look deeper into the water to explore shapes and patterns at the bottom or edges of the tide pool. Aside from the animal and vegetal organisms, there is often a considerable amount of shells, stones, and debris.

Make drawings, not of the entire contents of the tide pool, but of sections or portions of it, closing in on forms and singling out groupings or clusters that interest you. Let these forms fill the entire page of your sketchbook as large closeups, emphasizing the abstract designs, rhythms, and textures of the forms. Study the colors intently or take accurate written notes so you will remember them later. If you want, take color slides of the tide pool interior, getting in close and making sure the sun or sky is not reflected, so you can document the varicolored forms beneath the surface of the water.

Although some of your drawings may be accurate and detailed, feel free to dampen the paper or spatter it with water, and then develop forms that relate to what you see in the tide pool, without being factually descriptive. Try to get the feeling of those sheltered, silent depths—a self-contained world of forms and colors removed for the moment from both land and sea. Search out the poetry of the tide pool, not just the facts.

Remember, your sketchbook closeups of the tide pool are more than merely informational. They are also supposed to evoke the essence of that world through the language of drawing and painting.

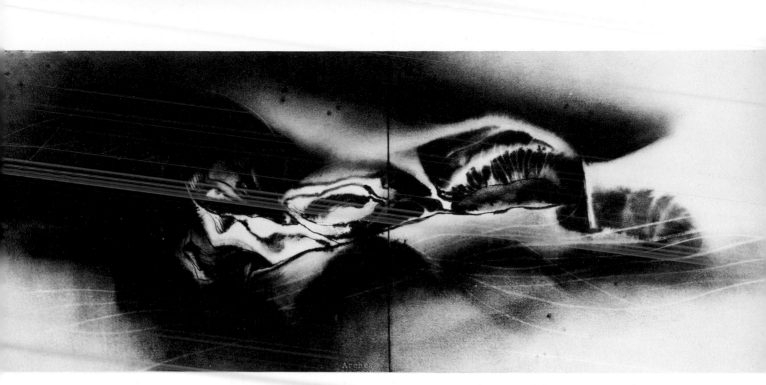

TIDE POOL SET NO. 1
by Nick Brigante.
India ink wash on paper,
22″ × 60″ (56 × 154 cm).

Nick Brigante's tide pool series of watercolors originated partly from his deep love of Chinese ink painting, and from the fact that for the Chinese the pool is a simile for reflective thought. It also originated partly from his deep personal response to tide pools as an intimate closeup view of an underwater world that brings together his own concerns with space, depth, undulating movement, reflections, translucency, and transparency. Using an expressive calligraphic style, Brigante sees his painting as an abstract evocation of a tide pool in terms of shapes, patterns, rich washes and rhythmic linear treatment. His technique is a highly individual one, with a satisfying interplay of sensitive delicacy and bold breadth of handling that links automatist methods, which are dependent on accident and chance, with a masterful control of the watercolor medium. Note also that he has spliced together two sheets of d'Arches paper to form a watercolor five feet wide. Brigante suggests that the painting might also be viewed as a vertical, with the left edge as the bottom of the painting.

12. DRAMATIC COMPOSITION

CONCEPT The most basic definition of the word *composition* is "the effective placement of forms within the four edges of the canvas or paper." To carry the idea further, composition is the arrangement of lines, shapes, masses, pattern, color, and space—again always in relation to the borders of the picture. It is through composition that people gain their first overall impression of a painting, grasping its total design long before they begin to notice technique, details, textures, and color nuances.

But composition can go beyond arrangement to intensify emotional impact and guide the spectator's eye toward the climax of the painting. This is called *dramatizing the subject*, and it can be accomplished through selection, lighting, distortion, emphasis, or suppression and through sharp or soft focus. It is a more sophisticated and complex way of using composition than is simple concern with tasteful placement on the picture surface.

By dramatizing the composition, the artist carries the subject matter beyond just the visual facts as they might be seen through a viewfinder, the traditional cardboard with a rectangular opening cut to the proportion of the paper or canvas. Since nature does not always compose well within a viewfinder, it is up to the painter to adjust and rearrange the motif and its surroundings to achieve maximum pictorial impact.

Part of the aim of art is to make a subject more vivid or striking than it actually may be or to bring out more forcefully its essential qualities. A skillful use of composition or design is the most direct means of putting across those aspects of the subject. Dramatizing does not necessarily imply a slam-bang, eye-grabbing treatment. It can also be accomplished with subtlety and sensitivity, intensifying other, perhaps poetic, aspects of the subject matter.

Look for the varieties of dramatic composition in the seascapes of Turner, Courbet, Heade, Inness, Homer, Ryder, Munch, Nolde, Bellows, Kent, Hartley, Marin, and Leonid. They use dramatic composition to project personal visual responses with exceptional immediacy, clarity, and individuality.

PLAN Before you begin to paint, first consider how composition can express the qualities of your motif that first impressed you. Try seeing the subject from several different angles or viewpoints, not just the obvious ones. Ask yourself what distortions you could use to extract the essence of the subject or how lighting and shadow patterns might make the arrangement more striking. Be unpredictable. Try the unexpected, but *always with a purpose*.

Use forms found in nature in designing your picture surface and decide how you can distribute those forms most arrestingly within the borders of your painting. In this way you are thinking of relating interior shapes to outer edges in more aesthetic terms. To make sure you don't slight those important relationships, always draw a rectangle in your sketchbook and do a compositional sketch that, from the start, will refer to the four edges of your painting. It just doesn't work to make a drawing first and then enclose it afterward with lines that define its outer limits. That is not compositional thinking.

Try elongations or geometric simplification of edges and planes. Try alterations of size and scale to bring about new or different relationships between various areas. Regard dramatic composition not as a preliminary formality but as a creative tool in communicating your vision of sea and shore.

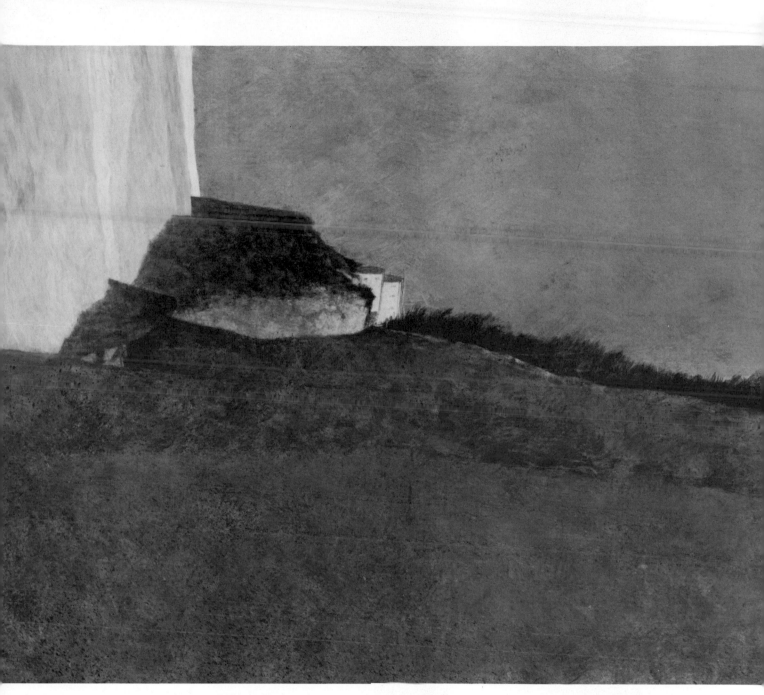

CLIFF HOUSE
by William Thomson.
Opaque watercolor on paper,
20" × 30" (51 × 76 cm).
Courtesy Ps Gallery, Ogunquit, Maine.

William Thomson has dramatized his composition of a hotel at the top of Bald Head Cliff in southern Maine in several ways. First, he has employed a bold, unusual division of the picture surface by using the cliff masses to divide the composition right down the middle, from top to bottom. Secondly, he has adopted the viewpoint of looking upward at his subject from the base of the cliff, which strongly emphasizes the great height of the cliff. This

impression is further reinforced by his keeping the hotel to a small-scale, minor element in proportion to the huge masses of rock. Finally, he has dramatized the lighting in the picture by using the sun to throw a spotlight on the hotel and across the distant water, while keeping all the other areas—sky, cliff, and foreground water—within a range of darker values and muted color.

13. DRAMATIC LIGHTING

CONCEPT In the Renaissance, artists explored chiaroscuro—contrasts of light and dark, or light and shadow—as a way of dramatizing their compositions. Since then, many painters have discovered how to use strong light sources to enable them to achieve striking theatrical effects by the way they manipulated brightly illuminated forms emerging from masses of deep shadow. Rembrandt would have made an excellent lighting designer for the stage, and so would Piranesi, Goya, Daumier, or Turner. Artists of their sort were most adept at controlling the spectator's vision by focusing strong light on the important elements and suppressing lesser elements in half-shadow or dense darks.

In addition, aside from its relation to the subject matter, the use of contrasting light and shadow gives painters the opportunity to design the total picture surface by using arrangements of the light and dark patterns as part of the abstract structure that should underlie even the most realistic painting.

Dramatic lighting can be particularly useful to the seascape painter because the quality of light at the shore—sharp, brilliant, harsh, soft, hazy, somber, foreboding, cheerful, sparkling, mysterious, and shifting from day to day and often from hour to hour—is a major part of the scene. No one can paint seascapes for long without realizing that lighting and light sources contribute a great deal to communicating the look and feel of the coastal environment. Look at Turner's moody lighting in *Fishermen at Sea Off the Needles* or the brilliantly lit *Peace—Burial at Sea* (both in the Tate Gallery, London); Martin J. Heade's spooky lighting in *Approaching Storm: Beach Near Newport* (Boston Museum of Fine Arts); the misty backlighting in Homer's *Winslow Homer's Studio in an Afternoon Fog* (Rochester, N.Y., Memorial Art Gallery), or the eerie silhouetted forms in Ryder's *Moonlight* (Smithsonian Institution, Washington, D.C.). These are but a few examples of how painters have incorporated dramatic lighting effects to augment the visual and emotional force of their sea imagery.

It should be noted that such uses of lighting apply mostly to realistic painting and perhaps to some semiabstraction. In short, lighting is generally fundamental to *tonal* painting, which is built upon relationships of light and shadow. It is far less pertinent to more abstract styles in which nondescriptive color, shallow space, and flatter pattern usually preclude any dependence on lighting and light sources. Therefore, the realistic painter can and should use dramatic lighting for all it is worth to create paintings that rise above the mass of ordinary seascapes.

PLAN Dramatic lighting usually involves a strong light source and the use of a complete range of values from very light to very dark. Once you have decided on your subject, it is a good idea to visit it at different times of day to see how it is affected by varying light conditions. Or if there isn't time, simply imagine from past experience what different light sources might do for it.

Strong sidelighting from left or right in early morning or late afternoon is always effective in revealing form and setting up rich contrasts and interesting cast shadows. Backlighting, where the subject is seen with the sun or moon behind it, is especially dramatic, although it takes some skill to maintain value and color distinctions within the dark masses so that they don't flatten out and consolidate into a single, overall silhouette. In general, avoid lighting at high noon or with your back to the sun. Except in unusual situations, neither of these promotes very dramatic effects, mainly because the light bathes the forms too evenly and tends to flatten a sense of volume and prevent the use of a full range of values.

If necessary, get extra contrast and drama by exaggerating some of your values, painting the lights lighter than they actually are and the darks darker. Mass the middle tones and also the darks. Be very selective about which lights are to be strongest or most brilliantly illuminated. Above all, use dramatic lighting for its potential to create a striking pattern on your picture surface, and for an organization of light and dark areas that not only makes the most of your subject but is also in itself a handsome design.

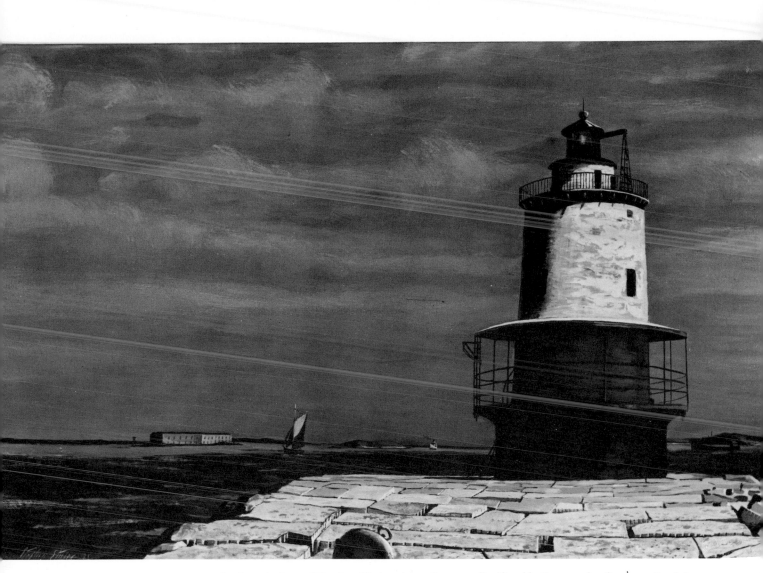

SPRING POINT LIGHT
by Stephen Etnier, N.A,
Oil on Masonite,
24" × 36" (61 × 91 cm).
Private collection.
Courtesy Midtown Galleries,
New York City.

In the paintings of Stephen Etnier, dramatic lighting has always been as basic an ingredient as the oil paint itself. Here he has dramatized his subject by bathing it in a strong light while the sky and bay are kept very dark. Thus, concentrated light is used to contrast Spring Point Light (at Portland, Maine) against its environment as much as possible. The intense light also allows Etnier to sharpen his description of detail and texture both in the lighthouse itself and in the mosaic of cut granite slabs on which it stands. He has also placed the greatest contrast—the lightest lights and darkest darks—in the area that interests him most. Even the accent of light on the sail of the boat in the middle distance has been suppressed in value so as not to compete with the picture's center of interest. This composition is stark, vivid, and striking, and it is the lighting that was instrumental in obtaining those effects.

14. ATMOSPHERIC LIGHTING

CONCEPT At the opposite pole from dramatic lighting are the atmospheric overcast or misty effects that cause the blurred forms and soft diffused lighting often found at the seashore. Until the nineteenth century, most painters worked in a clear light. It was not until the arrival of Turner and later the Impressionists that artists began to use mist, haze, and fog, not only as natural lighting conditions but as legitimate subjects for painting in themselves. Turner's depictions of hazy morning light in Venice, whirling mists along the shore and out at sea, and swirling snowstorms over the ocean opened up new paths for painters to investigate these phenomena of nature for unusual lighting effects and, to a lesser degree, for their occasional potential to suggest shapes and designs.

Because of the interaction of wind and water temperatures, almost any coastal area is subject to fog and mist, a condition that sometimes never reaches very far inland. To the artist addicted to sea and shore, fog can generate quite lovely effects because of the way cliffs or islands or promontories seem to disappear and reappear. Also, color is more subtle, edges of forms are softened and blurred, other forms are flattened into delicate gray masses, and detail is lost. It is a world of nuance, a more poetic lighting than that resulting from strong sunlight. In fog or mist, because lighting is diffused, without a single concentrated source, it is all the more difficult to perceive and express form, to make clear differentiations between the various areas, to keep the color neutral and subdued but not monotonous, to suggest the complex tonal gradations, and to handle edges and transitions. And since such effects are often transitory and extremely subtle, it is also a challenge to any seascapist to deal with them successfully. Obviously, atmospheric effects are not for the neophyte.

It might seem that the above considerations would apply principally to realist-impressionist painting, and in part that is indeed true. But many lyrical abstractionists are equally attracted to the visual qualities and experiences that derive from atmospheric lighting. There are also some fine paintings in the abstract vein that explore and capitalize on the mystery and the beauty inherent in gentle, pearly grays; the interplay of clear and blurred edges; and subtly textured surfaces. These are pictures in which energetic or formalistic interpretation is less important than poetry and understatement.

PLAN When you are painting atmospheric effects, close observation is your best tool. Walk the shoreline, roam the harbor area, studying the effects of fog and mist. In particular, study the grays. Ask yourself which ones are cool and which ones are warm. Note the ways the muted colors in the foreground recede to flat, pale grays in the distance. Understand how depth can be achieved simply by showing the exact value gradations of grays merging from foreground into background.

Study edges, transitions, and gradations. Don't assume certain relationships of color or value, but look hard and see what is really there as opposed to what you *think* is there. Locate your darkest darks. Are they as dark as you think they are? Usually, because of the diffused lighting, the darks are lighter and have much less contrast than might be expected under a brighter light. Look for the subtleties, the fine distinctions, the specific range of values. They're hard to record in a sketchbook, and even a camera does not always capture the colors and values with reliable accuracy. Back at the studio you will ultimately have to resort mainly to your memory and to your accumulated knowledge of how haze, mist, and fog affect the coastal scene.

Realize that in this sort of painting you will have to abandon strong pattern and sharp edges, so the structure will be less evident. You will find yourself relying more on the art of suggestion and on delicate, precise adjustments of color and value relations. None of this will be easy—to capture the look and feel of atmosphere is no small achievement—but in the long run you will find the effort was worth it.

WHITE FOG
by John Maxwell, N.A., A.W.S.
Oil on canvas, 36" × 48" (91 × 122 cm).
Courtesy Fontana Gallery,
Narberth (Philadelphia),
Pennsylvania.

This painting was developed from an on-location black ink and sepia wash drawing that contained quite specific information and detail. Although his subject was nothing more than two charter fishing boats moored at a wharf, by bathing the scene in fog, Maxwell has imbued it with extra qualities. The forms, softened by the diffused lighting, are mysterious and almost indefinable. There are some gentle contrasts of values to help suggest the various forms, but within a very tightly controlled range of values. It is a masterful, daring performance in handling values with such delicacy and restraint that the values are barely perceptible, and so the picture becomes a sort of visual game of hide-and-seek, or "now you see it, now you don't." All detail has been rigorously eliminated in favor of the atmospheric effect, and the picture surface itself is kept interesting by the use of impasto underpainting, strokes, accents, and encrustations that are thoroughly incorporated into the composition as an integral part of the total image.

15. WATERY REFLECTIONS

CONCEPT The reflective qualities of water have long held a special attraction for painters of the sea. The way water reflects sunlight or moonlight, the sky itself, land forms or buildings, or boats, nets, and sails is an effect not usually present (barring rivers and lakes) in most landscapes. In fact, the study of reflections, the movement of light on and in the water, and the relation of reflected forms to the actual forms that caused those reflections can be reason enough to undertake a painting.

In the course of painting history there have been quite a number of artists who were particularly fascinated with watery reflections, primarily in seascapes. One thinks immediately of paintings by Corot, Boudin, Cotman, Constable, Turner, Monet, Fitz Hugh Lane, Homer, Whistler, John Fredrick Kensett, and Hassam; and, nearer our own times, Nolde, Feininger, Kokoschka, Marin, Loren MacIver, Jason Schoener, Leonid, Laurence Sisson, Denny Winters, Stephen Etnier, and Reuben Tam.

To artists, probably the most appealing aspect of the ocean is its ability to reflect light, especially that of the sun. Depending on the weather and time of day, the ocean reflects light in several different ways. At sunset, it mirrors the red setting sun as it casts its elongated reflection from horizon to shore (seen as a vertical shaft in a picture). When it is windy, the light glints off the choppy water. When on a calm day, the brilliant sunlight spreads across the silent water in a broad sheet. And when it is cloudy, the ocean is covered with gray cloud shadows except perhaps for a long, thin streak of light reflected off the water at the horizon. All these effects of light as it bounces off the water have been pictured by artists, many of whom often combine their love of sea with their study of light. As might be expected, most of their work has been done in a realist or impressionist manner.

The reflective qualities of the ocean's surface also present an opportunity to use reflections of land masses, clouds, harbor structures or boats, masts, and sails as painting subjects in themselves. For some reason reflections seem to exert a certain fascination for artists, whether as clear mirror images of the forms seen upside down in calm water or as the wavy, rippled reflected images visible in gently moving water. Such reflected images run vertically in a painting and would be employed to add a more interesting design or structure to the composition. Reflections are especially effective when they form geometrical horizontal-vertical arrangements that have an abstract look. Such abstract qualities can be capitalized on by representational painters, or they can be more consciously ordered and designed by abstractionists.

PLAN When the sea is your subject, you must explore it in as many aspects as possible. While the dynamic movement of rolling waves splashing on rocks is a rich source of imagery, the reflections of light off the water or of forms reflected in the water are also worthy of any artist's attention, either as the principal subject of a painting or as a major contributor to its design.

If light reflected in water is your primary concern, look directly toward the source of light. Having the light source behind you or off to one side does not give you a chance to observe that bright light as it is reflected in the various surfaces of the water. These surfaces and facets catch the light differently depending on the motion of the water—active or inactive—and the effects of breezes or gusts of wind. Also, walk along the beach at the ocean's edge and study the glint of sun reflected in receding shallow waters or in very wet sand and try to memorize these effects. In a situation like this, sketching is not too useful. A camera will probably be more helpful.

If reflected land forms, boats, or harbor architecture interest you, make sure that the light falling on those forms makes them visible in the water. You don't want just a reflection of a shadow mass. In this case the sun should be generally behind you or only slightly off to one side. The amount of movement in the water will determine how clearly and with how much detail the forms will be reflected. The reflections of pilings, ladders, docks, masts, and sails will act as vertical divisions of your picture field and will be of considerable help in filling or designing the lower part of your composition. Whether handled realistically or abstractly, such reflected lines and shapes are an inviting subject.

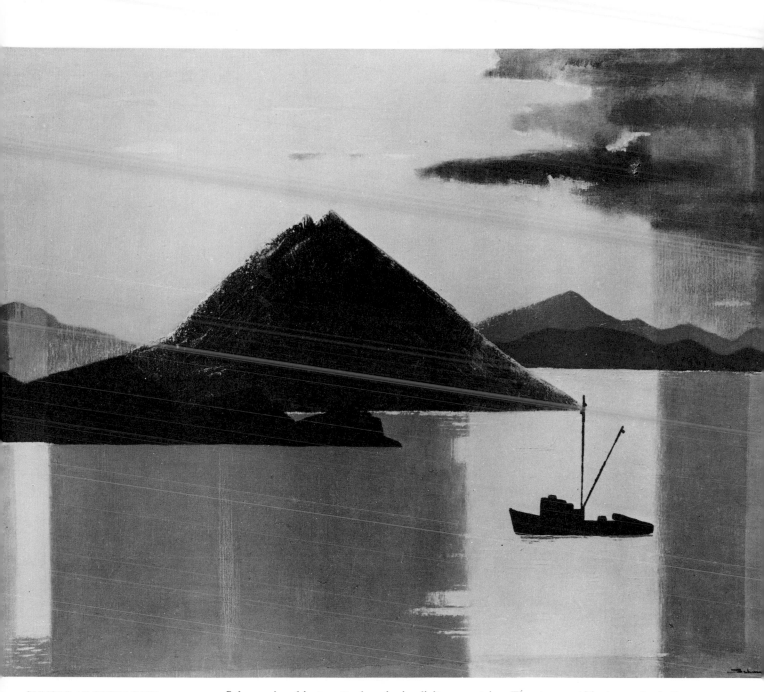

SUNSET AT COSTA RICA
by Jason Schoener.
Oil on canvas, 30" × 40" (76 × 102 cm).
Courtesy Midtown Galleries,
New York City.

Schoener's subject matter here is simplicity itself: sky, land forms, water, and a boat. What gives interest to the composition is his use of light and the reflective surface of the water. The reflections of sky, clouds, and mountains are handled as flat masses that drop vertically through the picture, passing through sky, land, and water as continuous divisions of the picture surface. The basic design is one of strong horizontals and verticals whose static quality is offset by the angular contours of the moun-

tains. The strongest block of color is the vertical shaft of light containing the boat. All other reflections in the water are treated as broad slabs or masses that are kept from being overly flat and simple by the use of vertical breakups within those shapes. A horizontal division crosses most of the picture near the lower edge, keeping the composition intact by the way in which it halts the forceful downward movement.

16. NIGHT SCENES

CONCEPT Although most seascapists have painted the ocean and shore in strong sunlight, fog, or stormy weather, only those possessing an unusually poetic or romantic temperament have found the beauty and mystery of the sea at night to be a subject for a painting. Names of such painters of night and sea that come readily to mind are Turner, Ryder, Nolde, Munch, O'Keeffe, Hartley, B.J.O. Nordfeldt, Henry Mattson, Joseph De Martini, and Reuben Tam.

Night scenes are particularly difficult to paint. For one thing, the range of values is generally restricted to dark or low-keyed colors, and with so little light available there is little opportunity to render specific details. Also, because of the darkness, it is not possible to paint on location, which means that the artist must always rely on observation and memory when he is at work on a night scene in his studio. Furthermore, a seascape by night could, in the wrong hands, become corny and sentimental or too picturesque. The true artist deals with the night seascape as a poetic, introspective, deeply personal experience that invokes all the many subliminal associations we have with darkness, the moon and stars, night skies, and the sea.

The ocean is one kind of scene by daylight, but by night it seems to assume other qualities and dimensions. Gavin Maxwell, in his book *Ring of Bright Water*, mentions the "perpetual mystery" of the seashore and the fact that "the sea's edge remains the edge of the unknown" and that a person at the edge of the ocean "stands at the brink of his own unconscious." Such feelings are greatly intensified on the shore at night, and the attempt to give visual form to these moods, feelings, and subconscious responses has brought about many of our best nocturnal seascapes. Some random picture titles that suggest the sort of emotional overtones of such paintings are: *A Harbour with Full Moon behind Dark Clouds; Wave, Night; Night Surf; Radiant Night; Moon-Driven Sea; Nightcoast; Moonshadow, Monhegan; Stars and White Tide; and Moonlit Cove.*

The ways in which a night scene can be treated are many and various, ranging from the dramatic lighting of Turner, to the simplified rhythmic masses in Ryder, to the severe stylizations of O'Keeffe, to the abstract expressive qualities of Tam. But style or treatment is less to the point than those artists' profound, poetic responses to the phenomena of the sea at night and all its rich associations that they have revealed or intimated through their art.

PLAN Forget your sketchbook and camera. In gathering material for night scenes by the sea, you should depend entirely on observation, contemplation, meditation, and memorization. It is not so much a question of acquiring data as it is of giving yourself over to experiencing as deeply and directly as possible the dark spaces, the moon, rocks, ocean, stars, and the entire sky above land and sea. Memorize the look of wet rocks reaching into the moonlit water, of dim masses of dark cliff against the starlit sky, the glimpses of phosphorescence in the sea, and the mysterious subdued whiteness of the surf as it washes to shore out of the darkness. Store away the impressions that mean most to you, that most touch your inner feelings.

Immediately after such an excursion, make quick sketches while your impressions are still fresh or write notes to yourself that will evoke the experience for you again later on in the studio. Or simply remember those impressions—intangible, vague, ineffable—and bring them into use in your painting whenever you need them or whenever you wish to communicate your own vision and most intimate responses as they relate to a night view of the sea.

Finally, don't miss reading the chapter called "Night on the Great Beach" in Henry Beston's masterpiece, *The Outermost House* (Ballantine Books and Penguin Books, New York, 1976). In fact, read the entire book, if you haven't already. But I defy you to read that particular chapter without having your mind fill up with graphic, lyrical images that cry out to be painted.

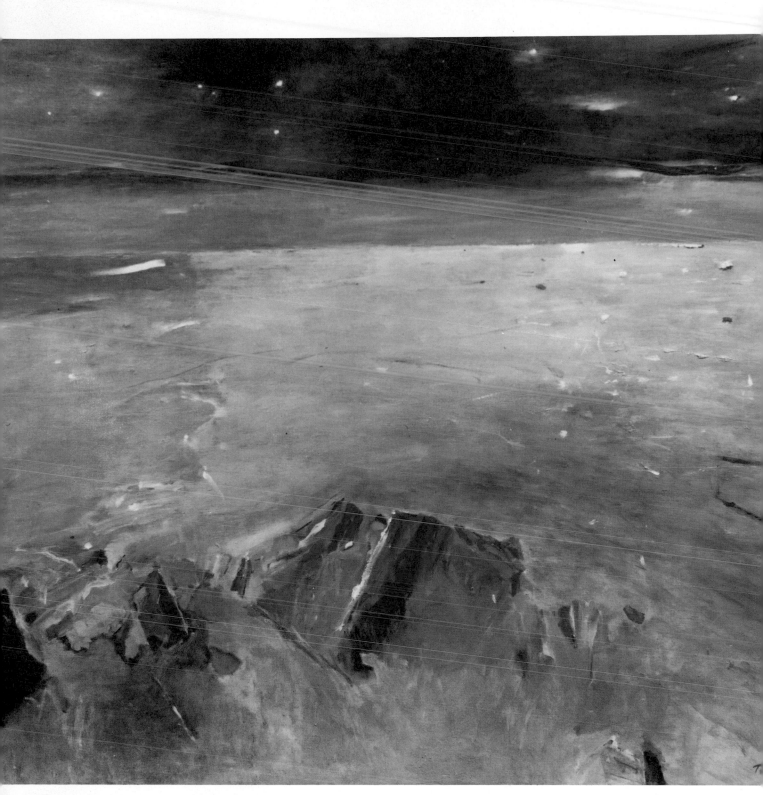

STARS AND SHOALS
by Reuben Tam.
Oil on canvas, 36" × 42" (91 × 107 cm).
Courtesy Coe Kerr Gallery, Inc.,
New York City.

Living as he does in a summer studio that faces the ocean, Tam can study the sea and sky at all times of day and night. In recent years he has undertaken a series of paintings in which stars are a major theme. Here the dark sky with bright stars and half-hidden moon, the play of light across the sea, the glints and touches of color and light in the water, the hints of phosphorescence and the spread of shoals just beneath the water's surface, and the rocky forms in the foreground, all add up to an

interpretation of the sea at night that is strongly lyrical, poetic, and very personal. *Stars and Shoals* is not in any sense a literal description, but for its success it depends on its power to evoke an experience in purely painterly terms that include sweeping linear strokes, quick flicks and dabs of lights and colors, and a deep sensitivity to edges and transitions. Above all, Tam has captured an essence, and that is what good painting is all about.

17. VARYING THE FORMAT

CONCEPT The standardized measurements of watercolor papers and boards (22″ × 30″, 26″ × 40″, 30″ × 40″— 56 × 76 cm, 66 × 102 cm, and 76 × 102 cm) and canvases or frames (16″ × 20″, 18″ × 24″, 25″ × 30″, 30″ × 40″—41 × 51 cm, 46 × 61 cm, 64 × 76 cm, and 76 × 102 cm) are so prevalent and have been around for so long that many painters accept them without question and habitually gear their compositions to those proportions. While those standard sizes over the course of years have proved useful and versatile for almost all subjects and compositional arrangements, on occasion, usually because of the requirements of the subject matter itself, artists have felt the need to vary those proportions.

One of these variations is the elongated horizontal format. Just as a wide-angle camera lens gives a better idea of panoramic breadth than does the standard camera lens, an elongated horizontal canvas is particularly appropriate for seascapes because it is the most direct means of expressing the extremely wide horizontal sweep of ocean or beach. Turner and Constable used this format, especially in some of their outdoor oil studies, and so did such sea painters as William Trost Richards, A. T. Bricher, J. F. Kensett, Sanford Gifford, Martin J. Heade, and Frederick Church.

The vertical format is another unusual one. But while the horizontal format seems naturally and ideally suited to seascapes, the vertical format is far less popular, mainly because it affords only a narrow vertical slice of the ocean view and does not attempt to suggest a spatial spread. A vertical format might be chosen either because of the specific demands of the subject or simply as a compositional variation for its own sake. Customarily, the only distance emphasized here would be in depth, not in breadth, which makes it a somewhat less useful format for seascapes than the conventional horizontals. Still, its very rarity and unexpectedness is in its favor, and as a concept it should not be casually dismissed.

The square format has traditionally been regarded as being a difficult proportion within which to design a composition, probably because it is hard to avoid equality of intervals and divisions, symmetry, or centrality. Nevertheless, starting with Turner and continuing with Twachtman, Hassam, Ryder, and, on occasion, Homer, square or near-square paintings have enjoyed a certain popularity. Its use by some contemporary Americans can be seen in some of the paintings reproduced in this book: John Laurent (page 131), Edward Betts (page 89), Sylvia Glass (pages 31, 142), and Helen Lundeberg (pages 59, 125).

Curved formats such as the circle and the oval are also useful in seascape painting for suggesting ways in which the outer edges of the picture echo or relate to internal rhythms of waves, surf, and water depicted in the painting itself. This is a more self-conscious and often more decorative format than those previously mentioned, and it is offbeat, expressive, and certainly just as challenging, in terms of design, as the square format. Again, this concept is a possibility that should not be overlooked.

PLAN Don't be afraid to try new formats. Get away from the tried-and-true and see what you can do to make the most of your subject matter by the use of unusual compositional proportions. Once you have selected a motif, put it through a series of variations in thumbnail sketches. Try out a really elongated horizontal or a tall skinny vertical (I once painted a seascape 8″ [20 cm] wide and 50″ [127 cm] high!), thinking always of how this proportion can emphasize the essence of your subject or can intensify its look or meaning in some way.

By all means try the square format. See how you can surmount its problems by unusual divisions of the surface, especially in terms of large, open, simple areas as opposed to smaller, more complex areas. Avoid centrality and equal divisions into three or four strata. But avoid symmetry too, unless it has some symbolic or formalistic purpose related to your subject.

Don't forget the oval or circle. For a watercolor, a circular mat can be accurately cut by machine at your framer's, but the picture must be *designed from the start* as circular or oval, and the mat should not be used solely as a cropping device. For oils, curved stretchers are often obtainable on special order. Or Masonite can be cut to the desired shape and then used as the painting support. Or canvas can be mounted on the Masonite, using acrylic gel as an adhesive.

Remember, such formats are not gimmicks. Their principal purpose is to aid expressivity, and secondarily to delight the eye.

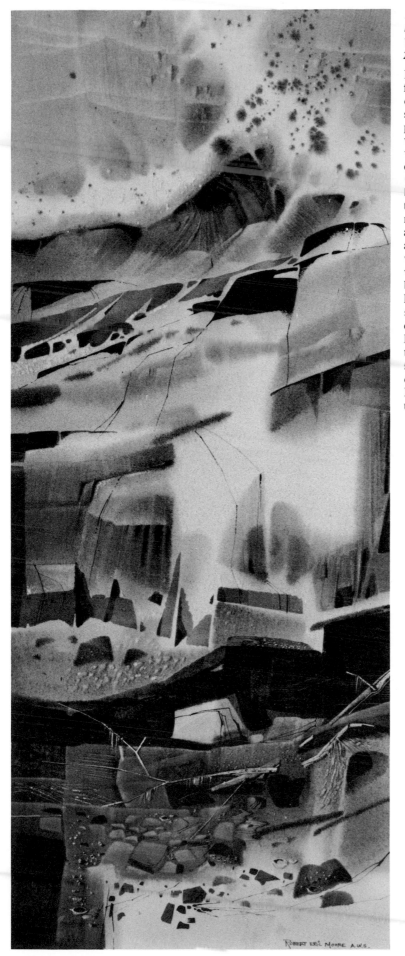

ADAM'S POINT, EARLY MORNING
by Robert Eric Moore, A.W.S.
Watercolor on paper,
29½" × 12" (75 × 30 cm).

Moore is equally at home in any rectangular format, but he is particularly adept at squeezing ocean and rocks into narrow vertical compositions. As in most verticals, the depth in this painting is read as a series of stacked layers, with the foreground elements situated at the very bottom of the picture and the farthest elements of wave and sky placed at the top, very much like an Oriental scroll painting. He has carefully controlled his surfaces and textures to create as much variety and as little monotony as possible: soft, wet-in-wet washes and spatter at the top, then harder rock forms and incisive linear accents, dropping downward into a large zone of mostly vertical broad washes of wet-in-wet, and culminating at the bottom in a cluster of hard-edge forms, crisp linear accents, and sharply defined detail in the stones and pebbles. The eye is kept engaged at every point—interest is never allowed to lag—yet the picture is so solidly conceived as a total unit that it never breaks up into a jumble of separate parts and pieces. Most of all, it stands out from the crowd of seascapes because of Moore's willingness to accept and deal with an unconventional format.

18. BREAKING THE RULES

CONCEPT It presumably makes the teaching of art easier when students are given certain iron-clad "rules" to follow. And, undoubtedly students are given a certain measure of security in knowing what these rules are and by believing that good paintings will result if the rules are followed. But for some time now I have harbored the notion that it might be fun to write a book called something like *Breaking the Rules of Painting*. It would list many of these so-called rules of painting and would be illustrated by paintings that successfully manage to break them!

No one in his right mind would fall back on the easy saying "rules are made to be broken," since there are indeed certain principles that are undeniably necessary in the creation of works of art. On the other hand, there are good rules and bad rules and rules that can easily be ignored when the occasion requires. When a painter refrains from doing something to his picture just because he has been taught that it is "against the rules," then it is time for him to question those rules and see if they really apply to the work at hand. If his instincts have led to an improvement of the painting, or make it more effective in expression, color, or design, then these artificial rules should be tossed aside and ignored, and the painting should be allowed to live its own life.

Some of the dullest pictures in the world are done by painters who dutifully observe the rules they were taught. They paint safe, ordinary pictures that never rise above a certain level of mediocrity. On the other hand, some of the most interesting paintings have come from artists who followed their intuitions rather than the rules, who took risks, who daringly tried out concepts or techniques just to see if they might possibly work despite rules. Their paintings have personality, flavor, presence, and a breath of fresh air—the look of having taken a chance and won.

The good rules, the ones that seem timeless, universal, and sensible in most situations, should be remembered and taken into account during the act of painting. If they suit the situation, fine. If they help to make the picture better, again fine. But even a "good rule" that is valid 99 percent of the time may not be entirely applicable to certain pictorial circumstances and may have to be bent a little, if not ignored altogether, for the sake of the total picture.

It is the foolish rules, though, that are the ones to watch out for. Rules like: "Don't cut the corners"; "Never sign your name in the water"; "Always use a standard-size rectangle"; "Always use 20 percent lights, 20 percent darks, and 60 percent middle tones"; "Never use the three primary colors all in one painting"; "Never divide the picture through the middle"; and on and on. Occasionally there is a fairly good reason for such precepts, but more often than not they restrict true creativity. I've seen some mature students almost immobilized because of their fear of breaking one rule or another. It is the point of this book to open up possibilities, not to narrow them.

PLAN Distasteful as it may be, try to remember some of the rules you were taught for drawing and painting and make a list of those that have lasted with you longest or that have made the strongest impression on you. Now separate the reasonable ones from those that seem prehistoric, quirky, opinionated, or downright useless. Now take those rules and check them against the paintings reproduced in this book to see how many were broken. Then ask yourself if breaking the rule ruined the painting or if the painting succeeds despite the break. Try to decide if your rules are generally universal or merely whimsical and idiosyncratic, applying only to certain limited situations.

When you are painting, try to forget any and all rules (including mine). Don't let any arbitrary laws of painting hinder the flow of your intuition and creativity. Then, after you have finished the picture, see if any serious, basic principles have been violated, and if so, decide whether their use would have improved the painting or whether it is successful despite such violations.

Think for yourself more and trust rules less. Your picture is more important than any set of rules.

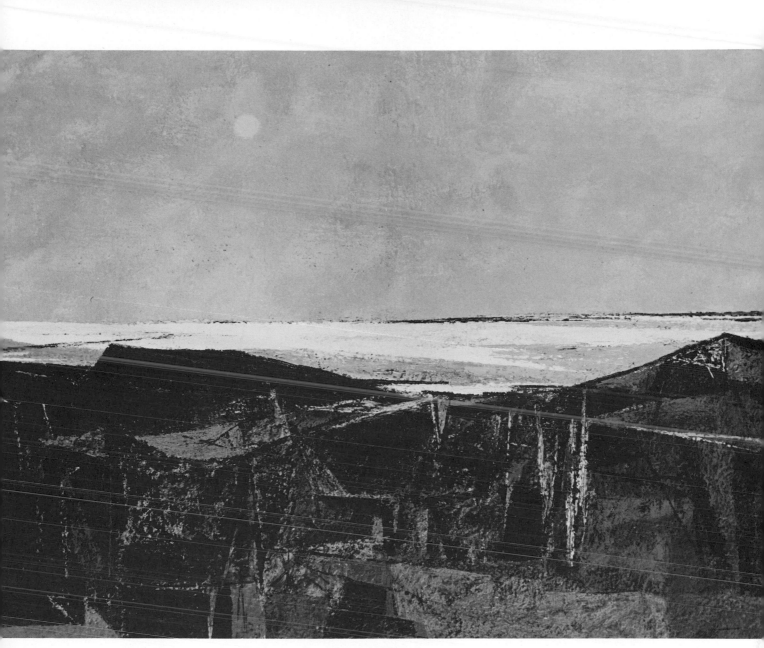

NIGHT MOOD—MONHEGAN
by Edward Betts, N.A., A.W.S.
Lacquer on Masonite,
28" × 40" (71 × 102 cm).
Private collection.

This is a fairly early painting of mine (1953), and it was not for several years that I realized that I had unwittingly broken one of the cardinal "rules" of painting: "never divide a picture through the middle." Actually it is divided just a fraction above the middle, but to all intents and purposes I had divided the surface into two equal areas, one above and one below the horizon. Even though the rule was broken, the composition works because the sky (except for the moon), was kept simple and uneventful while the lower half of the painting serves as a contrast to the simplicity above through the

strong band of light on the water and the complex abstract breakup of the dark rock masses that are accented by incisive linear touches. The varying proportions of a simple arrangement of three values of light, middle, and dark perhaps help to disguise the unfortunate defiance of the rules. Disregarding my compositional crime, the jury of the 1954 annual exhibition of the National Academy of Design awarded this painting the Second Altman Landscape Prize of $750. So much for the "rules"!

19. STYLIZATION

CONCEPT Stylization is one of the first stages in moving away from realistic depiction toward a more formalized view of nature. The sea in particular lends itself most readily to a stylized treatment in which the artist conventionalizes its shapes, contours, movements, and rhythms.

One thinks immediately of the Oriental ink painters and printmakers to whom stylization was the most artful way of expressing aspects of nature. In terms of seascape, the picture that comes most immediately to mind is Hokusai's wood-block print *The Great Wave*. Ostensibly a view of Mount Fuji, it is actually one of the most memorable seascapes of all time. Although stylization has often had associations with stylishness, decoration, and Art Nouveau, when it is used by an artist as great as Hokusai, it becomes a conscious way of designing nature—or exploiting the design in nature—to express vividly the power of that surge of water, the foamy breaking crest, the ocean rhythms, and a dramatic use of pattern and handsomely designed shapes. It is quite possibly more wavelike than any photograph of a wave could be and certainly far more expressive and universal, since an image of this sort is a summary of an artist's lifetime observation of ocean and waves.

American artists of the twentieth century have often used stylization in their seascapes. Painters come to mind such as Kent, Marin, O'Keeffe, Hartley, Avery, and Kantor (especially in his magnificent series based on Monhegan Island). Of those artists reproduced in this book, there is Helen Lundeberg (pages 59, 125), Robert Eric Moore (pages 45, 127), Maxine Masterfield (pages 83, 91, 118), Pauline Eaton (pages 75, 141), and Phil Dike (opposite). Painters who work with stylized forms usually present nature realistically, but it is more consciously organized and more flowing or graceful, with greater attention being given to bringing out its basic design structure than would be expected in more straightforward descriptive representation.

In fact, the search for design—in line, shape, pattern, and color—is fundamental to the use of stylization. It is a more artificial (in the very best sense) means of revealing the specific design aspects that the artist has discovered in the coastal environment, and by stressing a largely two-dimensional formalized treatment, the artist makes sure that the viewer reads his painting as a personal interpretation of the sea—not as a copy or a reproduction of what he has seen.

Considerable variety is possible within the stylized approach. It has more range and breadth than we ordinarily credit it with. Certainly it can be precious and superficially elegant, but it can also be rigorous in the way it cleans out the clutter by concentrating on the removal of all nonessentials. Depending on the subject and the artist's technique, it can be used with strength or delicacy in a wide range of approaches from designed or decorative realism all the way to free or hard-edge abstraction.

PLAN The seashore provides a rich source of forms that lend themselves to varying degrees of stylization: patterns in the wet sand left by the outgoing tide, sand dunes, flowing waves, the impact of surf smacking rocks, beach stones, boats in dry dock, cliff forms topped with pines, fishing gear, wharf pilings, stacks of lobster traps, grasses in a tide pool, eroded sculptured rock—the list could go on and on. Look for forms that already seem to contain design qualities. Draw them realistically in line at first; then try simplifying their shapes and contours. Ask yourself how you can intensify their natural design or how their design can be made more graceful or harmonious.

Omit unimportant details or accidental effects, and put greater stress on expressing the basic forms as two-dimensionally as possible. After you have explored the linear aspects of those shapes, work for conscious patterning in light, middle, and dark values. Make the pattern as handsome and pleasing as the shapes and contours you have already developed. Feel free to play with nature, to alter it for the sake of a better drawing or painting.

Or capture the essence of a breaking wave by watching surf for hour upon hour. A snapshot will freeze it, but you should use pencil or brush to explore and discover strokes and rhythms that for you are the equivalent of all that you have learned from continually watching the action of the surf: strokes that express weight, motion, and buildup and fall of the wave; the washing up of the water on a sandy beach; or the lacy white arabesques of the splash of water on rocks.

Use stylization as your beginning effort to gently distort and rearrange nature in the interests of art by creating a painting whose formalized pictorial considerations are somewhat more important to you than your actual subject.

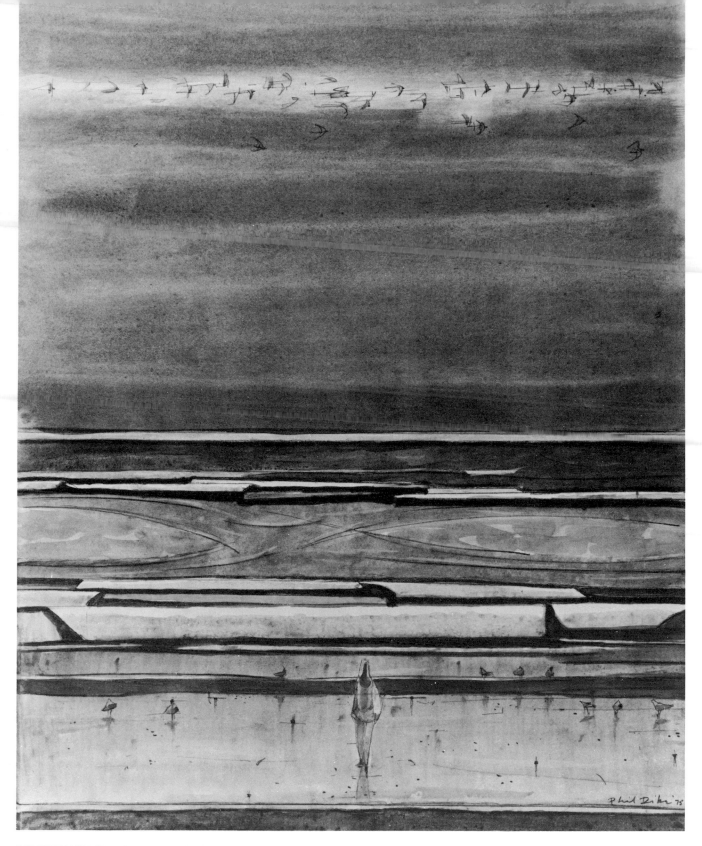

MOON FANTASY NO. 2
by Phil Dike, N.A., A.W.S.
Watercolor on paper,
24" × 18" (61 × 46 cm).
Private collection.

Phil Dike is a master of many styles and techniques in both oil and watercolor. Preferring not to be locked into any single style, Dike lets the subject and his response to it dictate the manner in which each individual painting will be handled. In contrast to the rugged gestural treatment in his painting reproduced in color in my earlier book, *Master Class in Watercolor* (page 126), this painting is much more formalized. He views sky, water, and shore as stratified layers, a two-dimensional stacking of horizontal colored bands. The sky is painted in broad wet-in-wet washes, accented near the top by the movement of a flight of stylized sea gulls. The waves rolling in at intervals are also stylized, with conventionalized shapes of white foam curling downward as the waves break near shore. Consistent with this treatment, the shorebirds and the lone standing figure are handled as formalized, not realistic, lines and shapes. As usual, Dike has stressed the design aspects suggested by natural forms at the seashore rather than content himself with a mere description of them.

20. SEMIABSTRACTION

CONCEPT In the largest sense, all drawings and paintings can be considered abstract. But somewhere along the line they break up into the two opposing camps of realism and abstract art. Realism—in which the subject is reproduced more or less as seen— is a concept that is readily understood, but the nature of abstract art is a bit more complicated. As in realism, a subject in nature is selected for reference as a starting point, but instead of its being copied precisely as seen, in abstract art formal or structural elements such as line, shape, pattern, and design are emphasized. If abstraction of the subject were to be pushed to its farthest limits so that only purely formal relationships were to remain and subject matter disappeared altogether, the resulting art would be classified as "nonobjective." But nonobjective painting is beyond the scope of this book, of course, since we are concerned here with a specific subject, namely the sea and its environs.

If the two opposite poles of abstract and nonobjective painting were to be represented by the work of Andrew Wyeth at one end and that of Piet Mondrian at the other, semiabstract art would lie somewhere in the middle. It is more abstract than most realism, yet it is not all-out abstraction either. In semiabstract art, the subject is still recognizable, but it is dealt with in a way that stresses its abstract design qualities as the major interest in the painting. At best, semiabstraction is a fusion of nature and design in which the chaos of nature and the order or design are brought into an equilibrium, an interdependence, that is aesthetically satisfying.

Semiabstraction demands somewhat more of the artist than either extreme of super-realism or total nonobjectivism by challenging all his powers of orchestration and organization. Any painter with a good eye and a thoroughly disciplined training in representation can learn to paint highly detailed realism, and any painter with a good eye and a thoroughly disciplined training in design can learn to paint handsome nonobjective compositions. But to reconcile these opposites in a way that successfully blends them on a single surface seems to me possibly the greatest achievement of all.

The semiabstract approach is not a specific style but a broad category of painting in which nature and design are thoroughly integrated and balanced. A number of the artists whose work is reproduced in this book paint from a generally semiabstract viewpoint: Hans Moller, William Thon, Sylvia Glass, John Maxwell, Jason Schoener, Reuben Tam, Robert Eric Moore, Sara Roush, Bonny Lhotka, Alexander Nepote, Balcomb Greene, Pauline Eaton, Maxine Masterfield, Jayne Dwyer, Sue Wise, David Lund, and Bill H. Armstrong. As can be seen from the range and diversity of their work, this approach allows plenty of room for differing styles and varying degrees of emphasis on design.

PLAN In some ways semiabstraction is an extension of stylization, but with even more emphasis on discovering and revealing the design in nature. A good start here would be to read Nathan Cabot Hale's *Abstraction in Art and Nature* (Watson-Guptill Publications, New York, 1972).

An inquiry into semiabstraction can also begin in your sketchbook. Try to analyze seascape forms in three principal ways, through shapes, planes, and patterns. First, select forms you find striking or that seem to invite an abstract treatment. For example, simplify or exaggerate the lines and shapes of a spruce tree and rocks. Or apply a cubistic analysis to cliffs and rocks, or sailboats, or fishing gear on a pier. Or search out the abstract planes and shapes of fishing shacks, drying nets, and stacks of lobster buoys. Feel free to distort shapes slightly if that will improve the overall design. Don't worry about correct perspective, but alter it if that will help to create a stronger or more interesting shape. Make yourself more conscious of shapes, and relationships of shapes, than you ever were before.

Analyze planes as a separate problem from forms.

Planes can be used in two ways: to design the rectangle of your sketchbook page and to suggest spatial relationships. Try taking them apart and reassembling them. Or break them up, redesign them, tilt them, or let them overlap and intersect. But always try to vary the sizes of the picture areas so that your surface is not broken up into a sort of checkerboard where each shape is equal to and cancels out the others.

Finally, to pull those shapes and planes together, use pattern. To do this, you must keep your values simple and clearly contrasted. Begin by taking some of your earlier sketches, and see how you can inject more design interest. For example, do a purely abstract arrangement in three to five values, then superimpose on it one of your previous linear-shape analyses. Once you have grasped the principle, try a painting based on a few of your best sketches. Remember, you're aiming for an equally balanced fusion of nature and design. If one or the other is too dominant, make adjustments so that the picture is neither too real nor too abstract.

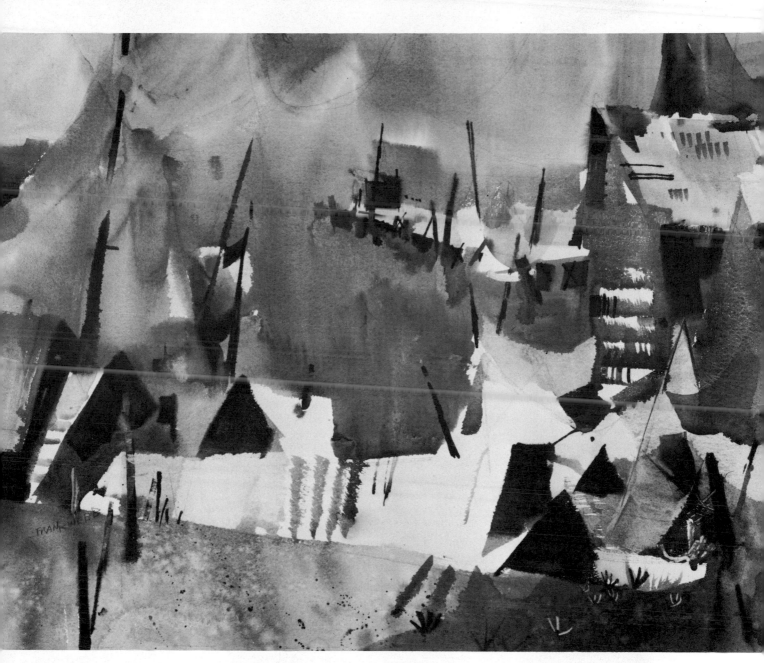

SHORE SPIRAL
by Frank Webb, A.W.S.
Watercolor on paper,
22" × 30" (56 × 76 cm).
Courtesy Bird in the Hand Galleries,
Sewickley, Pennsylvania

Although Frank Webb is best known for his vigorous, boldly designed realism, in *Shore Spiral* he carries his passion for shape and pattern to the brink of abstraction. Although, as in all semiabstract paintings, his subject matter—water, wharf, pilings, shacks, and roofs—is still clearly recognizable, the harbor forms are merely a point of departure, an excuse for the way Webb first divides the picture surface. Webb concentrates instead on the dramatic interplay of lines, shapes, and planes, which he establishes in strongly contrasting values and colors. He then further activates the surface of the painting with complex but controlled forms and patterns that constitute the principal interest in the painting. Webb is a skilled designer of shapes, but he creates those shapes only after a thorough analysis of his subject. The resulting art is a fine example of the process through which the artist unites nature and design.

21. EXPRESSIVE ABSTRACTION

CONCEPT While semiabstract art is based on a balance of nature and design, in abstract art the emphasis is more strongly than ever on the side of exploring relationships of line, shape, pattern, texture, color, and space. Although abstract art is based on some kind of subject matter, the actual subject is of little consequence except to spark the creative urge and generate ideas for rearranging or distorting nature for pictorial purposes.

There are many varieties of abstract art, but I group them generally into three categories: expressive, formal, and lyrical. In expressive abstraction the most moving or meaningful aspects of nature are emphasized. In formal abstraction, the least emotional of the three, there is an analytical or geometrical view of nature. And in lyrical abstraction is found an intuitive, poetic view where nature is only implied. On the following pages, beginning with expressive abstraction, we'll see how each of these categories of abstract art can be applied to painting the sea and its environs.

Anyone who thinks that abstraction precludes expressiveness has only to be reminded of Picasso's *Guernica* to realize abstraction's potential for expressing feelings and ideas with an incredible visual force and emotional impact. Among expressive abstract seascapes I have seen, I am reminded of Marsden Hartley's moody, massive wall of white surf and dark rock in *Evening Storm, Schoodic, Maine* (Museum of Modern Art, New York City); or of Edward Corbett's spacious evocations of summer sun, sand, dunes, and skies in his Provincetown series of shore paintings; or of Balcomb Greene's storm scenes, which express so much of the turbulence of the sea, but do so in terms of an intentional ambiguity in which clouds, waves, surf, and shore are all inextricably interwoven.

Expressive abstraction is ideally suited to projecting all the varied aspects and moods that exist in the coastal environment. Since most abstraction is concerned with translating a three-dimensional world into a basically two-dimensional treatment, there is bound to be some degree of distortion or alteration of normal relationships of shapes and planes moving forward and backward within a controlled, shallow space. In addition, there are the expressive distortions—of gesture, rhythm, design, color—through which the artist forcefully and directly projects such subjects as storm clouds, churning water, high cliffs, wind-driven spray, tall pines, and shadowy tide pools.

In short, because expressive abstraction springs from a subjective personal response rather than from rational analysis, despite its abstract nature, its principal appeal is to the emotions rather than to the mind.

PLAN When it comes to learning how expressive abstraction can be applied to seascapes, you should study the paintings and writings of John Marin. In Marin's work you will find spontaneity, vigorous gestures and jabs of the brush, personal identification with the subject, and the use of design and distortion in communicating the intensity of his responses to the coast of Maine.

Once you have absorbed Marin's lesson (and by that I mean the principles underlying his approach, not the surface characteristics of his very personal style), you are ready to attempt your own version of abstraction as an expression of your innermost feelings as they relate to sea and shore. You can start either with your sketches or your reference photographs, but use them creatively to put you into a state of intense emotionality. Do some swift studies, dashing in areas of wash or color with complete abandon. Lose yourself in your subject. Paint almost faster than you can think so that your images appear with as little mental interference as possible. Get the rockyness of rock and the energy and grace of sea spray. Swing your entire arm to move your brush with the movement of turbulent water. Splash the picture surface with paint or pour on pools of color; then tilt the picture so that the running pools reflect the flow and fluidity of the ocean itself.

You can also try an alternative approach by doing a series of studies in which you are in more control and are conscious of the ways you might rearrange and distort in order to communicate most vividly and persuasively your response to the ocean scene. Make each study a little more abstract, a little more condensed, always working for increased immediacy and expressiveness of the fundamental aspects of your subject.

Then analyze the results of your experimentation. Of the two approaches, the method that generally seems to offer the best results is probably the one that is most natural to you and the one you should pursue into greater depth with all your energies.

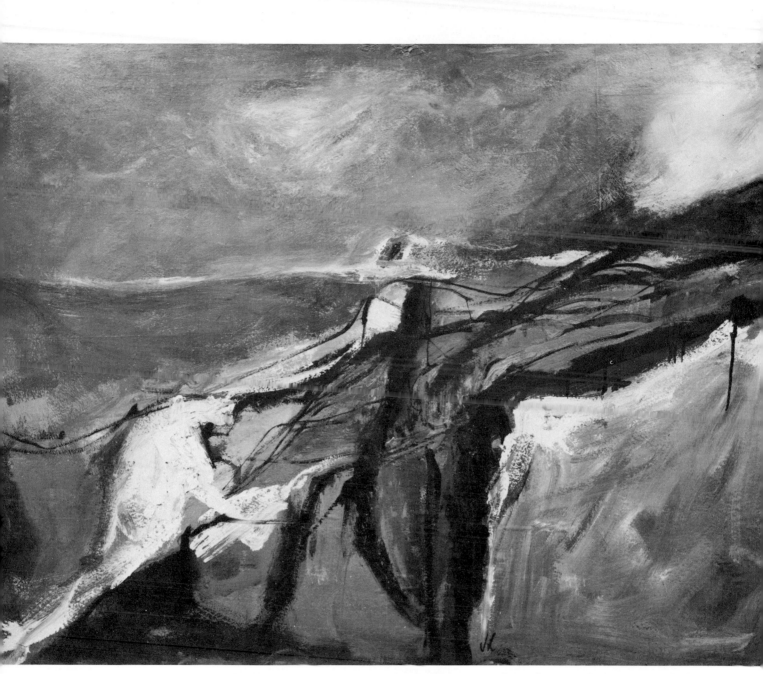

FINISTERRE
by John Laurent.
Oil on canvas, 36" × 48" (91 × 122 cm).
Collection Hamilton Easter Field
Foundation, Portland Museum of Art,
Portland Maine.

John Laurent has long been associated with the coast of southern Maine, with its rocky ledges, cliffs, and beaches. But he is also acquainted with a very similar sort of coast in France, the area that inspired this painting. Here he evokes the feeling of a dark, stormy sky and heavy surf rolling in against a rocky headland. This is a commonplace subject for a seascape, but Laurent has escaped the threat of banality by his use of abstraction. The brushwork is open, free, and painterly, applied with a vigor and breadth that are strongly expressive of the surging turbulence of the ocean and the impact of white surf against the cliffs. Set against the large masses of land and sea are freely wandering lines or linear definitions that refer to natural forms and also act as an accent and foil for the major masses. The primary enjoyment in this painting comes from the mood, the drama, and the sense of nature's forces that have been communicated through Laurent's skillful, expressive use of abstract relationships.

22. FORMAL ABSTRACTION

CONCEPT Where expressive abstraction invites an emotional involvement with subject matter, formal abstraction is directed more to the intellect. Loosely handled organic forms and gestures are put aside in favor of precision and geometric analysis of nature, an approach nearer synthetic cubism than expressionism. Formalist painters devote themselves to rational, logical rearrangements and interpretations of nature where planes and shapes are carefully and consciously designed within a strictly two-dimensional context, and that means greater emphasis on preserving the flatness of the picture plane.

Formal abstraction appeals to those who don't like messy surfaces, ambiguous relationships, and emotional display. It is above all else an art of order, clarity, and refinement where everything is planned and carried out with precise, sensitive adjustments of shape, line, value, and pattern throughout the surface. The primary concern here is not so much with nature (which as usual is only a point of departure) as with the most basic elements that go into the construction of a painting: line, shape, pattern, color, texture, space, positive-negative relationships, and so on.

This sort of emphasis seems to some people to be too cold, analytical, and impersonal. Yet this kind of intellectual design, if pushed to its limits, can result in nonobjective art, which many people believe to be the purest, highest order of art—a sort of cerebral perfection that represents the most profound capabilities of the creative mind. And there is indeed a certain deep aesthetic satisfaction in seeing formalistic art, which is, after all, a celebration of a sense of order where the painter presents a clear, controlled, rational distillation of nature, substituting a purely intellectual reorganization—or analysis—of nature for the casual disorder of nature itself.

Distortion is used here not in the interests of expressiveness but in the interests of design. Sometimes it is used toward the devising of handsome or striking shapes, sometimes for refinement and elegance, or sometimes for stronger pictorial structure. Nature's forms incite the artist to redesign a painterly world of his own where he eliminates vagueness, emotionality, and indecision, paring away all that is unnecessary or distracting. All that remains is his personal fusion of nature and geometry.

PLAN First of all, in painting a formal abstraction, I recommend that you give yourself a fighting chance by making a wise selection of your subject matter. Choose something in which you already perceive design qualities or geometric elements. In other words, avoid for the time being such things as trees, beaches, or surf, and concentrate instead on harbor forms: boats, docks, sheds, storage tanks, fishing shacks, oil drums, ladders, bait barrels, rope, sails, nets, flags, and so on. You can refer to a particular scene, or you can combine elements from a number of sketches or snapshots as the basis for your design.

It is important to keep in mind that here you are working entirely in a flat, two-dimensional treatment, that you should try to avoid or distort perspective or any strong indication of depth or recession into the picture. There should be no lights and shadows in the realistic sense: a shadow is to be considered only for its possibilities as a *designed shape* in your composition, not as a shadow. Similarly, a window, roof, or bow of a boat, for example, would exist in your design first of all as a colored shape or plane

before it would be seen as being a window, roof, or boat.

Probably the most efficient procedure here is to work out preliminary line drawings on a series of sheets of tracing paper. Design only flat shapes that relate well to each other, shapes not necessarily invented but based on your visual notes and experiences. Analyze the planes in your forms, treating them as so many sheets of cardboard, touching each other or overlapping and intersecting, some slightly behind or in front of others. Play with those planes: tilt them, bend them, or alter their normal proportions if your overall design requires it. When the final line version satisfies you, work out a strong pattern in values, alternating light against dark and dark against light. Then translate your value study into color.

Once you have mastered this approach as it applies to harbor subjects, you can apply the same thinking to an analytical designing of pines, rocks, cliffs, dunes, and surf patterns.

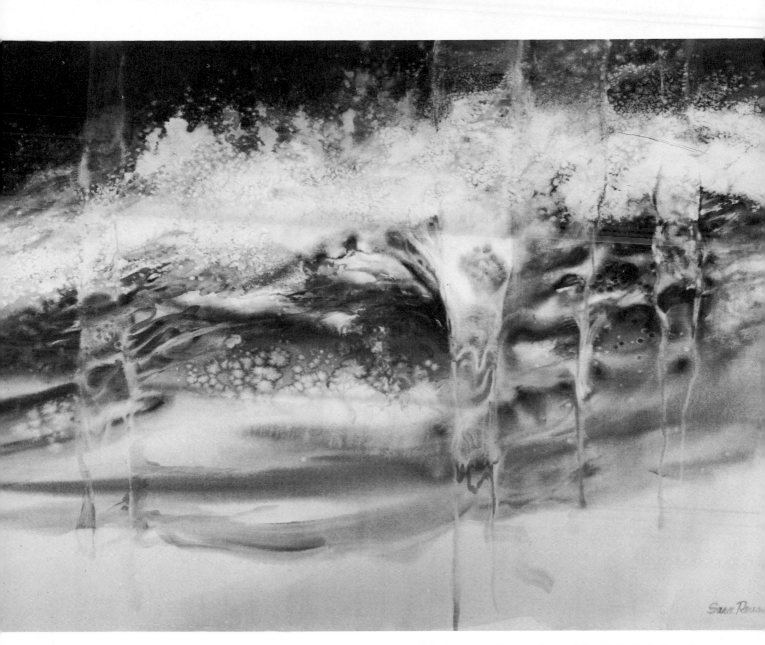

PIER FIVE
by Warren Spaulding.
Watercolor, gouache, and pencil
on mat board, 16" × 28" (41 × 71 cm).
Collection of the artist.

One of the high points in Warren Spaulding's art is his recent series of watercolors and gouaches based on harbor forms at Rockland, Maine. While some of his earlier work was concerned mainly with stylization, the new paintings have pushed toward a more personal, elegant, highly abstract art that involves juxtapositions of beautifully wrought nautical shapes assembled into flat patterns. The surface here is enriched by a use of linear elements that links the shapes together and contributes to the clean, crisp handling of the total design. Except for some areas of unobtrusive, subtle textures (in which he makes good use of his pebbled mat board support), Spaulding's treatment is resolutely flat, with all areas firmly anchored to the picture plane very much in the manner of synthetic cubism. The shapes, which have been based on what he has seen and known, are firmly designed and suggest a nautical environment without being overly explicit so that the viewer is not tempted to decipher an identifiable inventory of marine forms. Instead, the main interest derives from the artist's formalistic manipulations of shape relationships purely for their own sake.

23. LYRICAL ABSTRACTION

CONCEPT Quite the opposite of formalist painting, with its logic and clarity, is lyrical abstraction. This type of abstract art is sensuous, poetic, intuitive, and romantic. Painters who work within this approach are often called "informalists" just because their treatment is much less consciously formed and organized, often depending to a great extent on an exploitation of accidental effects during the painting process. If this sounds like Abstract Expressionism, it is true that there is indeed some relation between the two and that quite possibly lyrical abstraction is derived in some measure from the styles of the earlier group of painters. But the principal difference between them is that where the Abstract Expressionists strove relentlessly to keep their work rough, tough, coarse, and brutal, the lyrical abstractionists work with multiple washes, glazes, and sprays to produce seductive surfaces. In a word—something of a dirty one in the fifties—they produce paintings that are unabashedly "beautiful."

To achieve their effects of lyricism, imaginative association, and atmospheric space, these painters resort to painting procedures that have been likened to the processes involved in nature's own growth, development, and change. They allow the accidental behavior of their oils or watercolors to contribute substantially to the formation of their images, but at the same time they exert conscious control over what is happening on canvas or paper. Many of their paintings are as amorphous and atmospheric and just as sensuously lovely as certain sea paintings by Turner. They use all kinds of paint application to develop their rich, subtle, complex surfaces: splash, spray, spatter, pouring, resists, drips, glazes, and impasto. Such surfaces frequently suggest a sort of spatial depth or illusionism that is absolutely forbidden in flat formalist abstractions.

Informalist seascape paintings are often filled with equivocal allusions to nature, but as inference, implication, or metaphor rather than recognizable references. It might even be said that this kind of painting is neither realistic nor abstract, but sensory: the naturalistic associations are sensed or felt but are not always necessarily identifiable. The appeal of lyrical abstraction lies first of all in the beauty and quality of the painted surface and secondly in the way in which the artist has been able to suggest natural forms and spaces purely through a poetic, sensitive use of controlled accident.

PLAN This approach combines elements of both phenomenalistic and improvisational painting (see Concepts 34 and 47) in that you begin the picture without any preconceptions as to what the subject will be (though you hope it will be a seascape) or what the final picture will look like. You discover your subject as you go along. This takes courage, but you must be willing in the beginning to follow along with whatever happens on your picture surface. If you can't accept that premise, you'd better wait awhile before trying this.

Unlike some techniques, where an unsuccessful picture is simply discarded or destroyed, lyrical abstraction can either happen as a one-shot operation, or it can be a long, loving buildup of layer over layer, repainting, washing out, glazing, revising, color over color, glaze over glaze, until the final poetic image has been achieved. Either oil, acrylic, or watercolor can be used, but obviously the latter has more limitations for sustained workability over a long period of time. Apply paint in any way that will allow it to act naturally, with a minimum of tampering or control in the early stages. Let color flow wet into wet. Tilt the picture and let large pools of paint flood across the surface. Spray on paint using an atomizer bottle or a spray gun. Use stipple, spatter, or drips, and always wait for one paint application to dry before applying the next.

Let your instincts and intuition tell you what to do, what to retain, and what to repaint. As the image becomes more apparent, nudge the picture here and there, but don't impress your own shapes and patterns on it. Let them occur as much as possible as a result of the behavior of the paint itself, but always under the supervision of your watchful eye. Make the picture look as though it just *happened* into existence.

Work for atmosphere, space, mist, light, the feel of weather, and changing seasons at the shore. Don't worry about specifics or whether the picture departs too far from everyday reality. Use the paint to call up associations that may be mysterious or unclear even to you but that have implications somehow related to the sea.

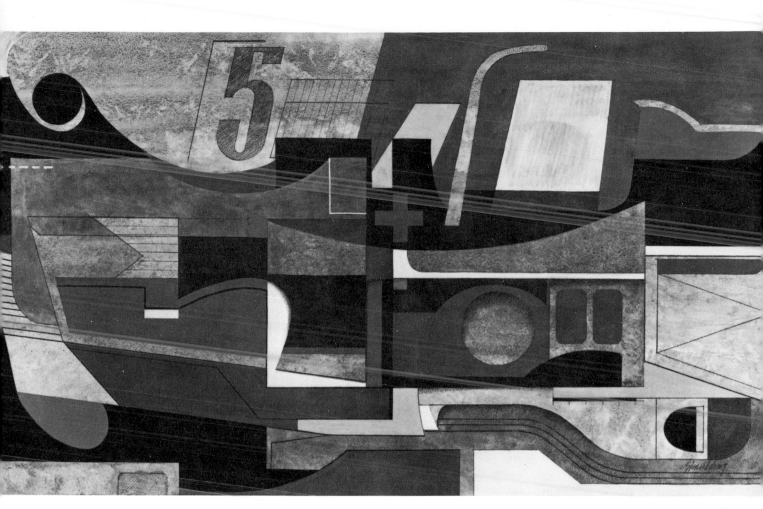

TIDAL WAVE
by Sara Roush.
Watercolor on board,
28" × 40" (71 × 76 cm).
Swearingen Gallery,
Louisville, Kentucky.

Water, whether seacoast or river rapids, is central to Sara Roush's imagery. This is due in large part to the way in which she daringly exploits the natural fluidity of the watercolor medium. She begins a painting without the faintest idea in mind and then lets it develop as it will. Although her pictures begin as totally abstract or improvisational manipulations of paint, naturalistic associations inevitably begin to appear as she brings memory and imagination to bear on the accidental formations of

colors and textures. The touch of the artist's brush is scarcely in evidence here, since the majority of shapes, lines, and sensuous surfaces are the result of pouring paint, tilting the paper, washing out with water, as well as spattering with clear water, salt, or a bit of opaque white. The result is a lyrical blend of unpremeditated accident and superb control, of boldness and sensitivity, to produce a personal, poetic vision of seascape.

24. THE MINIMAL APPROACH

CONCEPT The minimal approach to painting refers, of course, to pictures composed with a minimum number of areas. This means an extreme simplicity, a rigorous reduction of pictorial elements. This approach is related to the architectural maxim that "less is more" and is an extension of the painting principle of seeing how much can be said with how little. There are many painters who seem to have a horror of a vacuum, who cannot bear to see any empty areas, and who clutter up their pictures with a multitude of small, fractured areas and busy brushstrokes that allow no rest for the viewer's eye. A good antidote for such painting certainly would be a touch of minimalism. Yet art critic Corinne Robins made a point when she once observed that in the work of some minimal artists, "the law of diminishing returns can too easily set in." Somewhere between the crowded, overworked surface on one hand and oversimplified emptiness on the other lies the best minimal painting.

The minimal approach is based on two considerations: extreme simplification or condensation of the image and abstract design of the picture surface, each relating closely to the other. The seascapes of Milton Avery are a case in point. Some of the best of his coastal subjects are paintings in which there are no more than three flat areas, and in some instances, only two: sky, seafoam and rock, dune and ocean, ocean beach and rooftop, or dune against sky. All of these are most severely simplified, but combined with that simplification is Avery's unerring sense of shape, color, and design, which results in a mutual enhancement of subject matter and design.

Minimalism means stripping down the motif to its barest aspects in order to get at its essence. There are no details, no frills, and no unnecessary touches, and textures are either negligible or absent altogether. The few selective shapes and contours that form the picture, the simple divisions of the picture surface, and the handling of color are all that sustain the entire burden of interest in the painting.

At first glance, such condensation into only two, three, or four areas may seem an easy accomplishment. But remember, the fewer the number of elements, the more precisely or exactingly they must be adjusted to each other and to the surface as a whole. Indeed, some Oriental painters felt that such simplicity was the ultimate test of an artist and that only after a painter had understood and mastered complexity was he ready to deal with extreme simplicity.

PLAN Study the work of artists who have handled extreme simplification: Matisse, Avery, Rothko, Lundeberg, or Motherwell. Then see how far you can go in reducing your subject to its barest essentials without completely losing recognizability.

Exploration through drawing is the best way to begin your studies in such simplification. It might be advisable to try the first ones on sheets of tracing paper, starting out with a realistic drawing and then carrying it through successive stages, each one more condensed and more reductive than the previous one. All the time that you are working for simplification, keep thinking also of design and draw shapes that are not only simple and compact but also well designed. Also, think from the very start of relating those simplified shapes to the framing edge of your drawing or sketch pad.

Make sure that you vary the size or proportion of your areas. If they are all about the same size, they will look too equal, and so make one area the dominant one, one subordinate, and the third (or fourth, if necessary) perhaps only a strip or minor accent. Vary the placement of your shapes so that they divide the surface as arrestingly as possible. Look for the emptiness that can contribute an unexpected shock to your composition. See how intriguing and visually satisfying you can make two or three areas look.

Now try for unusual distributions of light and dark or of color. You haven't many areas to work with, and so they have to be absolutely right in their relation to each other. You can invent your own colors, but they must relate beautifully and perfectly. Minimalism leaves you no place to hide. There are so few elements that everything can be immediately seen and grasped without the benefit of any visual distractions, flashy brushwork, or ingratiating textures. Everything must be solved, then integrated and orchestrated with infallible skill and taste. If it is done well, your painting will not seem empty or boring; it will in fact be far more rewarding than those paintings that chatter on and on without really saying anything.

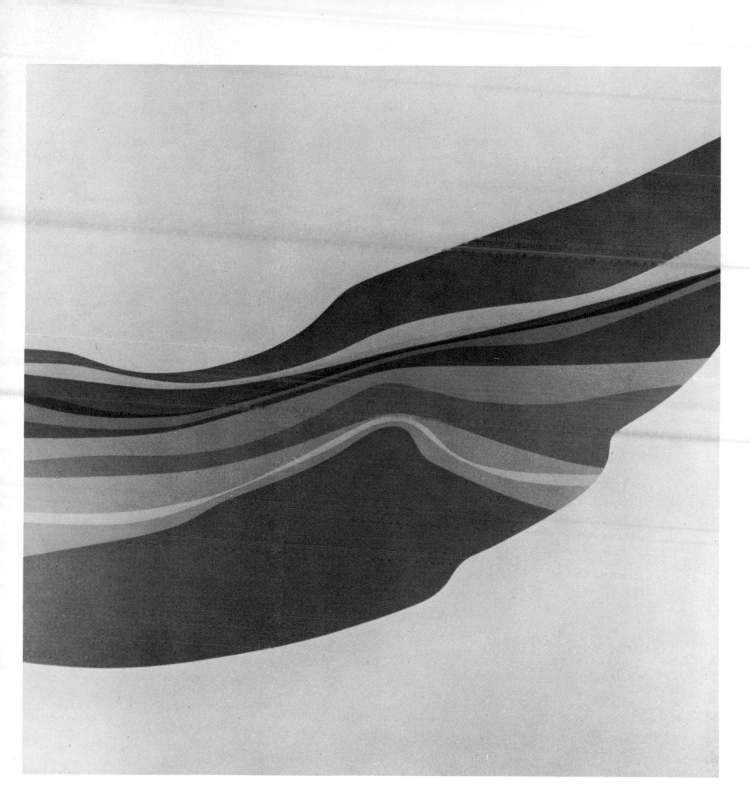

ICARUS BAY
by Helen Lundeberg.
Oil on canvas,
60" × 60" (152 × 152 cm).

Helen Lundeberg is well known for her minimalist versions of West Coast seascapes, of which *Icarus Bay* is a typical example. Her compositions are invariably hard-edge, flat, extreme simplifications of nature that are conceived from the very beginning in terms of abstract design, so that the final painting is a satisfying balance of formal color patterns and lyrical references to nature. Here she has established two large areas of open sky and empty shore. Then, running generally through the middle of the picture is an irregular mass composed of several rhythmic stripes, varying and fluctuating from wide to narrow. The top darker stripe might suggest coastal hills, and beneath it the curving shore of the bay. The other undulating ribbons of cool colors refer to the surging water forms of the ocean. The simplification stresses purity and austerity, yet the treatment is graceful and elegant and, despite the insistence on two-dimensionality, there is a strong suggestion of coastal spaciousness.

25. WATER PATTERNS: REALISTIC

CONCEPT One of the most rewarding ways to investigate seascape subjects is in terms of patterns. Many painters view nature primarily in terms of its relationships of shape, color, or light. But giving special attention to patterns can open up a new realm of possibilities for painting the coastal environment.

The term "pattern" as used here refers mainly to the arrangment or distribution of values in a pictorial composition, but it may also describe the design aspects visible in nature—linear configurations combined with shapes and tonal value relationships. (There is also color patterning, but that will be discussed later in the color section.)

When artists become aware of patterns in nature and begin to see pattern as an isolated element in painting, they find that, even within the context of realistic, descriptive work, their subjects become less important for their own sake and more important for the design ideas they provide. For the seascapist, the most obvious place to begin is with a study of water. One of the greatest fascinations of the sea, aside from its endless motion, is its constantly changing patterns. The ocean contains all kinds of patterns, depending on weather, winds, and tides, and a marine painter's first job is to study and assimilate these patterns and make them part of a repertoire of forms that can be put to use in paintings.

Water forms a wide variety of patterns: the splash of spray flung straight upward into the sky, the lacy froth that washes in on the beach, the rivulets of white water running down the dark rocks after a wave has struck, the foam left in the wake of a moving boat, surf churning around rocks on a stony beach, the concentric forms of swash along the beach as the tide rolls in, the delicate linear patterns on water pulled upward as a wave comes to crest and is about to break, and the rhythmic linear tracery of several sets of waves approaching a beach as seen from the air directly above. All these patterns are available to the realist painter (as well as to the abstractionist) as aspects of the ocean that are charged with a strong element of design. Because good realism has always relied on an underlying sense of pattern and design, a seascape can be much more than a documentary report. It can arouse in the viewer an awareness of the timeless aspects of design within nature.

PLAN There are several excellent photographic books that deal especially with beach and water patterns. One of the best of these is Ernest Braun's *Tideline* (Viking Press, New York, 1975), but I also recommend Stella Snead's *Beach Patterns: The World of Sea and Sand*, (Barre Publishing, Barre, Massachusetts, 1975) and Ann and Myron Sutton's *The Wild Shores of North America* (Alfred A. Knopf, New York, 1977). All these books, and some of those in the Sierra Club series, have splendid photographs of water patterns that will show you the sort of thing you must become deeply aware of if you are to study the design aspects of the ocean.

What should preoccupy you most is not the grand panorama of the sea environment but the more artistically interesting elements such as the swirling motion of water, the textures of bubbles, foam, and spray, the shapes of tumbling white surf, and the ripples and foamy tracery left in the wake of a boat.

Photography would be one way to record these patterns, but sometimes a photograph looks too static or frozen. So make many drawings, one right after another, until you feel you've captured the water movement both in line and in wash. At other times, you need not draw at all. Just observe closely and intently and store away as much in your memory as you can.

And continue to notice light and dark patterns in nature. Try to almost perceive the pattern and value relationship first, before you fully recognize the forms. Use these relationships to give your realistic seascapes an aesthetic quality and a personal point of view that puts them a few notches above standard realism. In short, aim for a more ambitious kind of realism, one with higher aspirations and more enduring concerns than a simple description of the scene.

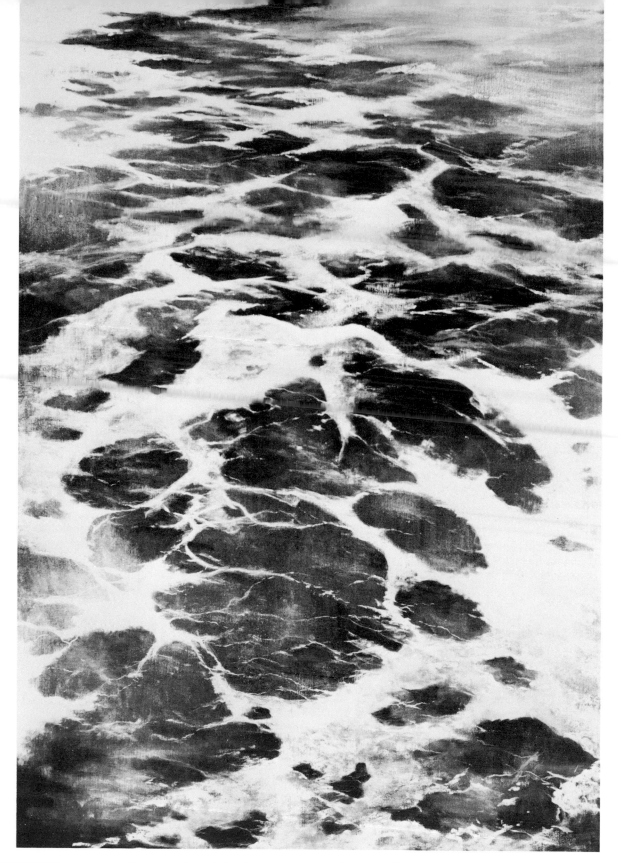

SPINDRIFT
by Edward H. Hergelroth.
Oil on canvas,
72" × 48" (183 × 122 cm).
Private collection.

Patterns of spindrift—foam swept along the ocean's surface by strong winds—have long fascinated Maine artist Edward Hergelroth. He knows the sea so well that his spindrift patterns are relaxed and fluid and, unlike those in photographs, they have the look of being in constant motion. Here he has chosen a downward view, which shows the shapes, patterns, and textures far more clearly than if he were looking outward across the water. Note that the forms in the lower part of the painting are more open, detailed, and varied and that they become simpler as they recede toward the top. For all the seemingly specific detail and intricate tracery of the flowing shapes and lines, the picture has a strong sense of design and a feeling of breadth and space that exists partially because the canvas is six feet high. But it is the intense concentration on water patterns that sets this picture apart from conventional seascapes.

26. WATER PATTERNS: ABSTRACT

CONCEPT Water patterns serve much the same purpose for the abstract painter that they do for the realist: a source of ideas for shapes and design and for investigating the abstract design qualities already existing in natural forms. The only substantial difference is that where the realist usually suggests depth and spatial recession into the picture, the abstractionist works primarily on the picture plane in a two-dimensional treatment that emphasizes or reinforces the very flatness of the painting surface, whether it be paper, canvas, or Masonite.

A great number of American artists have explored the abstract possibilities of water patterns: John Marin, Morris Kantor, Milton Avery, Balcomb Greene, Reuben Tam, Robert Eric Moore, Valfred Thelin, Robert Perine, Phil Dike, Nike Brigante, Ruth Snyder, Maxine Masterfield—the list seems endless. But all of these artists, and many more, have extracted the designs they have perceived in sea forms and manipulated them within the framework of their individual aesthetic concerns. The interesting point about all these seascapists is that each one really is quite different and individual, and so it would seem that there are as many interpretations of water patterns as there are painters. That this is possible is due largely to the immense wealth and variety of ocean patterns that are available to artists who search out those forms and then interpret them in paint.

The abstract sea painter possesses the same intense awareness of nature as the realist, but he puts that information toward a slightly different purpose, making the design itself the major interest or principal justification for a particular painting.

PLAN To get some idea of the wide variety of interpretations of water-patterns that exist, start by looking at the works of some of the abstract seascape painters just mentioned (some of which are reproduced in this book). What you will find is that there are so many ways of dealing with ocean forms—and all of them look so inviting and exciting—that you will find it hard to decide just which one is best for you. Well, the answer is simple: the best style for you is your own. And that means getting down to the beach and experiencing water shapes and patterns firsthand.

You may have made many drawings and paintings on location and perhaps have taken hundreds of black-and-white snapshots of surf and waves, offshore and onshore. But it is in the studio that the real work, transforming this documentary material into art, takes place. Certainly you can model your abstract compositions on some painter's seascapes you deeply admire—we all have to start somewhere—but as you work you should be thinking of how you can gradually develop your own viewpoint and your own manner of dealing with the marine forms that excite you.

Work in several media—inks, wash, watercolor, gouache, or acrylic—and try everything. At first select only one or two motifs that particularly attract you and put them through a number of variations in all media. Paint some of them swiftly and spontaneously and others more reservedly, more hard-edged, and more thoughtfully. Try some collages and some mixed-media paintings, using inks and watercolor or acrylic combined with rice papers and prepainted sheets of color. Spray, spatter, and pour. Let the color run and the paint flow and drift the way the ocean does.

After you have filled your studio garbage pail several times with discarded efforts, look over the best studies, the ones you've kept. Those—the ones that seem closest to capturing the essential look and feel of your own encounters with water patterns—are the ones that point out the direction of your future investigations. And it is out of those studies that your own personal style will finally emerge.

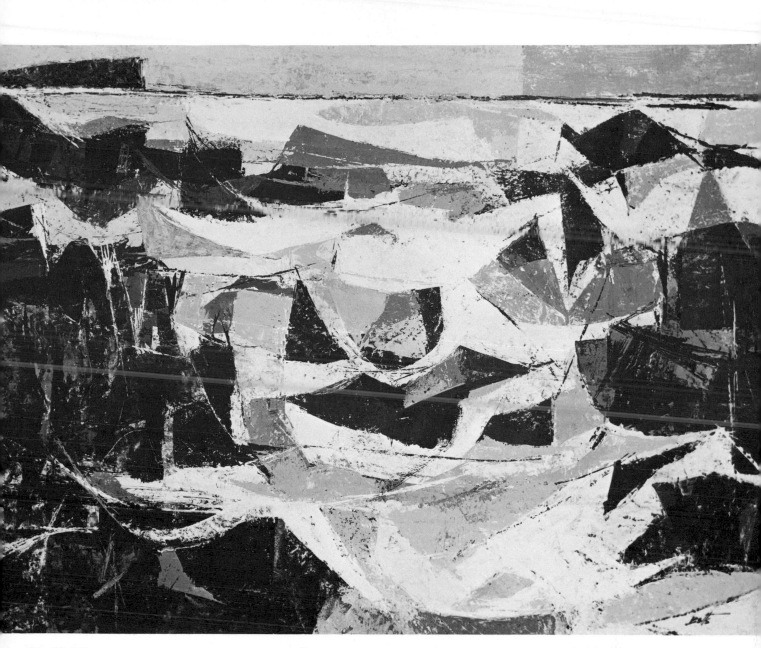

SEA FOAM
by Edward Betts, N.A., A.W.S.
Lacquer on Masonite,
24" × 34" (61 × 86 cm).
Private collection.

This is an early painting of mine, but it demonstrates that even more than twenty-five years ago I was obsessed by the interaction of sea foam and rocks. The foamy water splashing in and churning around and over coastal rocks interested me solely as an excuse for playing with complex, two-dimensional organizations of shapes and patterns. Rocks and surf are more or less abstract to begin with, and so my only urge was to put all that activity into some kind of order. My solution here was a sort of cubist treatment of sharply defined shapes and

patterns, yet handled freely and gesturally enough to suggest the driven, surging movement of the water. The palette was purposely restricted to a range of browns, blacks, grays, and whites so as to emphasize the harsh, rugged qualities of the Maine coast. As I look back on it now, this painting seems a bit hard or brittle—my present treatment of the same subject would be far more fluid, relaxed, and colorful—but at that time I was most deeply concerned with patterns above all else.

27. ROCK PATTERNS

CONCEPT Artists have long found rocks to be rich in associations as a source of pictorial imagery and designs. In fact, the Japanese for many centuries have cultivated the art form of *suiseki*, discovering references to nature in rock forms and patterns. They would collect rocks with formations and markings that seemed to represent natural land or sea forms and then use them as objects for contemplation. While on the literal level such rocks might be considered similar to "picture rocks" often sought after by American rock hounds, in the Japanese culture *suiseki* took on symbolic overtones and became a personal means of communing with nature. Like many paintings, such selected rocks were a vehicle—a connection between human beings and the world of nature or even the universe.

Many contemporary painters find themselves strongly attracted to rock forms and rock patterns, not only because they frequently evoke associations with seascape or landscape but simply because they are fundamentally abstract in appearance. The same volumes, shapes and planes that inspire a sculptor also touch off inner responses in a painter. Rocks and cliffs at the seashore also have other specific qualities that naturally appeal to painters: both angular and rounded forms; textured surfaces that are rough, smooth, scraped, mottled, or covered with patches of lichen or barnacles; strong patterns of light and dark; and clefts, fissures, or incised lines resulting from the action of time, weather, air, and ocean. Even beach stones that have been worn rounded and smooth may display a variety of linear designs on their surfaces—concentric ovals or circles, or irregular rhythmic patterns that might seem almost symbolic to the receptive eye. Some stones may even look as though they had been designed by sculptors such as Moore, Miro, or Calder.

Painters have viewed coastal rocks in various ways. Morris Kantor used them to create sinuous calligraphic patterns; Marsden Hartley used them as dark, flat masses contrasting starkly against white surf; B.J.O. Nordfeldt treated rocks as massive sculptural forms that served as a foil for the activity of ocean and surf. Among contemporary artists, Joseph De Martini deals with rocks and cliffs as gigantic slabs and planes; Reuben Tam seeks out the coloristic qualities of rock, using glints of color integrated with gestural brushstrokes that suggest textured surfaces and planes; Carl Morris interprets rock patterns as a kind of personal geological symbol; Balcomb Greene manipulates overlapping planes and patterns, sometimes treating rocks as though they were visually interchangeable with water, foam, clouds, and beach; David Lund plays up the architectonic quality of rock formations; watercolorist Barbara Osterman uses sunlight on ledges and rocks as vehicles for luminous washes of color; and Jason Schoener stresses cubistic patterns and an invented, intensified color range. Obviously, the ways of seeing and interpreting rock patterns are limited only by the number of painters who are deeply and inevitably attracted to them.

PLAN In a fourteenth-century treatise on painting, Cennino Cennini wrote: "If you wish to acquire a good style for mountains and to have them look natural, take some large stones, sharp-edged and not smooth, and copy them from nature, applying the lights and darks as the rule prescribes." Certainly this is also as good a way as any to become familiar with the surface patterns, textures, and forms of coastal rocks, cliffs, and ledges. Morris Kantor must have taken a cue from Cennini; his Union Square studio contained a group of rocks that he had had mailed to him from Maine's Monhegan Island. His own on-the-spot drawings, together with those actual rocks, were the basis of a memorable series of abstract tempera paintings. In essence, that would be taking small-scale forms and then enlarging them.

An alternative to that method of scaling up small forms is daily direct contact and long concentrated observation of rock forms and patterns. This means a lot of walking along the shoreline, sheaves of sketches and drawings, hundreds of photographs, and lots of just plain looking. This is the best way to ascertain which rock patterns you find most appealing and most apt to be translated into a painting. Some painters are attracted to rocks that are basically structural, with architectural planes and masses; others are more fascinated with freer organic forms; still others might be concerned with ways to blend a combination of both.

Remember, you are mainly searching for pattern and design, ways to emphasize the rockyness of rocks. In painting, sometimes you will tend to bring out their sense of weight and volume; other times you will handle those forms as flat, simplified shapes.

Painters seem to be mysteriously attracted to certain forms in preference to others, and you will find that you get your best paintings out of those rock patterns that seem closest to your inner world of forms. Often, as has been suggested before, it would seem that you don't choose your motif—the motif chooses you.

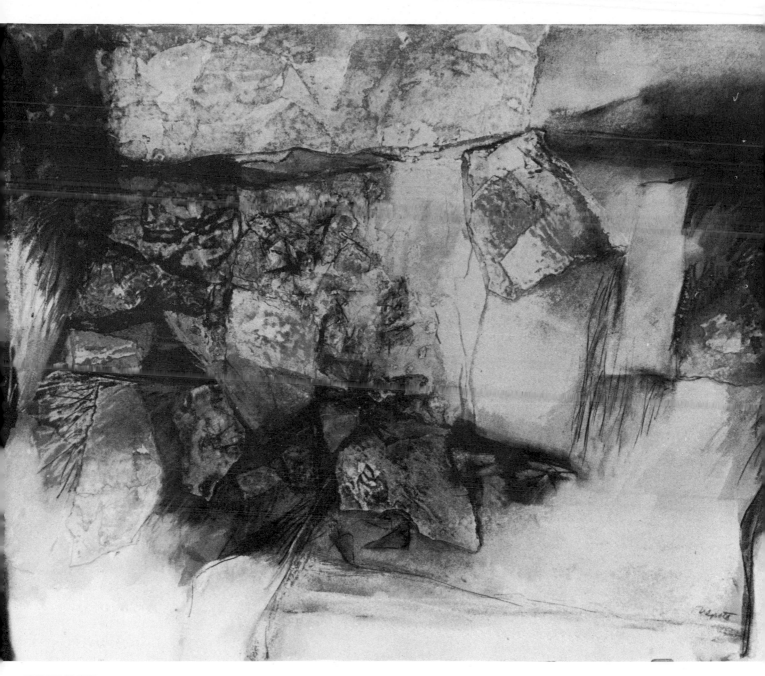

INLET CLIFF
by Alexander Nepote.
Mixed media on paper,
30" × 40" (76 × 102 cm).

The dominant concern over a long period of years in the work of Alexander Nepote has been an exploration of the patterns, shapes, and textures of coastal rocks. Rocks, boulders, cliffs, and sea caves have supplied him with a repertoire of forms, spaces, and textured surfaces that symbolize to him nature's processes of change and transition. He has always been partial to mixed media as a means of discovering anew in each painting the· pictorial possibilities of rocks. Mixed media techniques by their very nature lead to improvisation and endless experimentation— not only in terms of the media being used but

also of the imagery they create. *Inlet Cliff* is one of a recent series in which Nepote has utilized water media, collage, and pastel in a freer, looser, and more relaxed and lyrical vein than he has ever previously used them. There is a cluster of rubbed, rough, and mottled textured forms set off by larger open areas. The strong angular masses are softened by a use of linear accents, some of which are crisp and incisive while others are blurred and out of focus. Nepote has sought out the inherent abstract qualities of rock patterns and used them for his own expressive purposes.

28. SAIL PATTERNS

CONCEPT Among the most interesting forms relating to seascape are those of sails, particularly in groups, as in a regatta, when their shapes overlap and combine into complex moving and shifting relationships. British painters such as Bonington, Cotman, Constable, and Turner often used sails as dominant shapes in their compositions, both in harbors and in open sea; Boudin and Signac made effective use of sails and rigging in their harbor scenes; and Ryder invented some unusual sail shapes for emotional purposes. Other painters who have utilized the possibilities of sail patterns are Homer, Feininger, Dufy, and Marin.

Of special note is Charles Sheeler, who did a series of precisionist drawings of sailboat regattas in which he studied the graceful elegance of sail shapes. He explored their contours individually as well as overlapped and interweaving, emphasizing the interplay of straight and curved contours in his personal brand of carefully ordered classical design. Balcomb Greene, who is concerned with similar subject matter, sees the same design possibilities in the expressive movement in space of the sails' tilted planes. In contrast to Sheeler, his paint surfaces are free and painterly, with a skillful use of lost-and-found edges, and he cultivates ambiguity as consciously as Sheeler sought clarity.

Charles Demuth also did a group of watercolors and tempera paintings that interpreted the sail patterns of yachts and schooners in severely geometric terms, the entire composition being given over to complex arrangements of straight lines, planes, and edges without a hint of a curve anywhere. His juxtaposition of linear masts with sails that were treated as tilted sheets of glass and cardboard combines a delicacy and sensitivity of handling with a rigorous, angular design structure.

Sail patterns have much to offer the seascape painter, not so much for their picturesque aspects as for their power to inspire the creation of an intricate arrangement of shapes and patterns that can be varied or adapted to the design preferences of each artist, whether his style be brushy and expressive or tightly controlled and analytical.

PLAN Your first step is to acquire some knowledge of the wide variety of sail shapes that exist. Any harbor in which large numbers of sailing craft are moored will provide you with a range of shapes that can be used as a starting point for a composition based on sail patterns. Observe sailboats entering and leaving the harbor, watch regattas whenever and wherever you can, and record what you see in sketches and photographs.

Since you are designing your picture surface in terms of the shapes and patterns of sails and boats as they move with the wind, make sure you close in on them as much as possible so that those forms will fill most of the picture. In taking photographs, it might be wise to use a telephoto lens, which can concentrate on the boats and sails and exclude extraneous areas such as the sky or foreground. After you have gathered all the information you need, there are two general approaches to follow, depending on your personal style.

One way would be to do a series of quick sketches in ink, watercolor, or acrylic, attempting to catch the spirit of several wind-filled sails and leaning masts moving across choppy waters. Keep these studies swift and spontaneous, creating broad washes and planes, and then cut across and through them with sharp lines applied with a painting knife. The result will be a free line arrangement that has been superimposed over large sail forms. You will have a counterpoint of light and dark shapes—overlapping, intersecting, shifting in space—and a linear design that operates simultaneously with and against the larger masses. When you are ready to develop the final version, you can then choose the best aspects of several of these studies.

The other approach is more analytical. Here you explore the geometry of a group of sails, using a straightedge for line delineation and gradually forming either a simple or a complex image that refers to sails, masts, and rigging, but one handled cleanly and precisely as an intellectual ordering of forms, lines, and patterns. Sometimes tracing paper may help in developing the image as it moves through various transitional stages toward simplicity or complexity. When the major design problems have been solved in line and values, then it is time to plan the color and move on to the actual painting.

Whichever approach you prefer, keep in mind that a liberal use of diagonal lines and tilted planes will give your picture a sense of animation that will reinforce the underlying theme of the composition.

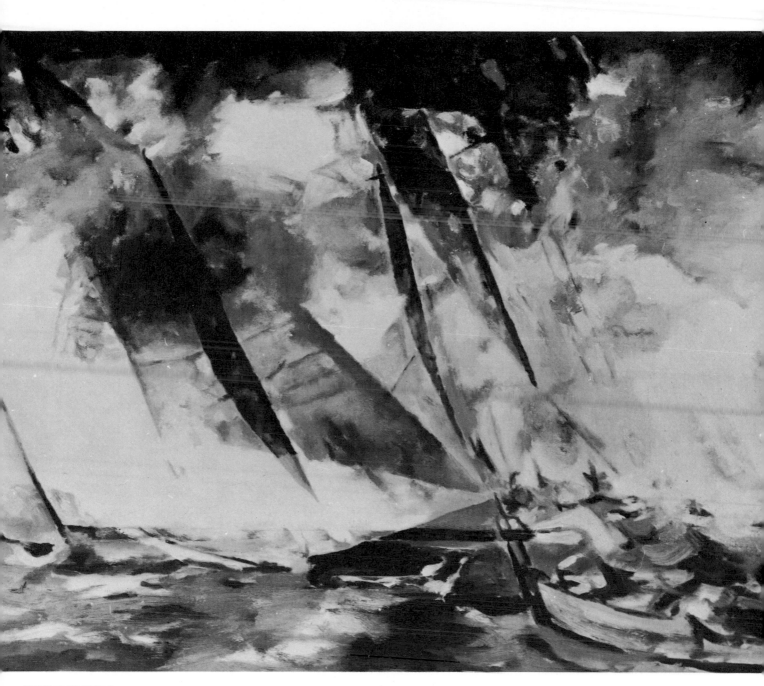

STORM CLOUDS
by Balcomb Greene.
Oil on canvas, 32" × 40" (81 × 102 cm).
Courtesy A.C.A. Gallery,
New York City.

Balcomb Greene has lived for many years on a cliff at Montauk Point, the outermost tip of Long Island, and this keeps him, as it did Winslow Homer in Maine, in constant touch with the sea and with the forces of nature. The result has been a series of highly romantic paintings of the sea that is altogether unique in the field of modern American painting. Despite its title, this composition deals primarily with intersecting and overlapping triangular sail patterns, exploiting shapes, planes, and diagonal thrusts to express the pressure and movement of sea winds. This is not a factual documentary; details have been submerged or eliminated in favor of the total design and the creation of formal relationships that transcend simple description. Here Greene first establishes a sense of stability by the use of a horizon that traverses most of the surface. Then he handles clouds, sails, masts, boats, and water as inseparable areas, one melting into another, disappearing and reappearing through his intentionally ambiguous use of lost-and-found edges and the skillful interplay of lights and darks. It is the manipulation of sail patterns that provides both visual excitement and pictorial structure.

29. HARBOR PATTERNS

CONCEPT Man-made forms—shacks, boats, docks, pilings, nets, rigging, buoys, pulleys, ropes, oil drums, bait barrels, floats, ladders, tuna flags, lobster traps, weathered wood, and torn tarpaper—are major elements in coastal scenes. Some painters use these forms to make the scene more picturesque, while others see them as a source of abstract designs and arrangements of lines, shapes, and patterns that offer a change and a counterbalance to the more organic natural forms of ocean, beach, and rocks.

It may well prove to be a boon to American painting that the famous "Motif Number 1" in the harbor at Rockport, Massachussets, was destroyed in a recent severe winter storm. Over a long period of years that particular wharf structure had made its contribution to American art, but by now it is questionable that the world needs to have still another version of it. There is really nothing wrong in depicting such subjects, except that they are too often dealt with unimaginatively: obvious subjects treated in an equally obvious or routine manner. Then, too, the visual appeal of harbor subjects is so strong that many painters are tempted to go no further than to simply show the scene just as it is, hoping that the picturesque qualities in themselves will carry the entire interest in the painting. But this has been done so well and so often that it seems useless to add another picture to the long list of harbor scenes unless there is some effort made to go beyond appearances and explore the forms on other levels of interest such as color, light, mood, pattern, or design.

Harbor patterns have an almost limitless potential when it comes to devising various combinations of shapes, structures, and linear elements that are to be found in that environment. Artists have dealt with that material in terms of rugged painterly realism (Bellows, Kent, Anthony Thieme), as a study of light (John Twachtman, Frank Duveneck, Etnier), for atmospheric effects (Whistler, Carl Morris, John Maxwell), as complex patterns of color and shape (Julian Levi, Robert E. Wood, Frank Webb), or as abstract design (John Marin, Hans Moller, Warren Spaulding). In the same way that beaches are the place where land and ocean meet, so are harbors; their patterns are just as much a part of the seascape as those of surf and rocks.

PLAN There are two ways to gather notes on harbor forms and patterns. One is to wander around the harbor on foot, sketching any material that strikes you as being potentially useful in a painting. The other way is to look at the harbor from the water, a viewpoint that offers a less familiar view of the scene and is therefore one that might lead to less familiar pictorial ideas.

Actually, there is such a wealth of material—both large-scale structures and closeup details—that a camera is a considerable time-saver in recording all the various viewpoints, angles, and details that abound there. Try for the unusual viewpoint, framing your subject with foreground elements or from beneath the pilings of a wharf.

Do sketches of whatever you respond to, getting a feel for dramatic or offbeat composition, and then use your camera to record significant detail you would not ordinarily have time to include in a sketch. Keep the sketches simple, bold, and free, wholly in terms of mass and pattern, and leave it to the camera to take care of the routine documentation. I have found that my students get their best paintings by utilizing this combination of sketchbook and camera.

Select your subjects with a sharp eye for their shape and pattern qualities, not just the obviously picturesque elements. Look for the things someone else might have missed: make it *your* version of the harbor patterns, not the common one.

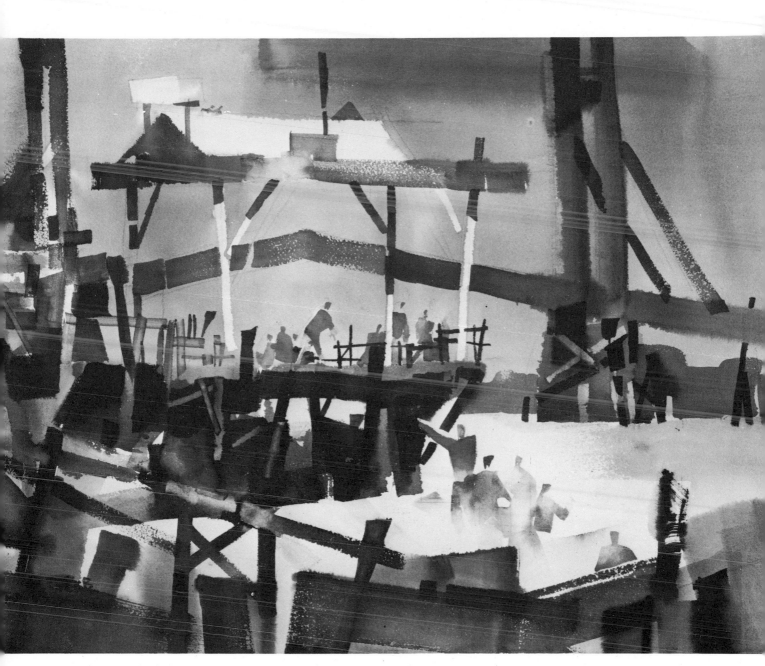

CELEBRATION
by Frank Webb, A.W.S.
Watercolor on paper,
22" × 30" (56 × 76 cm).
Courtesy Bird in the Hand Galleries,
Sewickley, Pennsylvania.

Frank Webb views all his subjects in terms of bold contrast and design. Basing his work on forms and patterns in nature, he uses them as a means of designing his picture surface with divisions of space that are as striking and dramatic as possible. Harbor structures such as those seen here (based on Perkins Cove at Ogunquit, Maine) provide Webb with an unusually wide variety of lines, shapes, and masses with which to create an exciting design. Despite a freedom and breadth of execution, which implies that washes and brushstrokes have been applied with a seemingly wild abandon, in reality every area has been thoroughly planned beforehand so that each wash, each line, each accent takes its specific place in the overall design. Webb has consciously worked not only for a full range of values but also a range of shape sizes, from broad masses to tiny linear accents. Also, attention has been given to an alternation of lights against darks and darks against lights, which ensures clarity, contrast, and readability throughout the composition. It is Webb's ability to dramatize the geometry of harbor patterns that makes this painting so successful.

30. HARD-EDGE TREATMENT

CONCEPT In drawing, lines are used to define the contours or edges of forms, and beginning art students are informed that lines are an abstraction, a convention used by artists even though such lines are not actually to be found in nature. In painting, however, especially representational or realistic painting, in an effort to reproduce the actual look of things, lines are no longer used to outline forms. Instead, a variety of edges are substituted—hard, soft, blurred, broken, dragged, or scumbled sharply defined in the light, or blended and soft within deep shadows—to approximate the boundaries of different forms as we perceive them in nature.

As painting developed and changed from the late nineteenth century to the present, artists became increasingly interested in interpreting nature in terms of designed shapes and flat planes. Many artists took to emphasizing the sharpness of edges and, in an effort to get away from visual realism and impressionism, often treated every area in the picture as hard-edged, sharp, and crisply defined.

Lately, hard-edge or sharp-focus painting has come to denote a whole category or style in contemporary art. Although hard-edge treatment is ordinarily associated with work that is abstract, as seen in paintings such as those by Helen Lundeberg (pages 59, 125), Pauline Eaton (pages 75, 141), George Kunkel (page 124), or Ernest Velardi (page 113), in many ways it is a treatment that can also be found in traditional realist seascapes, ranging from Fitz Hugh Lane in the nineteenth century to more recent practitioners such as Leonid, Stephen Etnier (pages 37, 130), and David Ligare (page 123).

The hard-edge method of handling is characterized by extreme sharpness and clarity, and therein lies its strongest appeal. It might be said that hard-edge is largely a classic, lucid view of nature, decisively drawn and designed, with none of the atmospheric softness to be found in paintings associated with the romantic tradition. The method involves clean delineation—definite, distinct, and unambiguous—a treatment, as we have seen, as adaptable to realism as it is to abstraction or nonobjectivism. Because of this adaptability, it is immediately apparent that as a method it is not nearly as restrictive as it might at first seem.

PLAN The main idea to keep in mind here is that there can be no fuzziness or blurring of edges in your painting. All blending or gradation of value or color must be tightly contained within the edges or contours of each specific area, and lost edges that allow one form to melt into another are to be avoided.

Just as doing a pencil drawing in line forces you to be decisive and clearly pin down everything, so the hard-edge treatment requires special attention to the contours of the various shapes and also to the design of the shapes themselves. Obviously this applies to hard-edge realism as well as hard-edge abstraction. All areas must be carefully, precisely planned and delineated. If you are faced with any problem areas, there is no way to hide or disguise the problem by resorting to hazy, soft edges or razzle-dazzle brushwork. Every form is clearly, sharply, and unavoidably visible.

I recommend that you start with a line drawing of your subject and first solve the composition in purely linear terms. This will make you fully aware of the importance of each of the picture areas and of how all those areas relate to each other. Pattern and color can be thought out later. Remind yourself of those primitive or self-taught painters who rendered each area in the painting with equal precision and clarity, whether it was in the near foreground or in the far distance, concentratedly describing all the forms as though they were of equal visual importance in the picture. That same kind of sharp definition is what you will stress here.

If you are using a realistic approach, be sure to put your seascape subject in a strong light that will emphasize distinct edges and lights and shadow. This is no place for atmospheric nuance and ambiguous form. If you are working more abstractly, use hard-edge handling to clarify and reinforce the severity and elegance of your design.

If you have avoided using the hard-edge treatment before, try it once in a while, just as an exercise in disciplined thinking.

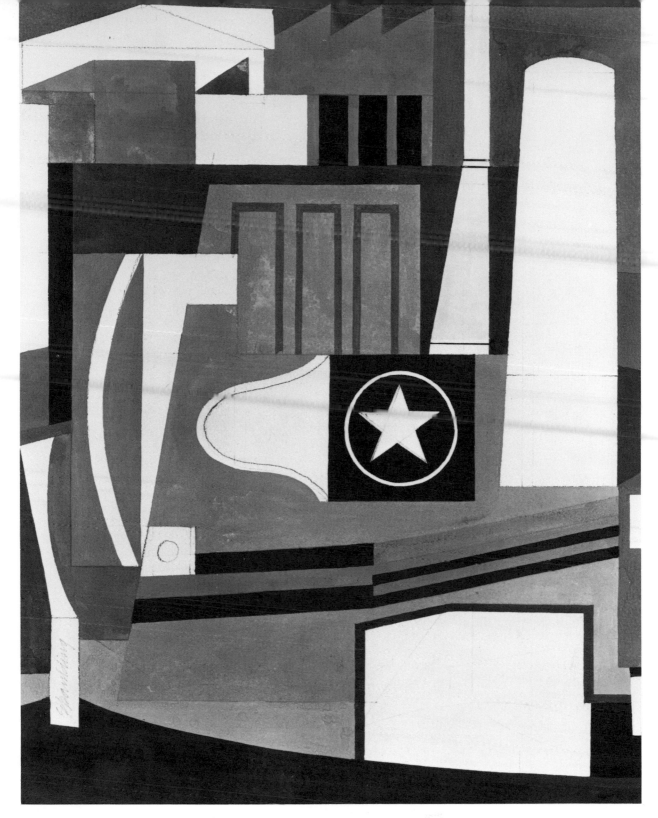

SEA STAR
by Warren Spaulding.
Watercolor, gouache, and pencil
on mat board, 13" × 9" (33 × 23 cm).

Warren Spaulding has found the hard-edge treatment ideally suited to the strongly designed shapes and patterns he derives from harbor subjects. The specific motif here was a fuel-oil boat at a wharf in Rockland, Maine. Using a compositional method related to synthetic cubism—interlocking planes of light and dark, coincidental edges, overlapping and interpenetrating planes, and multiple viewpoints—Spaulding has taken elements of his subject and rearranged and reorganized them into a tightly knit two-dimensional structure. This intellectual approach is further borne out by his use of hard edges, which

reinforces the overall sense of austerity and classical order. The sharpness and precision of these clear-cut forms help to express the geometric or mechanistic qualities Spaulding finds so exciting, and it is his skill in handling these crisp hard edges, both straight and curved, that is one of the most satisfying aspects of this design. Soft edges would have been out of place here and would not relate at all to the fundamental spirit of the subject matter. The hard-edge treatment is not simply a personal style randomly applied. It plays an integral part in projecting the essential character of the forms.

31. SOFT-EDGE TREATMENT

CONCEPT Where the hard-edge treatment is clear, sharp, and usually formalistic in character, the soft-edge treatment is diffused, blurred, lyrical, and more inclined to be relaxed in structure. Some painters, simply by nature or personality, lean toward an art that is sharp and clear, with everything neatly in its place. Those painters would be most at home with the hard-edge approach. On the other hand, there are those painters who want to avoid clarity, who favor haziness, mystery, and ambiguity, or whose subjects demand less crisp representation. They, of course, are the ones who would elect to use the soft-edge treatment.

Soft edges are associated with forms dissolved in blazing light or with atmospheric effects such as haze, fog, snow, or even smoke. Many of Turner's sea paintings are glorifications of swirling color and mist, completely free of edges of any kind. The Impressionists also consciously eliminated clear-cut edges in many of their paintings, allowing strong sunlight to blur the forms of sailboats set against shimmering water, or allowing it to bathe an entire harbor scene in the sort of radiant brilliance seen in Seurat's *Fishing*

Fleet at Port-en-Bessin at New York's Museum of Modern Art.

Aside from atmosphere and light, much of the soft-edge treatment is closely allied to the character of the medium in which an artist works. Although oil paints are extremely versatile and can be made to produce almost any desired visual effect, the heaviness of the paint itself precludes anything resembling the wet-in-wet technique so natural to water-based media. When oils are thinned down to the extent needed for wet-in-wet handling, a considerable amount of linseed oil must be added to the mixture in order to maintain the necessary bond between oil and pigment. If you add too much turpentine (and too little oil) to thin the paint to this diluted, liquid consistency, you will find that there is too great a dispersion of pigment in proportion to binder and thus a dangerous weakening of the paint film. On the other hand, watercolor, acrylic (thinned with water and acrylic medium), and inks lend themselves easily to wet techniques in which a great variety of soft blendings and blurrings are possible.

PLAN As I mentioned above, opaque oil paint can indeed be used for soft-edge effects, but the softening or blending must be handled skillfully, using sprayed, dragged, or scumbled transitions whenever possible. Simply blending the paint by brushing back and forth too often has the mechanical look of having been done by a house painter. Well-diluted oil paint in which a wet-in-wet technique could be used might be more desirable, but as we have seen, it may have serious technical disadvantages.

The most appropriate medium for utilizing the soft-edge treatment is watercolor, especially the wet-in-wet technique. Here you would be painting transparently on wet paper, injecting rich color into previously applied color areas that are still wet, and allowing the paint to flow, blur, and blend. Naturally, the wetter the surface, the less control there is over how far the paint will spread. But as areas near drying, the spreading of the color is much more restricted. You can also adapt this technique to ink washes or to inks combined with watercolor.

For both transparent and opaque soft-edged treatment, acrylic can be thoroughly diluted with a mixture of three parts water to one part acrylic medium and then painted in the wet-in-wet method. When acrylic white is added to those transparent mixtures, varying degrees of opacity will result, depending on the amount of white used. An atomizer or spray bottle or stipple techniques can also be used to obtain other soft-edged forms and blendings.

Because without sharp edges it is sometimes difficult to achieve a strong sense of either shape or pictorial structure, you must make an effort to suggest shape and pattern in a subtle manner that does not overly insist on edge as such. At the very end you could insert occasional sharp accents or lines, but they should ordinarily be kept to a minimum if you are to get the maximum effect of the soft-edge handling.

Your subject matter, and the feeling or mood you want to express, will largely determine when and how soft edges are to be used in the creation of your sea imagery.

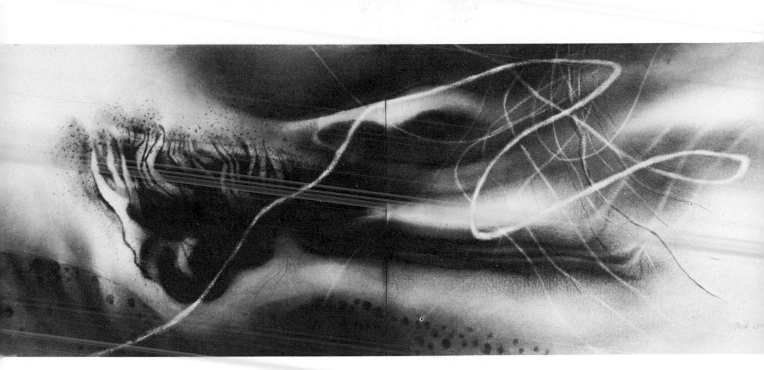

TIDE POOL NO. 7
(FLIGHT OF A DRAGON FLY)
by Nick Brigante.
India ink on Arches paper,
22" × 60" (56 × 152 cm).

Whether he is using monochromatic India ink washes or richly saturated watercolor, Nick Brigante is a master of the soft-edge treatment as a means of expressing his intimate, poetic vision of nature at the shore. He employs the wet-in-wet technique for a variety of subjects: wind-blown fog, mountain mists, turbulent seas, or the depths of tide pools. Relying on his personal form of calligraphic improvisation coupled with atmospheric effects reminiscent of Oriental painting, Brigante evokes the look and feeling of natural forces and sensations.

The superimposed "energy lines," as Brigante calls them, were derived from childhood memories of the patterns created by insects as they flew above the surface of a tide pool. These lines serve a double purpose, acting as a counterpoint to the soft, flowing tide pool forms and creating a separate visual plane that increases a feeling of depth. Note also that Brigante has spliced together two Imperial-size sheets of watercolor paper to create a larger image than is usually possible.

32. MOSAIC TREATMENT

CONCEPT The mosaic treatment can be approached in two ways, either as technical handling in terms of paint application or as a compositional method that is closely related to certain kinds of subject matter.

Technically speaking, in the mosaic treatment the picture is formed primarily out of numerous small units of color. Some of these units are tiny, similarly sized touches of color that have been applied with a very small brush. Other colored spots, shapes, and forms are considerably larger in scale.

Seurat, in his seaside dunes and harbor scenes, utilized the module of color dots in his pointillist method, which is about the smallest unit possible in painting. His work contained no flat masses or surfaces but was made up entirely of innumerable color dots that were uniform in size. On the other hand, Bonnard, in his Mediterranean seascapes, could be said to have enlarged Seurat's dots into larger and more irregular color patches and clusters, creating a color mosaic that because of its very irregularity was more varied and less restrictive than Seurat's tiny pointillist units.

Contemporary seascape painters who have used the mosaic treatment include Alan Gussow, Hyde Solomon, Gabor Peterdi, and Hans Moller. Gussow's tide-pool compositions were made up of an intricate and complex network of touches and dabs of color not unlike those in some of Monet's paintings. Hyde Solomon's early Monhegan Island paintings were created out of multiple interwoven strokes that were brushed on freely and energetically, bringing sky, land, and sea into unity and coherence by the overall use of similar touches of various colors. Gabor Peterdi brushed on bars or bands of color—elongated rectangles that jostled and overlapped throughout the surface. Hans Moller uses the mosaic treatment to bring out designs and color patterns in island trees, rocks, flowers, and lobster traps.

When the subject matter itself demands the mosaic method of handling, it is not necessarily the paint application that is broken down into small units or patches but the subject itself. That is, it is the complex, overall subject, which is composed of many units and covers all, or a major part of, the picture surface. This means that if a subject such as shells, beach stones, sea, foam, stacked lobster traps or buoys, or coils of rope, were to be selected, it would be arranged into a mosaic pattern that would fill the entire composition with modules of a very similar size and scale. In short, the forms themselves, not the brushstrokes, would become the mosaic.

It should be pointed out that this treatment is equally effective in representational or abstract approaches, whether the subject is dealt with as an assemblage of many color touches or of many forms.

PLAN A good bit of patience on your part is in order here. The mosaic treatment is most certainly not one of speed and breadth, but quite the opposite. Its success depends on multiplicity, on literally hundreds of dots or touches of color, or on the depiction of a tremendous number of forms. (Care to count the stones in Pauline Eaton's painting on the opposite page?)

Since there are two general approaches here, you can try either one or both, depending on your patience and stamina. If you will be using modular color units, it might be a good idea to begin by brushing in several broad areas of color, either the local color of each area or, more interestingly, the color complements of what you intend the final colors to be. Over this under-painting you can then apply colors in small dabs or dots, breaking up the various areas into innumerable units of color. Of course, these units can range anywhere from those seen in pointillism on up to larger patches or strokes—it's the multiplicity that counts. Heap them on, keep adding more until your picture surface is loaded everywhere with touches of color that are more or less uniform in size. Your subject matter can be broad and simple, but the handling will be complex. Oil or acrylic is a natural choice of medium for this particular method, although I've seen occasional examples of it in watercolor.

If you view the mosaic as a complex compositional arrangement of many depicted forms or objects, you will see that it's not the treatment but the subject that should be busy or complex. So for this treatment you would choose a motif composed of a great many parts. Look down at a densely packed area of pebbles, beach stones, shells, barnacles on a rock, a barrel of fish, stacked lobster traps, or other fishing gear, and let this multitude of forms fill your composition until it bursts.

In painting them, you will find that you won't get tired and lose interest. Instead you will be fascinated to see the surface gradually develop into an overall patterning, and you will be impatient to get on with it and complete this mosaic, every inch of which is packed with interest and detail. Again, any medium is appropriate here. Selection of one should depend partly on the character of your subject and partly on your willingness to lose yourself fully in the mosaic treatment.

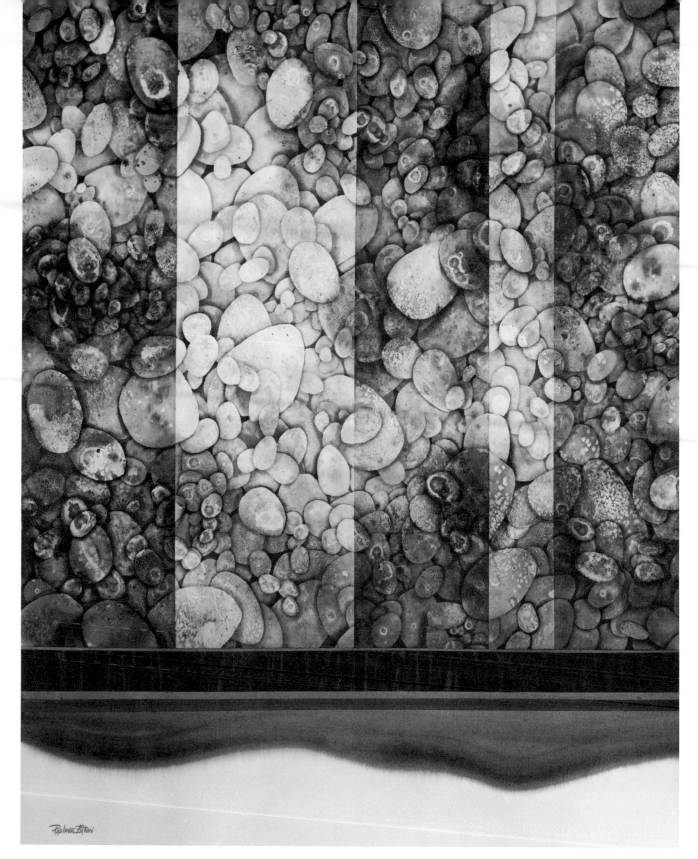

TIDE POOL TAPESTRY
by Pauline Eaton, A.W.S.
Watercolor on cold-press
illustration board,
40" × 30" (102 × 76 cm).

Pauline Eaton has used a multiform subject as the basis for a mosaic—or as she calls it, tapestry—treatment. The many stones seen at the bottom of a tide pool have provided her with the chance to present an overall design of realistically depicted stones within a formalized compositional structure. The severe vertical bands and the use of both soft-edge and hard-edge in the lower zone of the picture constitute a sort of abstract environment for her realistic subject matter. Those vertical di-

visions help to break up and activate the upper section of the painting, and at the same time they create a sense of several different levels or transparent planes through which the stones are viewed. Her mosaic pattern is further varied by her loving attention to detail and texture. Indeed, it is her sensitive and skillful handling of textures—some rendered while others are the result of the interaction of salt and watercolor—that truly enhances and enriches her mosaic composition.

33. GESTURAL TREATMENT

CONCEPT Gestural painting—though it now has connotations of what used to be called "action painting" in the 1950s, as exemplified by Pollock, Kline, and De Kooning—has actually been with us for a much longer time. We think immediately of the free gestural sketches and drawings by Rubens, Rembrandt, Constable, and Turner, and of the loosely brushed paintings by Constable, Monet, Sargent, Kokoschka, Hartley, Marin, Hyde Solomon, and Nick Brigante, among many others. Gestural painting is characterized by speed, immediacy, spontaneity, and a feeling of painterly excitement that invites the viewer to share vicariously in the physical act of swinging the loaded brush across canvas or paper.

This painterly quality is not nearly as evident in the work of, say, artists such as Hopper, Avery, or Demuth, all of whom have painted various aspects of coast and sea in a more restrained, unemotional, classic treatment in which spontaneity is consciously suppressed so as not to distract in any way from the clarity and control with which they present their coastal images.

Gestural painting does not have to be as intentionally brutal or aggressive as it became in the hands of the Abstract Expressionists. Some gestural painters determined to be less resolutely vanguard found themselves labeled Abstract *Im*pressionists, while others fell under the new category of Lyrical Abstractionists. Both groups of artists displayed an obvious and infectious joy in handling paint for its own sake, yet at the same time most of them formed their freely brushed strokes in reference to nature. They found that their brand of expressive brushwork was equally ideal for evoking active surf, turbulent skies, streaks and shafts of light, winds, storms, or rainshowers according to the way they applied that brushwork to serve as a painterly, gestural equivalent of events or forces in nature.

Thus, while the Abstract Expressionists utilized gesture almost as an end in itself, as a kind of personal glorification of the very act of painting, other and later gestural painters used that approach in a somewhat more traditional way—with greater purpose behind it—as a means of achieving close identification with nature. It was therefore a method that was meant less for "self-expression" and rather more for expressing something outside the artist—nature itself.

So the gestural treatment operates or functions on two distinct levels: by inviting spectator participation in the joy of painterly application of color, and by communicating moods and forces in nature through direct identification of gesture and brushwork with various natural phenomena.

PLAN When I think of gestural painting, I am continually reminded of Robert Henri's remark in *The Art Spirit* (J.B. Lippincott, Philadelphia, 1923) about someone painting "like a man going over the top of a hill, singing." Because that is largely what the gestural treatment is all about: a spirit of excitement, exuberance, and spontaneity put to expressive use. This is no time for neatness and calculated precision. This is your chance to relish fully the way you apply the paint, with all the emotional energy at your command.

If you can possibly do it, work standing up at your easel or painting table. Paintings done while sitting down are apt to be tight and static, and what you are really after here is a sense of freedom and looseness. Put your whole body into it and swing your entire arm, not just the wrist or fingers. Don't paint on a small surface; use as large a canvas or paper as you feel you can handle. Because there is something about a large surface that brings out a feeling of expansiveness in a painter, prepare yourself to forget niggling detail and attack your painting with the aim of achieving as much breadth and freedom as possible.

Work with as large a brush as you can control, load it with paint, and swing it across the picture surface. Your brushstrokes must not be sloppy or aimless. Because you are trying to express some aspect of nature, they should have tremendous energy and dash. They should also closely relate to the essence of the idea you are trying to convey to your audience: a clear blue sky filled with sun and breezes; the rugged, angular planes of a dark, wet rock; the vertical splash of lacy spray; clouds scudding across a dark, stormy sky; the graceful confusion of a crowd of sea gulls whirling, dipping, and zooming upward in an aerial ballet.

Remember, you are using nature as your inspiration, attempting to catch the action, the movement, or the innermost qualities of forms perceived and felt. The speed of your brush precludes hesitation and thoughtful analysis. Do your thinking *before* you paint, but once into the act of painting, lose yourself so completely in the process that your responses are absolutely direct and immediate, without distractions. You must put yourself into a state of mind where you feel that the jab of your brush *is* the sea gull, that the downward stroke becomes the cliff itself, that the brush moves the paint as the sea itself moves. Gesture and subject are inseparable.

Accept the fact that your gestural treatment may sometimes get out of control. The solution? Do twenty more pictures and keep the best two. The more paintings you do, the more successes you can expect.

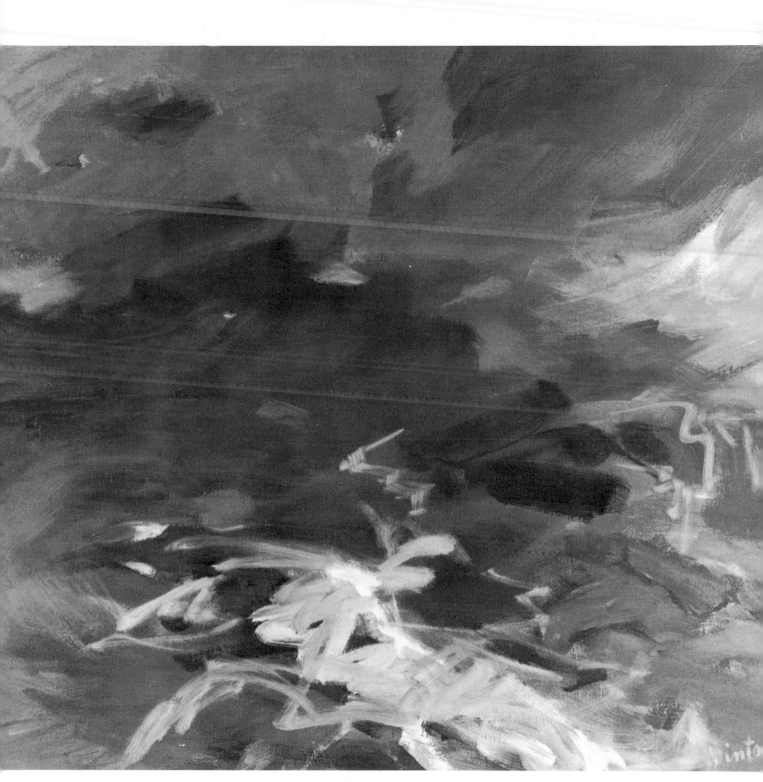

ROLLING SEA
by Denny Winters.
Oil on canvas, 34" × 40" (86 × 102 cm).
Collection of the artist.

Many of Denny Winters' paintings combine her love of the sea with her innate love of paint handling, translating elements of the Maine seacoast into painterly gestures. There is no horizon indicated in this painting. We are looking downward into the turbulent water, which is not rendered realistically but is dramatically expressed by the energetic, spontaneous movement of the brushstrokes. Part of the enjoyment in this picture comes from the artist's evident enthusiasm in applying a variety of brushy areas of color and pigment. Further enjoyment is derived from the immediacy of the pictorial statement, the unhesitating directness of her gestural treatment, which projects the essence of her sea imagery with an uncommon forcefulness and intensity. This is an excellent example of the inseparability of subject and gesture.

34. PHENOMENALISTIC TREATMENT

CONCEPT The phenomenalistic approach hinges on the painter keeping his hand and brush away from the picture in its developmental stages, allowing images to emerge and take form almost of their own accord. Using both the natural behavior of the medium itself and the effects of gravity as the paint flows freely when it is poured onto the surface or when the picture is tilted, the painter guides the fluid color washes and invites accidents that will suggest a composition that can turn out to be realistic, abstract, or nonobjective.

It is true that phenomenalistic techniques in both oil and acrylic and watercolor have been used by several contemporary painters such as Helen Frankenthaler or Paul Jenkins, both of whom have dealt with subjects pertaining to the sea. But these techniques are not as exclusively contemporary as we might think. I have in mind a 1786 treatise by Alexander Cozens, *A New Method of Assisting the Invention in Drawing Original Compositions of Landscape*, in which the great British watercolorist recommends using paint blots to produce accidental forms "from which ideas are presented to the mind." In order to obtain a large number of accidental shapes, he advises crumpling or folding the paper before blotting. "To sketch is to delineate ideas; blotting suggests them," Cozens wrote. Just how this method was received by the artists of his time is difficult to imagine, but perhaps his seemingly eccentric ideas were mitigated by the fact that he was using the method to develop conventionally realistic paintings.

In our own time, artists have used accidental, phenomenalistic techniques to free themselves of stale habits of traditional paint manipulation and to try for more interesting and unusual shapes, textures, and designs. Such techniques are especially appropriate for seascapes because of the fluid, watery effects that are the natural result of letting paint blend and flow by itself. The painter may occasionally guide or nudge the paint flow here and there, but the idea is to let the picture look as though it had formed itself with only a bare minimum of human interference or control. Some painters go to great lengths to remove anything from the picture that would appear to be conscious manipulation of shape or color. Others frankly use the phenomenalistic treatment primarily as a means of creating or suggesting sea or coastal forms, while feeling quite free to inject some realistic subject matter as a foil for the free-flowing color areas.

This is another instance of a technique that is of immense value in stimulating creativity, regardless of personal allegiances to realism or abstraction.

PLAN This technique is for those painters who are ardent risk-takers and intensely curious to see what evolves out of accidental methods. Although there is always a possibility that events will temporarily get out of control, continued experience and an accompanying sense of timing will eventually produce a creative state in which you can exert considerable control, more than might be thought. Your skillful use of controlled accident will allow for unexpected successes and lessen helpless dependence on pure chance.

If you are working with watercolor, it is best in the early stages to paint on an unstretched sheet of heavy paper, and the bigger, the better: double elephant size (26" × 40"—66 × 102 cm) allows plenty of room for the paint to flow. You'll have to experiment with pouring watercolor from a container onto dry sheets, wet sheets, and sheets that have been only partially moistened in random areas. Tilt the paper or curl up the edges, changing angles swiftly as you see where the paint is flowing. If you like what you see, promptly place the sheet on a flat surface and let it dry until you are ready to repeat the process with another color. As in more traditional watercolors, leave some white paper showing and always paint with lighter washes at the beginning, followed by middle tones and darks later. Very diluted acrylic paint can be used as a substitute for watercolor, as can some of the permanent, lightfast inks. As the painting nears completion, you may want to moisten the rear of the sheet and stretch it so that you can apply your final washes on a taut, flat surface.

In oil or acrylic on canvas, I again recommend that you start on an unstretched surface. Here, too, you must experiment to find ways to pour the paint down a groove of partially folded canvas or to drape the canvas on sticks of varying heights and pour on the paint from the outer edges, draining off excess paint in a pan or pail. Lay the canvas out flat to dry, and then repeat the process using the sticks rearranged in different positions or sticks of different heights. Work on canvas that is dry or that has been partially moistened with turpentine if you are using oils and with water if you are using acrylics. Much of the fun—and the challenge—of working this way is in using your powers of invention to discover ways to apply paint.

Above all, keep yourself alert to what is happening and seize the best accidents immediately as they occur. Nudge the flow where you need to, but try to consider yourself merely a guide for the phenomenonalistic events that take place in your painting. And by all means, use this treatment as a *supplement* to your painterly vocabulary—not as a total replacement for other standard techniques.

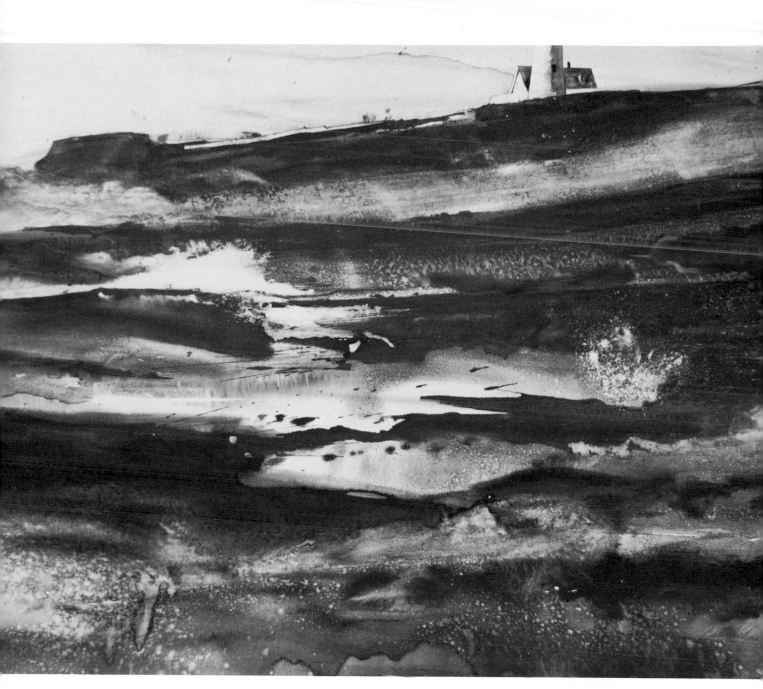

LONELY VIGIL
by Don Carmichael.
Watercolor on Strathmore High
Surface cold-press board.
30" × 40" (76 × 102 cm).

An inveterate explorer in the field of aquamedia techniques, Don Carmichael is willing to try anything and is always eager to see what will happen next. Although he lives in the Midwest, his imagery is predominantly related to coastal waters. Rather than treat the ocean in *Lonely Vigil* as a realistic depiction of waves and surf, Carmichael has used the phenomenalistic treatment to create the feeling of the ocean in a less literal way. He has flooded the surface with successive washes of rich color, saving some areas as whites to suggest waves and spray.

Other areas are subtly textured with spattered water or salt, and the darkest masses give depth and strength to his design. The flow method of applying paint was a most natural one for expressing in purely painterly terms the fluidity and splashiness of ocean waters striking the rocky shore. The lighthouse, casually inserted to give scale and meaning to the composition, is a very minor element. It is the major area of phenomenalistic handling of paint and color that is the real subject matter of this picture.

35. CALLIGRAPHIC TREATMENT

CONCEPT Calligraphic painting has always been associated with China, where painting and calligraphy were regarded as different aspects of the same art form. In fact, it has been clearly demonstrated that Chinese handwritten characters are basically simplifications—a sort of shorthand treatment—of forms in nature. This process of simplifying natural forms into handwritten forms is what calligraphic painting is all about, for calligraphic paintings appear to be written rather than painted. And it is particularly interesting to note that Chinese characters are written as though they are contained within an imaginary square—that is, the various strokes relate to the boundaries of that imaginary square in the same way that the calligraphic painter's gestural strokes relate to the edges of his paper or canvas.

The vitality of calligraphic painting, its asymmetrical design, and its sense of energy and movement, all combine into an expressive whole. Because the calligraphic treatment of a seascape or landscape requires spontaneity, speed, breadth, emotional drive, and an instinctual grasp of both nature and painting, gestures and sweeping brushstrokes that have the feeling of strength and abstract structure are of great importance. Strokes that are stiff and static or soft and flabby have no place in this sort of art. The brushstroke works the first time, or it doesn't work at all. There is neither room nor time for tidiness and precision. Instead, there are many instantaneous, intuitive judgments to be made about placing, spacing, pressure, movement, and meaning, all requiring absolute coordination of eye, hand, mind, and emotional response with the brush and paint.

Strokes are usually made in single, continuous motions that result in images characterized by immediacy, directness, and economy of means, as well as a sense of naturalness and inevitability. Calligraphic painting is not for the inexperienced, but in the right hands it can be a rich and forceful expression of natural forms and forces.

PLAN Calligraphic painting takes long, arduous practice and commitment on your part. If you are going to look to models on which to base your beginning exercises, you may as well go to the best sources: Oriental ink paintings. For starters, there are several books and catalogs I recommend highly, just to look at and to absorb the spirit of the calligraphic approach to painting. The two most directly concerned with the relation between calligraphy and painting are Wan-go Weng's *Chinese Painting* (Dover Publications, New York, 1978) and Chiang Yee's *Chinese Calligraphy* (Harvard University Press paperback, 1979). Two superb exhibition catalogs are the Seattle Art Museum's *Song of the Brush* (1979) and Sherman Lee's *The Colors of Ink* (Asia Society, New York, 1974). After that introduction, study the work of contemporaries who often work in the calligraphic mode, painters such as John Marin, Mark Tobey, William Kienbusch, Syd Solomon, and Cleve Gray.

Once you feel you have fully grasped the spirit of spontaneity, simplification, and the sureness behind each expressive brushstroke, go directly to nature for your inspiration. Use paper, ink or watercolor, and a brush, and do a series of black-and-white brush drawings from seashore subjects. (Your brush does not have to be a sumi brush; any good brush will do.) Study the forms of surf; capture the movement of an incoming wave, the masses of rocks and pines, storm clouds, cliff forms and sea caves, trees bending in the wind, foam washing around a rock. Then reduce them to "written" symbols that are brief, beautifully done, and above all, expressive. Quite aside from their relation to subject matter, the brushstrokes in their own right should be aesthetically satisfying as abstract gestures. It may sound easy, but it isn't. You must be completely involved in your subject and totally unconscious of technique, letting yourself function entirely on the level of instinct and intuition. Too much thinking, a moment's hesitation, and all could be lost.

Doing dozens of such drawings is not enough; I'm speaking of hundreds. After you have attained some skill in monochrome, start using color. It's another dimension, another concern to be dealt with and controlled, but it's worth the try to include color as a major aspect of your calligraphic experimentation.

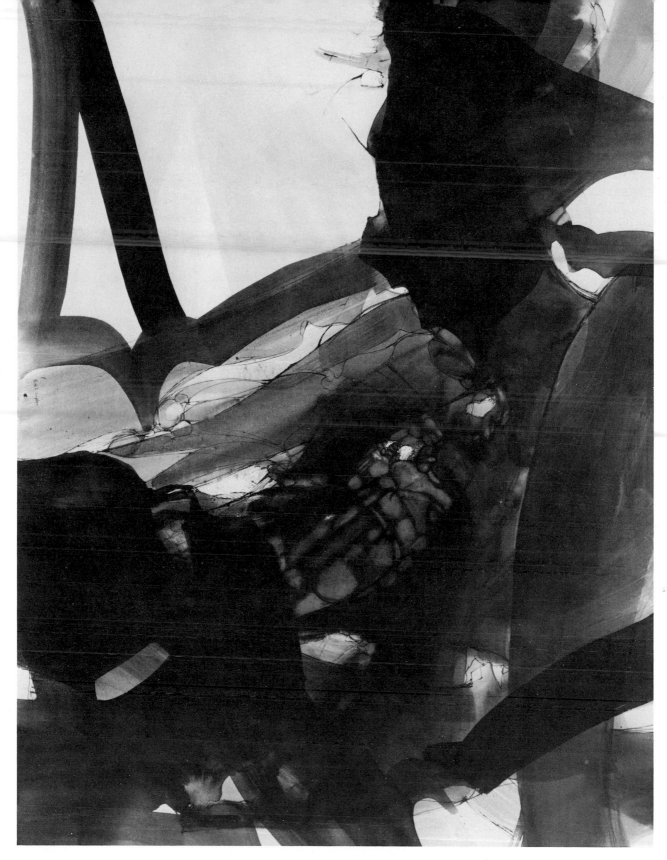

MALIBU SERIES:
SEEN THROUGH PIERS
by Ruth Snyder.
Watercolor on illustration board,
40" × 30" (102 × 76 cm).
Courtesy Landau-Alexander Gallery,
Los Angeles, California.

Ruth Snyder has painted near the Pacific Ocean for some time and feels totally involved, even addicted, to the ocean in all its varied aspects. Her freely swinging, wide brush pulls the viewer's eye along with its rapidly sweeping intuitive movements up, down, and across the picture surface. The spontaneous energy, the interplay of sharp and soft focus, the direct translation of ocean forms into broad brushstrokes and gestural activity, all contribute to the visual excitement here. The broad swaths of color and line are accented here and there by delicate, spidery lines that weave in and out of the picture space. Handled with a sense of confidence, breadth, and exuberance, the bold brushy treatment only implies or suggests marine forms. Thus it is not the subject but the brushstrokes that give the picture form and structure and that ultimately are appreciated as being the primary interest in the picture. Nature has served mainly as a springboard for the calligraphic style.

36. MASSES OPPOSED TO LINEAR RHYTHMS

CONCEPT One of the major contributions modern art has made to the art of today is its isolation of some of the basic elements of picture making—elements such as shape, pattern, texture, mass, line, color—permitting their open and frank use, both for their own sake and for expressive purposes. These basic elements are the "bricks and straw" of picture construction, and the contemporary painter often feels free to let them show in the final composition rather than hide or disguise them.

Traditional descriptive painting has also made use of these conventional, basic elements informing the understructure of the design. But in the finished work, those elements were more or less kept out of sight—the less obvious, the better. The dominant aim of traditional painters was a realistic description of visual appearances, and so the pictorial bricks and straw that gave a picture its fundamental sense of order and structure was subordinate to the picture's descriptive qualities.

Artists of our own time are more willing to emphasize structure and design, the means through which pictures are formed, and even to be quite bold about overtly displaying their use of line, calligraphy, delineation of planes, or the tensions set up by oppositions of shapes and masses to linear brushstrokes. A parallel in the field of architecture would be what was called "The New Brutalism," which frankly revealed the necessary parts of the building structure—pipes, ducts, concrete, and other rough materials—with no attempt to hide them or gloss over their presence. The building materials and structural elements were there to be perceived directly and honestly as an integral part of the look of the entire building.

In much the same way, many contemporary painters contrast bold shapes and masses against delicate linear tracery, using that opposition or contrast as part of the aesthetic satisfaction to be found in the picture. Working entirely in terms of large powerful masses is one excellent way of painting. To interpret natural rhythms and forms solely as a formalized linear arrangement can be extremely effective, too. But when both line and mass are intimately combined and interrelated on a single surface, then each complements and sets off the other, and together they can produce an image that is more visually satisfying than what either one could achieve on its own.

PLAN You will be dealing with two distinctly contrasting elements here: broad masses of value or color and rhythmic linear arrangements, either of which should be able to stand pretty well independently, but which you will ultimately bring together into a total, unified composition that is more rich and complex than either one could be if used separately. Imagine that you are planning a painting by using two transparent slides: one is all shapes and masses, the other side containing a wholly linear pattern. Now superimpose one slide over the other and view them combined into a single arrangement or image, an interweaving of line and mass.

The best way to get acquainted with this approach is to do some watercolor or gouache studies, about 12″ × 16″ (30 × 41 cm), on paper or board. Work monochromatically in a range of no more than three or four values, designing shapes and large masses that can be either fairly realistic or quite abstract. Now place a sheet of tracing paper over that design and create a linear pattern that is self-contained but that relates to the design underneath. The lines may be descriptive, defining a recognizable subject within the large shapes, or they may simply function as an abstract counterpoint to those underlying forms. (Avoid using lines merely to define or repeat the contours of the masses.)

After the linear design satisfies you, remove the tracing paper and freely draw those linear rhythms and arabesques right on top of your arrangement of masses. You can use black lines, if appropriate, but you might try other studies in which you employ colored lines such as red, bright blue, or white. The final design should not look like two separate conceptions; it should be wholly coordinated so that one seems inseparable from the other.

Now, omitting the tracing paper stage, try the same treatment using several colors. But don't use too many; if you do, the lines may become visually confusing and difficult to disentangle from the masses. Let your lines be black if you want, but again you should feel free to experiment with color oppositions, with lines whose colors vibrate or contrast against the underlying design.

Once you get the feel of this concept, apply it directly to seacoast material: surf forced between rocks; rocks and spray; swirling water patterns; a forest atop a promontory with white foam around the rocks at its base; the patterns of a single breaking wave. This concept can be used gesturally and expressively, or it can just as well be used in a more controlled, analytical, or decorative manner. The technique itself will inevitably stimulate your imagination to new and different possibilities. All you have to do is follow along and enjoy your discoveries.

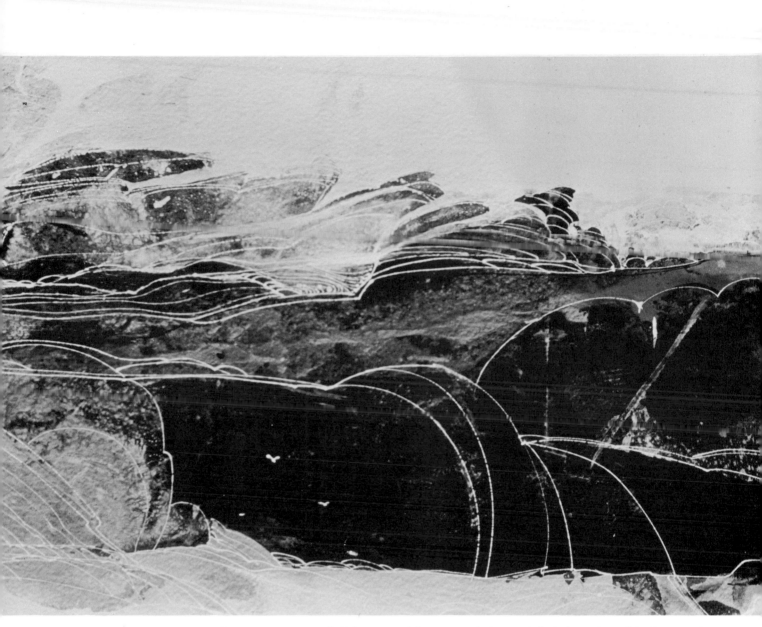

WRAPPED IN MIST *(detail)*
by Maxine Masterfield, A.W.S.
Watercolor on Morilla board,
40" × 42" (102 × 107 cm).

Since Maxine Masterfield is a compulsive explorer of media, methods, and ideas, her work is in a constant state of flux. *Wrapped in Mist* is one of a series she painted a short time ago in which she built her compositions out of oppositions of line and mass. The picture has been divided into three horizontal zones of misty sky, rocky coast, and churning white water. These divisions are large, simple masses that suggest a coastal environment, but they are further activated by her use of freely moving, white ink lines that sometimes define an edge or a change of plane but more often operate as

being partially independent of the forms and textures beneath them. The lines vary: some are large and open, referring to massive cliffs; others are dense, rhythmic repetitions that indicate the terrain above the cliffs or the rocks at water's edge; still others suggest the movement of surf. The deep color masses, the use of textures that are either rich and rugged or subtle and delicate, the vigorous, confident use of stylized linear patterns, all complement each other in a complex interplay and resolution of opposing elements.

37. TEXTURES AND SURFACES: OPAQUE MEDIA

CONCEPT When we speak of textures in painting, we are not thinking of textures that are rendered or described, as in early Dutch still lifes, but of the paint textures and surfaces that come from handling a particular painting medium; that is, the physical appearance of the paint application. The Old Masters were interested in variations of paint textures also, and their paint surfaces usually ranged from transparent paint in the deepest shadows to heavy, brushy impasto in the lightest lights. Later on, painters became fascinated with paint textures for their own sake or for expressive purposes. In Turner's work, these two functions existed simultaneously. His surfaces could be enjoyed equally for the richness of dragged, scumbled passages and glazed impasto or for the intense brilliance of light and vibrating color relationships that resulted from his heavy pigment.

In twentieth-century painting, texture often became as essential an ingredient to the look of a picture as shape, line, pattern, or color. There were many painters who were interested in achieving in each picture as varied a range of textures as possible through stains, flat layers, scumbles, spatters, glazes, impasto, sand mixed with paint, or resists, all of which were intended to make the painting surface a rich visual feast.

By the 1950s, an international school of painters had developed who more than ever before celebrated textures and surfaces as a major element in their work. The group included such painters as Tàpies, Bogaert, Hosiasson, Wagemaker, Levee, and Olitski. Ordinary paint impasto was not enough for them, and they took to using any inert fillers that would add a look of weight and substance to their heavily textured surfaces—fillers such as sand, coffee grounds, sawdust, or other exotic materials. Their pictures took on more the look of sculptural reliefs as they achieved the heaviest impasto surfaces to date.

Tactile effects such as the ones described can be successful purely as visual sensations, or better yet, they can be put to expressive use as close parallels of nature: the textures can be metaphors for rocky surfaces or encrustations; sandy beaches; flotsam and jetsam on the shore; stones and pebbles; or the crest of a breaking wave. The painting is no longer *about* the seashore, but the surface of the picture *is* shore and surf, thus creating an immediacy of contact with the viewer that cannot be rivaled by conventional descriptive techniques. The picture therefore becomes its own subject and not just a reference to that subject. By combining fluid-flow methods of paint application with various sculptural textures, the artist can come very close to making his picture almost a substitute for a vivid direct contact with nature itself.

PLAN One of the advantages of oil paints (or of acrylics used like oils) is the way they can be built up into thick impasto applications in the form of generous slabs and lumps of pigment. Even if you use oil gel or a quick-drying underpainting oil white, creating sculptural surfaces can be time-consuming and quite costly. So you may need to use inert fillers to give the paint far more body than it usually has and to add textural interest to the paint. Sand has been mixed with oils since the early days of Braque and Picasso, but there are other fillers you might try, such as small pebbles, bird seed, pine needles, or any of the others mentioned above. Whether some of these are really permanent and reliable when mixed with oil paint is still open to some question. So if you are interested in exploring textures and surfaces, perhaps you might do better to use acrylics.

Acrylics can be built up using acrylic gel or modeling paste, which is marble dust ground up in acrylic medium. (For extra heavy applications, you can avoid cracking by mixing the modeling paste about half and half with gel.) Or you can add sand or other inert fillers. Generally, acrylic impasto, combined with various fillers, seems to be considerably more stable and permanent than that of oil.

If you are working in oil it is better to work on a rigid support such as Masonite, since oils get brittle with age and do not adapt well to the expansion and contraction of canvas as it is affected by atmospheric conditions. Acrylic, being plastic, is flexible enough to move with the canvas. But if you wish, it, too, can be used on Masonite.

Don't be stingy. Slather the paint on generously with a large painting knife or a kitchen spatula. Create surfaces and see if they suggest seascape associations. Try combining thick and thin on the same surface, using fluid, transparent washes in opposition to impasto. Spray on color. Pour on color glazes and tilt the picture to let them flow. Use your textures expressively to call up tide-pool or beach imagery. Make your surfaces as subtle or dynamic as you please, but do be sure they are making a positive, functional contribution to the ideas contained in your painting.

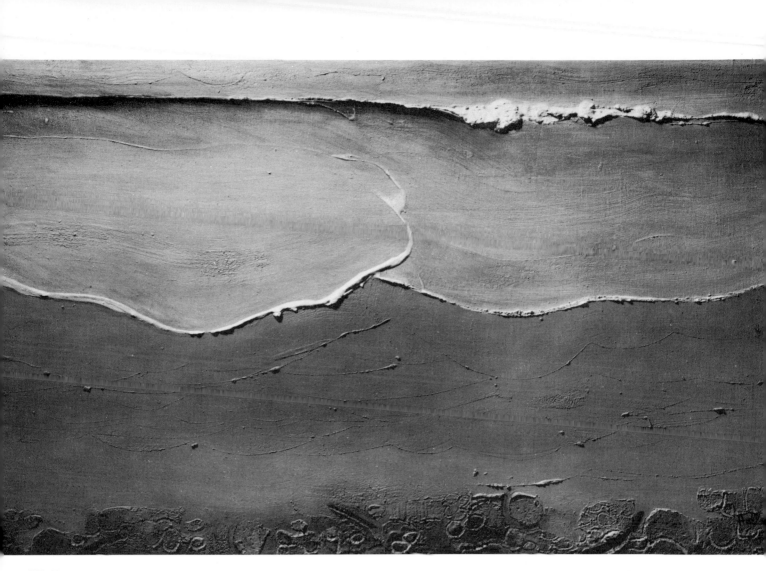

BEACH
by Beverly Hallam.
Acrylic and mica talc
on Belgian linen,
20" × 28" (51 × 71 cm).
Collection
Mr. and Mrs. Edward F. Dana,
Trundy Point, Maine.

Beverly Hallam has an established reputation as a leading experimenter in synthetic media. *Beach* was painted in a flat position, the stretched canvas being nailed to the studio floor. The surface was built up using mica talc mixed with an acrylic composed of polyvinyl acetate and Resoflex, a plasticizer that made it possible to achieve heavy impasto textures without cracking, while at the same time keeping the canvas light in weight. The textures were created by the use of several different spatulas, sponges, rags, and a whitewash brush. After drying, the textures were coated three times with white acrylic gesso and then glazed with various colors. When lights were needed, Hallam always sponged back to the original white undercoat; white pigment was never used. The result is a relief painting with a strong sense of weight and tactility that persuasively conveys the sensation of the actual beach itself. The broad, sweeping rhythms and the physical materiality of the surfaces and textures constitute more of a direct identification with the motif than a mere reference to it.

38. TEXTURES AND SURFACES: TRANSPARENT MEDIA

CONCEPT The transparent media—watercolor, inks, and acrylics used as transparent watercolor—have their own range of textures and surfaces. Textures used by watercolorists are somewhat more fluid, subtle, and transparent than those usually found in opaque oil techniques. In fact, any heavy impasto treatment of the water media would be entirely out of place and totally uncharacteristic, because the sense of body and weight or exaggeratedly heavy paint is antagonistic to all the special qualities associated with the aqueous media.

There are still a great many watercolorists, both traditional and modern, who confine themselves strictly to direct washes, using only a minimum of textural differentiation in their paintings. At the other extreme, there are painters who throw in such a wealth of textured surfaces that it is often difficult to locate the image and grasp what the picture is really about. Somewhere in between these extremes are the painters who know all the technical tricks of creating textures, but instead of displaying the full range of their knowledge throughout each picture, they hold it in reserve for the times when texture is needed for expressive reasons or visual variety. In the long run, a painting with little or no emphasis on texture may well be better than one in which textures were used too liberally and thoughtlessly.

The basic textural resources of watercolor are wet-in-wet, drybrush, blotting, lifting, scraping, spatter, and the use of various resists. Contemporary watercolorists have experimented with a number of other devices and substances to create textural interest. Probably the most common of these is the use of salt to achieve dappled or mottled effects. If there is ever a salt shortage in this country, it will undoubtedly be caused by the popularity of salt as the watercolorist's favorite plaything.

But there are other methods of achieving textures: using soap, denatured alcohol, starch, squeegees, stampings with cardboard strips or corrugated cardboard, creasing and crumpling the sheet before painting—the list is seemingly endless. As perhaps it should be, since it is important for us to extend the possibilities of a medium, not to limit them artificially or arbitrarily. Exploitation of texture is only one of several elements in a painting, and it should be subservient to shape, pattern, color, space, and design. It should be supplementary seasoning, not the main ingredient.

Texture can be used for ornamental or decorative purposes or for descriptive or expressive purposes, but just as with the opaque media, it should above all serve some definite pictorial purpose and not be tossed in simply as a demonstration of an encyclopedic knowledge of aqueous techniques.

PLAN By all means explore texture as a way of adding visual richness and variety to your watercolor surfaces. Go through some books on watercolor and make a list of all the different ways to create textures. Then set aside a day to become familiar with them and perhaps even develop a few of your own. Don't wonder what such-and-such a technique would do in combination with watercolor, but try it out and see what happens! Even if it doesn't work, you've learned something.

Now examine all your textural examples and decide which ones are most appropriate to expressing aspects of the coastal environment. Perhaps a random white tissue-paper collage applied before painting will, when glazed with blues and greens, evoke a feeling of waves and surf. Maybe lifting color out with a sponge will remind you of rocks and sea. Dark color applied with a brayer might look like massive cliffs, or scattered salt in wet paint might relate to sea foam or a sandy beach. Store all these possibilities in your mind so that when a certain situation arises in your seascape, you will remember the technical means of achieving specific effects and can put them to immediate use.

If you have areas in a painting that seem too flat or uneventful, use textures to activate them: spatter with clear water and then blot; spray on color with a fixative blower or spray bottle; spatter and fling on paint; scrape off color with the broad side of a single-edged razor blade. Use any resource you can think of to sustain interest throughout the picture surface.

If you are in a daring mood, dispense with any kind of preconceived subject matter and start a watercolor painting with a number of different textures and surfaces: intentional back runs of color, wet-in-wet, salt, spatter, washing off color under a faucet. Then let the random textures suggest a seascape, a storm, a sea cave or a tide pool. Once you have identified the image, you can develop the painting more consciously and with more control over its destiny.

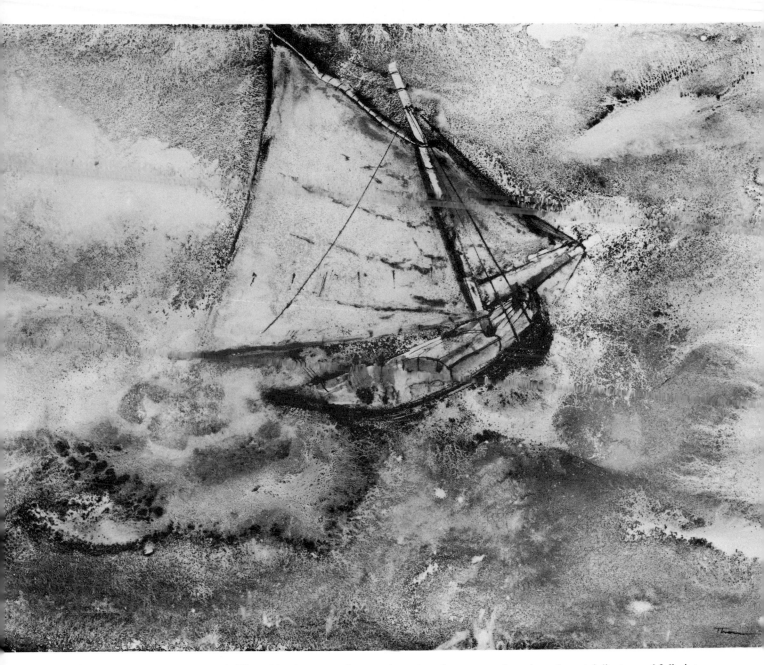

SUN AND FOG
by William Thon, N.A., A.W.S.
Watercolor on paper,
20½" × 27" (52 × 69 cm).
Courtesy Midtown Galleries,
New York City.

William Thon's watercolors can be enjoyed as much for their rich and varied textural surfaces as for their subject matter. In the early stages, working with his paper temporarily submerged in about an eighth of an inch of water, Thon let the colors mix in the water and settle onto the paper, thus creating some textures by capitalizing on the granulation and sedimentation properties of watercolors and inks. His textures here are used to suggest the flowing, splashing sea, spray, foam, and fog. The surfaces are largely what the picture is all about, yet they are unobtrusive, almost delicate, and fully integrated into the total composition. Thon is obviously more interested in their expressive function than in manipulating them for their own sake. Starting with a simple subject, Thon has produced a visual experience partly by allowing his medium to create its own natural textures, which also happen to be equivalent to textures associated with the sea. Interest has been sustained throughout every inch of the surface by his controlled use of textural treatment.

39. OCEAN DYNAMICS: REALISTIC

CONCEPT Many painters have dealt with the motion and energy of the sea, most often by emphasizing the picturesqueness of white surf crashing against coastal rocks and cliffs. Although nature's forces can be used as a source for very routine seascapes, they also can be used as Turner perceived them—as forces that could be interpreted in terms of painterly dynamics. Turner developed a visual vocabulary that was equivalent—or parallel—to the elemental forces of nature itself. In so doing, he went far beyond surface appearances to get at the structure, energy, and truly universal essences of the sea.

On an immense scale, Turner's heroic sweeping rhythms of clouds, air, spray, and snowstorms at sea and the sense of stress, flow, resistance, and violence he portrayed captured the dynamics of the ocean—not just as grand drama but as a deeply moving inner experience. It was through Turner's art that the dynamics of nature and the dynamics of a painting style had finally been unified.

Much the same situation resulted when Marsden Hartley returned to his native state of Maine and did a memorable series of seascapes that were based on a form of starkly simplified realism. But here again the style became inseparable from the elemental forms to which Hartley was attracted: the harsh, rugged masses of dark rock dramatically opposed to walls of white water that had as much weight and substance as rocks and cliffs. Hartley's painting style was also harsh, brutal, moody, and mystically elemental, communicating with a directness and intensity that was possible only because he had found a way to achieve a close identification of his personal stylistic dynamics with the dynamics of coastal waters.

Both painters dealt with primal forces, and each felt and interpreted them in a purely individual fashion. In dealing with their subjects, they were both fundamentally realists who had been brought to the edge of abstraction by their intense personal identification with nature's forces. It is when these forces find a direct equivalent in paint—even in realistic styles—that a pictorial experience acquires an added dimension that places it on a higher level than simple picturesque description.

PLAN Your aim here is to find a way, within the mode of realism, to make your study and knowledge of the dynamic forces of the ocean coincide closely with a painting style. Obviously, this is not something that can be developed or arrived at overnight. It will take you years of observation and thought and years of painting. If you are lucky, you might bring it all together in a more compressed time period, but don't depend on it.

Do a great deal of on-location sketching and painting and a lot of intense observation of ocean activity. You will be looking not for the pretty or the picturesque but for elemental relationships, the most basic forces of nature. Press beyond graceful or dramatic patterns: learn the *structure* of splashing surf, waves, and sea foam. You should be digging for something deeper than the surface appearance of the ocean.

If possible, try to arrive at a painting style that reflects or parallels what you have already observed and felt about the ocean: the impact of water against rock; drifting, surging aquatic rhythms; the turbulence of surf; the sense of spray, foam, spindrift, splash, energy, and resistance. Paint in a generally realistic style, but don't take the easy way. Make it a realism that has a certain power and intensity both of vision and emotion. Make your painting method as close to nature's own processes of growth, change, and interaction of forces as you can.

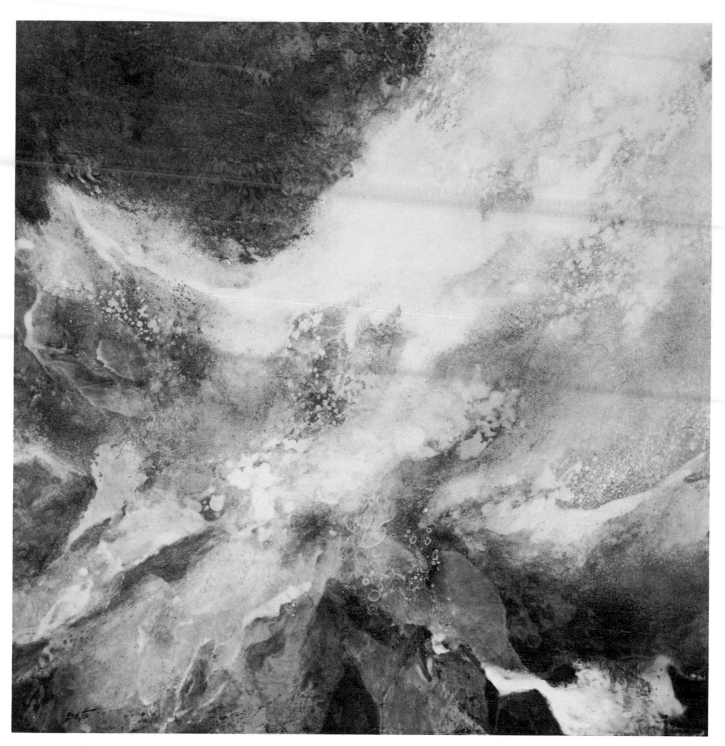

SEA SPRAY

by Edward Betts, N.A., A.W.S.
Acrylic on board,
29" × 29" (74 × 74 cm).
Collection Tupperware International,
Orlando, Florida.
Photo courtesy Midtown Galleries,
New York City.

This painting grew out of the complex interaction of several swinging arcs and opposing diagonal movements, and the only defined edges were reserved for the partially submerged rocky reef at the bottom edge. The principal concern here was to search out and reveal the structure underlying such hazy, indefinite forms and substances as splash, spray, foam, and bubbles. Along with that, I tried to develop several different layers of depth within the picture space, from the dark, watery mass at upper left, to the large mass of white foam and spray, then to the churning, flowing water and rivulets, down to the rock form's nearest the picture plane. A variety of techniques were used to obtain aquatic textures and movement: tilting the panel to let the paint actually drift and flow, spatter, spray, glazing, and stipple. These natural, often accidental processes were used as an equivalent of ocean dynamics, but in a generally realistic treatment. Although I actually painted *Sea Spray* on a very modest scale, I hope I achieved the sense of enormous spaces and violent forces.

40. OCEAN DYNAMICS: ABSTRACT

CONCEPT The dynamics of the ocean lend themselves readily to an abstract treatment, which intensifies an image in terms of expressive gesture and design. This means departing from realistic description to translate nature into an abstract world of line, shape, pattern, color, and texture. Nature always remains the source, however, no matter how abstract the final painting might be.

One of America's major abstract seascape painters was John Marin. It is worth remembering that Marin never let anyone forget that he was far less interested in ''Art'' than he was in a painter's response to subject matter. Marin was deeply concerned with realizing in paint his direct personal involvement with nature's forces, insisting that ''it's for the artist to make a paint wave breaking on a paint shore.'' Marin was intensely conscious of ocean dynamics, which he once expressed as being forces that pushed or pulled upward, downward, and sideways. In fact, in 1947 he decided to call his then-recent series of paintings ''Movement in Paint.'' Although still couched in his own version of cubism, these paintings were primarily experiences in paint above all else. In them, he used the motion or action of his paint surfaces to express the sense of movement in the sea: the heaving water, the weight, the movement of air and water, the flow, the clash of diagonals, and the evocation of deep forces not apparent to the eye.

Marin dealt with ocean dynamics as a gestural, and later as a calligraphic, painter, but there are a number of other ways to apply an abstract language to those same forces, ways as varied as those used by such painters as Balcomb Greene (pages 67, 95, 135), Edward Betts (pages 47, 63, 89, 109, 126, 138), Richard Gorman Powers (pages 107, 115), Don Carmichael (pages 79, 120), Reuben Tam (pages 43, 143), Maxine Masterfield (pages 83, 91, 118), and Ruth Snyder (pages 81, 132). In contrast to painters who habitually deal with specific geographical locales on the East or West Coasts, these artists, whatever their original sources, choose to deal with elemental oceanic forces in terms of abstract imagery that is universal rather than local. To put it another way, in their art the local has been translated into the universal. They have used the visible world of the sea as a parallel to their individual inner visions, which are brought into being through the dynamics of their various painting styles.

PLAN You might at first consider it worthwhile to study the work of many of the seascapists reproduced in this book; however, I feel strongly that a better way to develop an abstract approach to ocean dynamics is not through the study of paintings but through profound, prolonged study of the sea itself. Expose yourself as frequently as possible to direct contact with the movement and energy of ocean forces. Watch the ocean from the land for hours on end, but also observe it from a boat. I wouldn't recommend it to everyone, but a transatlantic crossing by ship in mid-January is one way to acquire some pretty vivid and memorable impressions of the ocean in some of its most emotionally moving and awesome aspects.

Your impressions and inner responses should be stored and accumulated continually during the time you are building an abstract painting style. Then, at some point, when you feel a particularly strong sensation needs to be evoked, attack the idea of capturing ocean dynamics with all your intensity and vehemence, using abstraction to communicate your deepest personal experiences of the sea. Be bold, exuberant, and uninhibited. Lose yourself in the power of your subject matter, and don't worry about whether the picture is coming out exactly as you had expected it. Keep on exploring and trying out new ways and different versions. The main thing is to get at essences.

Keep a file of hundreds of sketches of the ocean in movement, and through them try to uncover its abstract structure. Later, in the studio, you can either work freely from the information and emotional qualities contained in those drawings, or you can begin a picture with improvisational color and shape, referring to your sketches for suggestions as to how you might develop in your composition a powerful sense of natural forces at work.

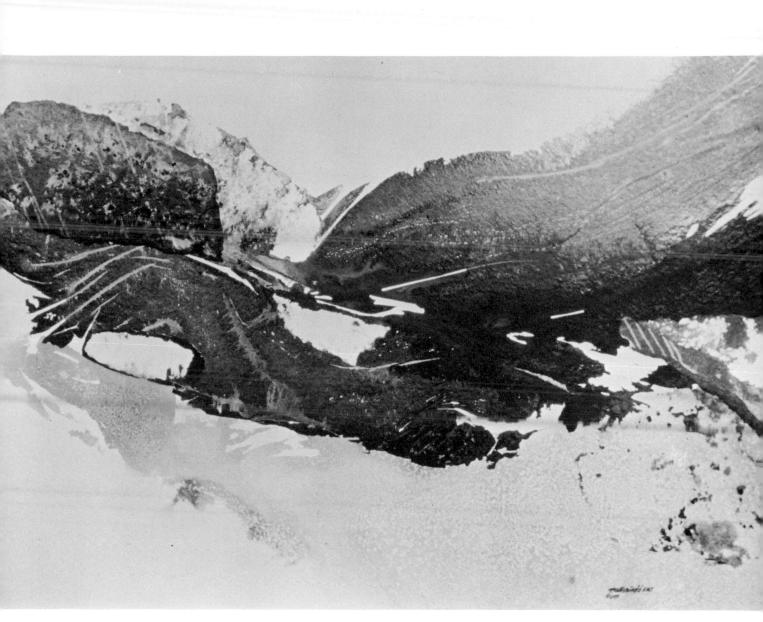

WAVES
by Maxine Masterfield, A.W.S.
Watercolor on Morilla board,
35" × 38" (89 × 97 cm).
Private collection.

Maxine Masterfield's treatment of *Waves* is as spirited and abandoned as the unleashed forces to which this painting refers. These are not realistic waves but rather the feeling of waves seen in terms of shape, color, and texture, an abstract arrangement that suggests the surge, flow, and splash of masses of water. Yet this is a more direct and intensified experience than is possible with accurate but conventional realistic description. Her ultimate reality is not the reality of nature but the reality of paint and textured surfaces. Masterfield's method is partly based on the use of phenomenalistic handling of the water and color in a manner contrived to look as though it had almost formed itself without benefit of human guidance—a quality that strongly reflects nature's own forces and processes. Her picture waves are an equivalent to real waves, revealing powerful ocean movement in a purely abstract language, yet this experience in paint could not have been initiated without being preceded by a necessary encounter with reality.

41. DESIGNING SKIES

CONCEPT Any painter who has studied the sea for any length of time comes to realize the interdependence of sea and sky. The sky is the source of light and as such is bound to affect the appearance of the sea. Similarly, the ocean is a reflective surface that echos the light and color of the sky. Constable painted innumerable studies of skies and clouds, even going so far as to note the date, time of day, and weather conditions on the reverse side of each study. Turner was equally interested in skies, but because he was less interested in documentation, he used skies more for atmosphere and drama. In much the same way, American painters such as Fitz Hugh Lane, Albert Bierstadt, and Frederick Church were fascinated with the ever-changing forms and light of skies and often made them the major element in their seascape and landscape compositions.

Today we put far less emphasis on the sublimity of skies than nineteenth-century painters but at the same time we continue to use skies for their many pictorial possibilities. Obviously, a sky can indeed serve as minor a function as merely a simple and undistracting background. Some painters, however, make the sky the dominant area in a picture, according it as much as 90 percent of the picture surface, since they are aware that in a seascape the sea is not necessarily always the most important element. The sea is there, of course, but it does not necessarily demand our undivided attention.

Storm clouds and turbulent skies have always appealed to the Romantic painters for their capacity to evoke various moods and provide dramatic settings for seascapes. But a clear sky in flat color can often be used as an effective foil for active or complex forms in sea and shore. Conversely, if the foreground is simple and empty, an active, agitated sky can inject considerable visual interest to the composition as a whole.

If a sky seems lacking in interest or is not contributing its fair share to the look of the picture, it can be made more interesting by the introduction of more intense color, color contrast, or broken color or by means of loose brushwork or more liberal use of painterly textures. Various cloud forms can help to break up the sky, too, or, in a less realistic context, clouds can become a source of designed forms that are consciously shaped or simplified to stress the sense of structure and pattern in nature.

Some semiabstract painters will extend land, sea, or architectural forms upward into the sky as transparent intersecting and overlapping planes that are common to both the sky and the land or sea. In this way both elements mingle, establishing a continuity in the total design of the picture surface.

In short, a sky can remain just a sky or, used wisely, it can be a very active contributor to the picture in terms of expressiveness and design.

PLAN In most instances it is fairly apparent how the sky should relate to the rest of the seascape, but occasionally you should take time to give skies extra consideration. Determine if there are other ways than the most obvious ones to utilize the sky more interestingly or effectively. Try several thumbnail sketches that will explore how much sky will be used, where the horizon will be placed, and how much foreground interest is necessary. How much sea does the picture actually require? How can you adjust the proportion of sky to sea less predictably?

How much activity does the sky seem to need? A very complex foreground simply does not need a busy, hyperactive sky. The general rule here is that a simple sky is the best setting when the foreground is filled with complex forms and patterns; but when the foreground is somewhat barren, then perhaps the sky should be activated by means of contrast, color, or texture to enable it to carry the major interest in the composition.

Paint some small studies to try out other alternatives. Treat the sky not just as you saw it but change its colors or values. Imagine that sky in different seasons; on a clear day; or before, during, and after a rainshower. Paint the sky as an exercise in studying light and brilliance. Invent your own colors for the sky, and see what its various colors suggest to you as you select unexpected colors in land and sea areas.

Design the sky. Break it up into planes and surfaces. Simplify or distort cloud forms until their configurations are no longer realistic but take on an abstract quality. Extend elements from the foreground up into the sky, breaking it up into planes and shafts of color in the manner of Demuth, Sheeler, or Feininger. One caution here: don't let those planes contrast too much, but keep them fairly close in value and color. If you contrast them too much they will destroy the readability and unity of the sky as an area. Work for subtlety and understatement without losing design quality. One nice thing about the sky—it's more or less abstract to begin with.

Treat skies creatively. They can be just as much of a painterly resource as the principal seascape elements of water, rocks, and shore.

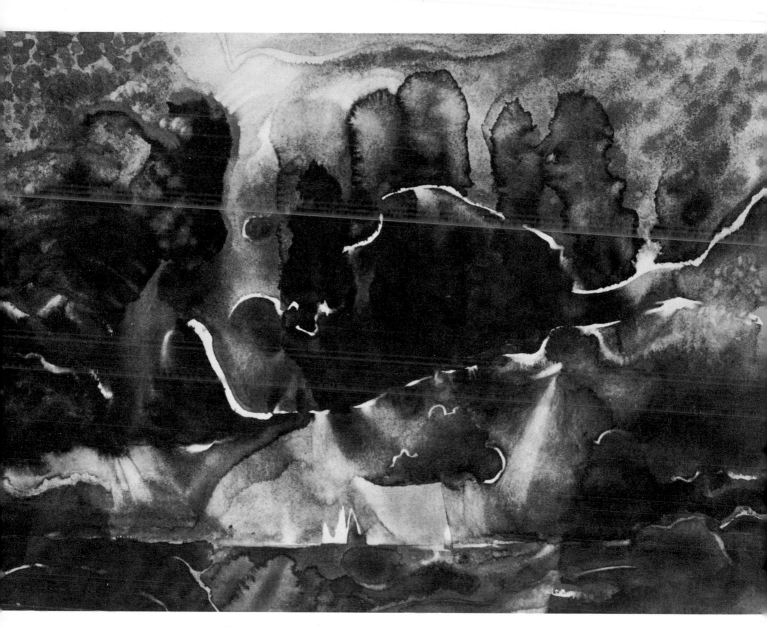

SOUTH JETTY/SUN LINES
by Miles Batt, A.W.S.
Watercolor on 140-lb rough paper,
21" × 29" (53 × 74 cm).
Private collection.

The ocean being kept relatively subdued, the real excitement in this painting lies in the spirited treatment of the sky. Batt has used shafts of sunlight breaking through clouds and strong light defining the edges of cloud formations to achieve a dramatic patterning of massed darks accented with bright lights. Batt has also encouraged the natural and partly accidental behavior of the watercolor medium itself to help create shapes, stains, blots, and textures that suggest overwhelming clouds vividly and imaginatively. This is not meant to be a real sky, but a *watercolor* sky, handled with breadth, verve, and richly saturated washes of color that produce a painterly experience rather than a meteorological document. The small scale of the sailboats at the horizon is our clue to the scale of the spacious areas of sky—a sky interpreted not as background but as the major interest in the composition.

42. USING FIGURES

CONCEPT Some seascape painters prefer to eliminate the human figure from their paintings because they feel, with some justification, that it might distract from the purity or universality of their view of nature and natural forces. It may also make it too easy for viewers to respond to the painting as illustrations—seeing stories in them—or as too sentimental. They have good reason to be wary. If the element of human interest is not handled well, it can lead to anecdotal painting of the worst sort.

Just as many tourists dutifully include family members or friends in their snapshots to "give a sense of scale" to the scene, so many painters have used figures in their paintings for exactly the same purpose. A few tiny figures can convey a sense of immense scale and open spaces. The figures need not be very specific or even identifiable—just dots or strokes of paint—but they serve a very legitimate function in creating the sense of scale without being unduly distracting.

Lyonel Feininger, for example, places small abstract or stylized figures in some of his shore scenes to add a human presence to them and to suggest vast areas of sea and shore and of sky and dunes. Other painters, such as Milton Avery and Robert E. Wood, see the figure as being equal in importance to the beach environment, with neither element particularly dominant. Avery uses the figure as a basic pictorial element for color, flat shapes, and patterns much as he would use water, sand, dune, and beach towel. Wood paints the figure as a natural form bathed in very strong sunlight, but he never allows it to lapse into illustration. Instead, he emphasizes light, brilliance, color, edges, transitions, and luminous shadows, all of which closely link the figure to its immediate surroundings and the sea beyond.

Another treatment of the figure in the seascape is that used by William Brice (in an earlier period of his work) and Balcomb Greene. Both artists envision figure and shore as ambiguous and interchangeable. The two elements melt, mingle, blend, appear, disappear, and reappear in a sort of now-you-see-it, now-you-don't magical illusion. In their work figures and environment are not just closely linked; they are literally inseparable.

Finally, David Levine paints crowds of beach figures, usually with a gentle, kindly satirical point of view that approaches something like a collaboration of Honoré Daumier's caricatures and Reginald Marsh's Coney Island scenes. Levine has also produced a striking series of watercolor studies of monolithic, matriarchal figures in wide-brimmed, floppy hats and bundled in wraps to keep out the sun. In those studies the beach figure is the sole interest in the picture and completely fills the composition, but the figure stops short of being anecdotal because of its monumentality, as well as the virtuoso handling of the watercolor medium.

PLAN If you're going to use figures in your seascapes, then you need considerable previous experience in figure drawing and painting as well as in seascapes. However, I would strongly recommend that you rely on your own research material—sketches, studies, or snapshots—rather than on trying to invent your own figures and poses. Even if you've had a thorough course in constructive anatomy and can draw the figure convincingly in any pose you might imagine, there is still no substitute for filling many sketchbooks with figure sketches done at the beach, around harbor and wharf areas, in boatyards, and among large rocks at the shore. Later, you can combine elements from several different drawings and sources into your own compositional arrangements.

Before you add a figure to a seascape, however, you must know why you wish to include one and what your attitude toward it will be. For example, do you plan to have human forms play a major or minor role in the painting, or will there be a more or less equal balance between figure and sea imagery? You should also know how the figure is to function in the painting. Is it to be used for scale, design, tapestried figure patterns, expressive distortion, social comment, or romantic statement of seaside solitude? Your attitudes must all be clear to you before you begin the painting.

Once you have worked out your composition, it is important to integrate the figure or figures with the seascape forms. All too often figures appear to be pasted onto a shore scene and thus not really a part of it. For example, the light sources on beach and figure might be coming from different directions, or the figures might be painted in a style or range of color that differs from the rest of the picture. Whether your treatment is realistic or abstract, figure and environment must be consistent with each other. If you plan an abstract treatment, get all the practice you can in stylizing figures or analyzing figure structure in terms of cubism or flat color patterns.

And don't forget to take advantage of props like colorful umbrellas, beach chairs, beach blankets, and towels or the jumble of fishing gear, nets, rigging, pilings, and signs around a harbor. Use these imaginatively for their color, design or decorative qualities to create an unusual or arresting environment for your figure subjects.

THE BEACH NEAR ST. TROPEZ
by Balcomb Greene.
Oil on canvas,
60¾″ × 48¾″ (154 × 124 cm).
Collection of the artist.

Balcomb Greene's art is invariably one of suggestion and ambiguity rather than direct statement. This is a typical example of Greene's urge to unify the figure and its environment, a unification achieved primarily by the use of lost edges that allow one form to melt and blend into another in a way that suggests the effect of superimposed or overlapping transparent images. This sets up tensions between forms that are clear and those that are blurred and between what is seen and what is hidden. Underlying the composition is a strong horizontal-vertical structure that sets off the horizon, ocean, and beach against the verticals of figure and poles. It is the artist's concern with the interplays of organic and geometric forms, solidity and transparency, lights and darks, lost and found edges that makes the painting such a rich, varied, and complex visual experience.

43. ORGANIZED CONFUSION

CONCEPT It is a truism that the artist's job is to bring order out of chaos, which is usually achieved through a standard process of selection, simplification, and design. There are times, however, when the character of the subject is that of an exceptionally complex arrangement made up of a great many forms, and to simplify it would be to lose a sense of that character. In that case, where confusion is a basic aspect of the subject, the artist must retain the effect of disorder yet at the same time exert enough control to make the picture readable as an ordered kind of chaos.

In a situation of that sort, the function of the artist is similar to that of a symphony conductor who must organize many forces and sounds into a performance that can be assimilated by the audience. An overriding sense of order can be brought to even the most confusing marine subjects, but it will require the artist's sharpest powers of organization and orchestration to integrate not only the forms themselves but also the light and dark pattern and the colors. If any one of those three were not sufficiently organized, the painting could become a visual mishmash. This puts an extra burden on the painter, since the kind of order necessary to the average compositional situation is even more crucial here.

This problem does not arise too often in seascapes, and of course an artist can simply look away if he finds a subject too busy and confusing and doesn't feel up to dealing with it. Nevertheless, there are occasions when a painter responds to the complexity of geometric forms and the bustle of activity in a boat yard, whirling patterns of flying gulls against sky and cliffs, boats moored in a harbor, and crowds at a beach, or to the jumble of fishing gear, masts, pilings, ramps, boardwalks, ladders, shacks, signs, and people at a marina. At such times the painter is challenged to catch the essence of the scene without allowing his painting to become as chaotic as the scene itself.

There are a number of artists whose work often reflects the complexities of harbor or beach, and their paintings are worth studying: Turner, Boudin, Kokoschka, Bellows, Maurice Prendergast, Phil Dike, Rex Brandt, Dong Kingman, Frank Webb, Robert E. Wood, and David Levine. The complexity of their subjects is frequently expressed more by suggestion than by detailed enumeration of multiple elements, but it is worth noting that beneath all of their imagery is the sense of formal structure that separates a work of art from the messy confusion of reality.

PLAN Don't be dismayed by the confusion of complex subjects. Take it on as a problem to be solved and see what you can make of it. There certainly has to be some degree of selectivity and simplification, but after that phase the subject should be broken down into its principal masses. Ask yourself, details aside, where those masses, the biggest forms, and areas are? If you can put some order into the underlying arrangement of large shapes and masses, then the details can easily be fitted into them. No matter how busy or elaborate the details and accents may be, they should keep their place within those masses. If the major areas are well designed, the details should not prove to be unduly distracting to the readability of the total surface.

To organize a chaotic scene, you should mentally eliminate all details in your preparatory studies. Begin by doing a series of small compositional studies in three values, just to arrive at the basic structure and patterning of your design. Once you are satisfied with the values, do similar studies, adding color as an element: a major or dominant color, two or three subordinate colors, and perhaps one or two color accents.

Now do a slightly larger study in color and value, but this time indicate how details and textures are to be included within the various masses, making sure that the overall effect of your design is not fragmented by the presence of details. The study should be orderly and readable, although the first impression of it would be that of a wild jumble of many elements. The readability is maintained by the order of its underlying design structure.

I believe that doing several informal preliminary studies is an absolutely essential start for someone who is unaccustomed to orchestrating many disparate elements and to interrelating shape, pattern, and color. Later on you may find that you can take care of most of your organizing in your first on-location sketches, which will leave you freer to improvise in paint, to follow up suggestions provided by various accidental effects, and to create your complex composition more loosely and imaginatively. But you must not forget that the big things come first, and, accordingly, you should set up the general arrangement and prepare the way for the introduction of minor areas and details as the picture takes form. You can't begin a painting based on a multiplicity of aimless detail. You must wait patiently and drop in the details like fried eggs when the surface is ready for them.

A sense of unobtrusive order and abstract design is the secret here, and if you have that you will have no trouble organizing confusion into a more orderly experience.

BLACK WHARF I
by Robert E. Wood, A.N.A., A.W.S.
Watercolor on paper,
22" × 30" (56 × 76 cm).

Robert E. Wood's wharf paintings have had a special niche in his total output over the years. Since he regards factual information as being secondary to bold design and spatial relationships, Wood uses a wharf purely as a vehicle for exploring an unlimited variety of forms, patterns, textures, and spaces. His subject is so much a part of him that he is free to change, invent, and reorganize with imagination and playfulness so that no two of these compositions are quite alike. He has an unerring sense of where to place his middle tones and darks, which comprise the real drama and structure of

his paintings. The architectural forms here are massed together as the major area, with figures, rowboat, steps, and pilings serving as subordinate areas. Although there was an overall planning that preceded the execution of this painting, Wood obviously kept the development of the picture open to spontaneous decisions resulting from his responses to what was happening on the paper. He has caught the flavor of complexity and confusion while containing it within a structured but uninsistent abstract design.

44. LOW-TIDE FORMS

CONCEPT The mention of seascape usually brings to mind turbulent seas, splashing foam, and dark, wet rocks. Indeed, that type of seascape is most popular, but a painter who genuinely loves the sea and studies it in all its manifestations sooner or later comes to realize that one of the most fascinating and rewarding aspects of the sea is during the absence of most or all of the water—that is, when the tide is out.

Low tide provides a refreshing change of pace from the color, moods, and treatment of the standard seascape. For one thing, without surf there is a lack of activity: no splashing, no foam, no turbulence, no conflict of forces. Then, although low-tide forms may not be exciting in the obvious ways, they often have other qualities that are equally or more satisfying, such as a mood of serenity and calm. Also, the seascape at low tide is made up mainly of horizontals, offering a change of pace from the customary diagonals of the more active seascape (although the artist may wish to introduce a few slightly slanted diagonals into the composition in order to prevent the design from becoming too static).

When the water recedes from the shore, new forms are revealed: rocks and wharf pilings are uncovered, sandbars of various shapes and patterns appear, shallow channels and pools are left among the beach formations, and tidal flats stretch into the distance. All of these constitute a whole new world of forms not ordinarily visible that are just as intrinsic a part of sea imagery as waves and surf.

Other elements, smaller in scale, also come into view at low tide: shells, seaweed, stones, pebbles, scraps of fishing gear, flotsam and jetsam, patterns in the sand left by the outgoing water, or fragments of an old wreck. These, too, provide the painter with a wealth of coastal forms that again are not the kind of material usually depicted in seascapes. It is a sort of seascape/landscape world that is neither wholly one nor the other.

In fact, this blending of seascape with landscape, where tidal sand flats, mud flats, sandbars, and beaches combine with watery areas, is a world that is less frequently painted by some artists only because, for some reason, they feel committed to more conventional seascape material. Actually, there is a long history of paintings of low tide that includes various pictures by Constable, Cox, Turner, Bonington, Fitz Hugh Lane, Whistler, Maurice Prendergast, Russell Flint, Edouard Vuillard, Eliot O'Hara, Leonid, Julian Levi, Walter Steumpfig, Lawrence Calcagno, Carl Morris, and John Laurent. And that is undoubtedly only the beginning of a list of fine painters who have found a strong attraction to the forms and patterns revealed by low-tide conditions. Although most of those painters work realistically, others paint more abstractly and all of them have something worthwhile to offer in the way of a personal response to this particular aspect of seascape.

PLAN Broaden the range of your seascapes by walking and studying the shore at low tide. It is even quite possible that you will find yourself responding more to the varied and interesting forms seen at low tide than to the dramatic effects of surf at high tide. Aside from the seashore, be sure to seek out inlets that are close to the ocean. They, too, are affected by tides, and quite often you will find rowboats, sailboats, dories, and even larger craft moored out in the midst of broad sand flats or mud flats, their forms reflected in puddles, pools, or rivulets. Or you will discover the intriguing configurations of sandbars and occasional tall-standing groups of rotted pilings left from a wharf or bridge long since washed away.

Because it is low tide, the sand is wet and darker in color and value than the dry sand of the beaches, presenting you with richer colors than you might ordinarily see at the shore: deep tans, siennas, ochres, lavenders, and a wide range of subtle grays. Rocks and stones are also dark and colorful—usually browns, purples, and earthy greens. And tide pools, too, reveal a shadowy world of brilliant, jewel-like colors and a variety of unusual forms and textures.

Use the wet sand to catch the glare of the sun, and use pools of water to reflect not only boats, pilings, shacks, and rocks but also the light and color of the sky above. Try different light effects. Throw foreground low-tide areas into shadow with a strip of light on the water in the far distance. Or use dramatic backlighting, or contrast strongly lit tidal flats with the dark grays of a storm sky.

Observe low-tide zones at all times of day, from early in the morning until slightly after sunset, and note the different effects caused by changing light conditions. Realize, too, that low tide can be a changing condition, first while the water is receding and again when the water returns to the shore. During those times, the world of land and water is in constant flux and is rich in pictorial possibilities for the observant painter.

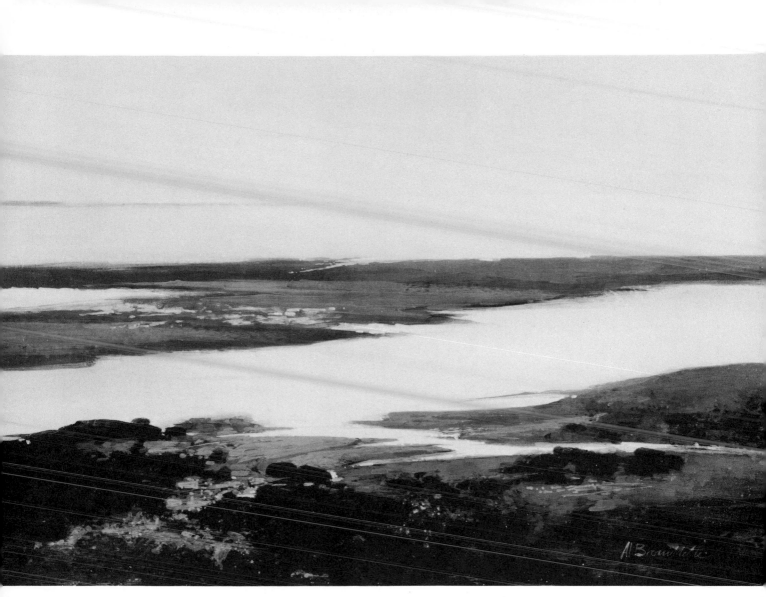

MORNING LOW
by Al Brouillette, A.W.S.
Acrylic on Masonite,
16" × 24" (41 × 61 cm).

Al Brouillette's composition in *Morning Low* is disarmingly restrained: a distant shore and water bathed in a misty morning light, and in the foreground an intertidal zone of sandbar and beach separated by a narrow channel that reflects the sky's brilliance. This placid scene, with its generally horizontal emphasis, is an area where land and water gently meet, and it is a pleasant change from the more energetic forms that characterize the usual seascape. This painting projects a serene mood in which the quality of light is as important as the treatment of water and shore. The immediate

foreground contains the darkest values and richest colors, the sandbar is handled more flatly and with less detail, while the far water and sky are almost indistinguishable in color and tonality. The forms and textures in the foreground are not specifically rendered but are merely suggested in a loose, casual, brushy style. It is the overall effect of light and mood that most concerns Brouillette here, and the result is a successful attempt to capture the essence of low-tide forms in terms of utter simplicity.

45. MULTIPLE IMAGES

CONCEPT When a painter discovers a motif he finds unusually compelling, he is apt to paint it over and over again in an attempt to probe every possible aspect of it in all lights and seasons and from a number of different viewpoints. The most obvious example of this would be Cézanne's prolonged affair with Mont Saint-Victoire, an obsessive relationship with a motif that ultimately resulted in a series of masterpieces, both in oil and watercolor. Yet, even though Cézanne had painted it repeatedly, it is quite possible he might have felt that he had barely scratched the surface in getting at the essence of what that motif meant to him.

Other instances of continued and intense involvement with specific images would be Monet and his water lilies, Andrew Wyeth and the Kuerner farm, or Reuben Tam and the rocks of Monhegan. That sort of painterly obsession leads to great numbers of individual paintings that explore a motif in considerable depth. But it was the Cubists who invented the notion of simultaneity, of viewing a figure or objects in a still life from several angles simultaneously—not in several pictures but all within the same picture. For example, in a single image a bottle could be viewed from the bottom, from the side, and looking down into it—three different views combined into one form.

When this concept was applied to figure subjects, the result was a kind of painting closely related to Muybridge's famous sequential stop-action photographs of figures and animals in motion. Painters like Marcel Duchamp and the Futurist painter Giacomo Balla suggested movement by combining and superimposing on the same picture surface several shifting sequential poses of the figure. The best known of these is Duchamp's *Nude Descending a Staircase* (which, when it was exhibited at the Armory Show of 1913, was described by an unfriendly critic as resembling "an explosion in a shingle factory"). This same use of simultaneity and superimposed multiple forms also appears in urban landscapes such as Joseph Stella's series on the Brooklyn Bridge, in Balcomb Greene's Montauk seascapes, and in a number of the industrial compositions by Charles Sheeler. Sheeler, being a superb photographer as well as painter, actually superimposed photographic images and used multiple exposures to produce his overlappings of different views of the same subject.

The various means of arriving at such imagery is not as important as the fact that such simultaneous combinations of viewpoints are a valid, intricate, and arresting means of interpreting nature in contemporary terms.

PLAN There are two general methods of approach to this compositional device. One is through drawing, and the other is with photography.

In using the drawing approach, draw your motif in line only from several viewpoints, using a pad of tracing paper. Then superimpose one drawing on another in various placings and combinations until you arrive at a composition that satisfies you as an arrangement of linear relationships. Parts of the resulting multiple image may be confusing, and so you'll have to do some simplifying and eliminating to make the design as readable as possible. Once that has been accomplished, work out the patterning of values, keeping in mind that some elements are more important than others and that although the composition is expected to be complex, it must still be coherent enough to be assimilated by the eye. Next, plan the color, but limit your color choices to no more than four or five, if possible. Too many colors could create a jumbled kaleidoscopic effect that would increase the confusion and destroy whatever unity you have already achieved in line and tone. Work for major forms set against minor forms. Be conscious of simplicity versus complexity and of emphasis and suppression. Your composition is supposed to be busy and intricate, but it must also conform to the basics of good design.

When using photography to create these images, you can superimpose two slides of the same subject seen from different angles. Once you find a satisfactory combination of slides that has promise as a painting, you can then project the multiple image on a large piece of paper (on which you will make compositional changes and revisions) or, if you wish, directly onto your painting surface. I warn you though, that such compositions usually require a good deal of organizing and rearranging in the interests of comprehensibility. Therefore you would be wise to thrash out all problems in a preliminary phase before attacking the final version. If you are working with black-and-white film, you can play about with multiple exposures in the darkroom, or you can persuade a photographer friend who has darkroom facilities to work with you and help you combine images to make photographic prints that will serve as the sources for your painting.

The whole problem here is really one of design and organization. Without them your painting could indeed resemble an explosion in a shingle factory. The final painting should be a complex interweaving of many lines, shapes, patterns, colors, and textures—its principal impact and its appeal lies in its intricacy. But readability is still a necessity.

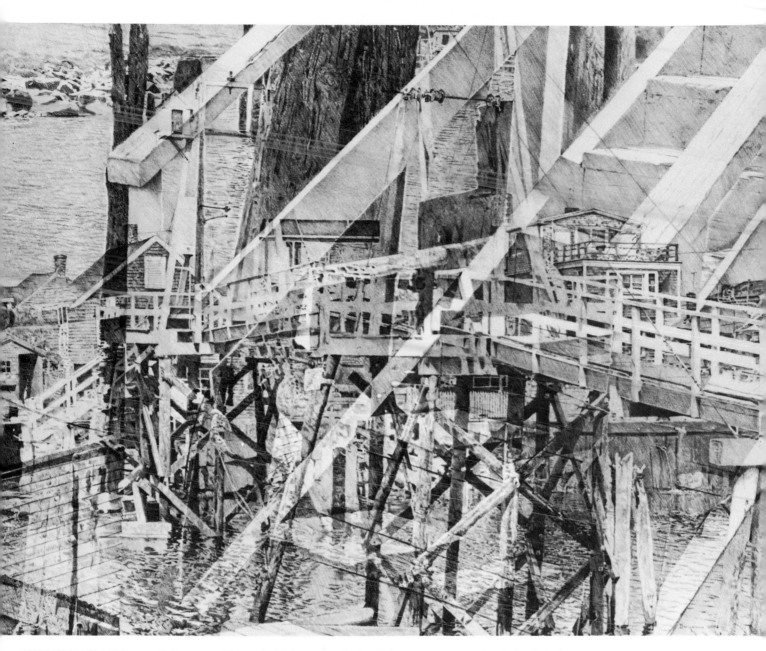

FOOTBRIDGE AT PERKINS COVE
by Jayne Dwyer.
Pencil on paper,
18½" × 24⅝" (47 × 65 cm).
Private collection.

Although this is not a painting, it is such a stunning example of the use of multiple images that it seemed impossible not to use it as an illustration, and there is no reason why the concept and treatment seen here could not be handled in paint and color. Jayne Dwyer's orchestration of many diverse elements is all the more astonishing when it is realized that she has employed images that are quite varied in scale. For example, there are two closeups of old pilings and the railings and steps up to the bridge, a general view of the bridge and adjacent buildings, and a distant view of rocks and water replacing the expected background of sky in the upper left-hand corner. Basically

the design is built on a complex system of intersecting diagonals but with just enough horizontals and verticals to give stability to the design. She has been careful to see to it that some forms are more dominant and clearly delineated than others and that details, enjoyable as they are, do not intrude on or distract from the overall design structure. Dwyer's craftsmanship, technical polish, and sense of organization are all masterly, but most intriguing of all is her ability to form an abstraction out of several completely realistic images, simply by the way those images are manipulated and combined in a single picture.

46. ENLARGED SCALE

CONCEPT Painters of seascapes are accustomed to translating the large scale of nature onto the smaller scale of their canvas or paper, a change of scale that is an accepted and necessary condition of the painting process. A twentieth-century contribution to the art of painting is the idea of reversing that usual translation of scale by creating compositions that are greatly enlarged versions of small-scale forms. This relatively new way of seeing things is undoubtedly due in large measure to the art of photography, most particularly to closeups and photomicrographs, although of course this is not the only way painters have been influenced by photography. (Anyone interested in that relationship cannot afford to miss reading Van Deren Coke's *The Painter and the Photograph*, University of New Mexico Press, 1972.)

Gigantic enlargements of details of nature appeal to the painter as being a fresh new view of our world, a view not always available to the naked eye. When small-scale forms are blown up to a scale that renders them almost unrecognizable, they can then stand entirely on their own to be appreciated purely as abstract shape, color, and pattern. The other quality that results from enlargement is that of the unexpected: an unusual manipulation of scale that often produces an effect of surprise or shock when the viewer suddenly realizes the true identity of the forms depicted.

Several contemporary painters have used enlarged scale very successfully: Georgia O'Keeffe, Carl Morris, Beverly Hallam, Joseph Raffael, Lee Weiss, and Janet Fish come immediately to mind. A good part of the impact of their scale distortions lies in the great size of their paintings. The larger they are, the less likely is the association with reality and recognizability. But it should be remembered that those forms are not enlarged merely for shock value, frivolity, or novelty but as a way of dramatically emphasizing the expressive or design qualities of shapes, colors, and patterns in nature and transforming them into powerful images.

Although sheer size will not guarantee the success of scale enlargement, some deceptively ordinary forms gain monumentality and visual impact when they are blown up to enormous dimensions. On the other hand, a weak, uninteresting form will remain weak and uninteresting no matter how large the format. It is the artist's eye that determines which ones will lend themselves to enlargement and which ones will not.

PLAN Keep your eyes open for the small-scale forms that strike you as being appropriate to considerable enlargement. These could be scraps of driftwood, shells, beach stones, rockweed, lichen, metal sheets, and tar paper in a boat yard, patterns and textures of wood shingles, peeling paint, glass, bubbles, rock, or sand—anything in which you see possibilities for the use of shape, texture, and pattern on a scale much larger than life.

You can work either from drawings or snapshots, and you should feel free to paint in a style anywhere from photorealism to complete abstraction. The scale and size of the final painting is important, because an enlargement on a 25″ × 30″ (64 × 76 cm) canvas simply hasn't the physical presence or the visual impact of a painting that measures 4′ × 6′ or 5′ × 8′ (122 × 183 cm or 152 × 244 cm). A form enlarged to that kind of scale is no longer itself but becomes a separate, distinctly different sort of entity and, blown up to a huge enough scale, it might well be almost or completely unrecognizable. Your aim should be to perceive and interpret that form in a fresh way, to put it into a context where recognizability is less important than formal or aesthetic quality, so that, as always, the completed painting is superior to its sources.

You will find that manipulations of scale can be a stimulating, offbeat viewpoint for creating a picture; the whole point of it is to go all out—to create not a modest enlargement or closeup but a monumental form that almost engulfs the viewer. So don't hold back, don't be timid or predictable, but be as daring as you can. Starting with a small form or image, transform it into something new, recreate it, make it an experience in paint and surface that is more visually exciting and more impressive than the original motif itself.

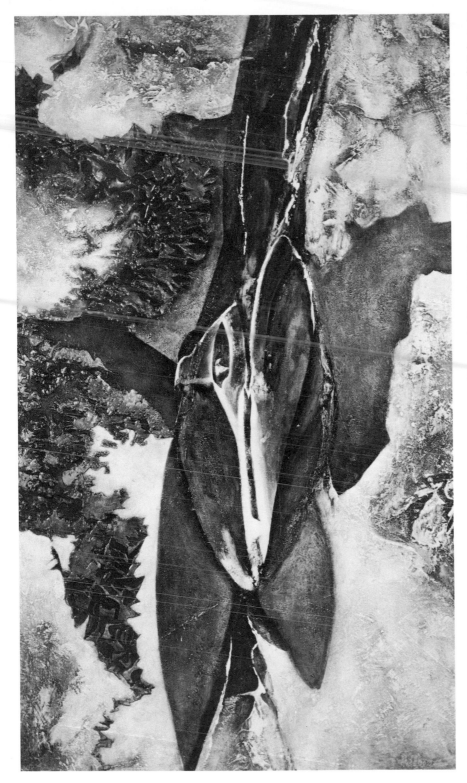

BIG MUSSEL
by Beverly Hallam.
Acrylic and mica talc
on linen canvas,
84" × 48" (213 × 122 cm).
Collection Addison Gallery
of American Art, Phillips Academy,
Andover, Massachusetts.

A four-inch mollusk is an unlikely candidate for the subject of a seven-foot painting, but Beverly Hallam has done it and made it one of her most powerful images. Seeing the painting reproduced in a book is no substitute at all for experiencing the actual painting, which is heroic in size and made all the more overwhelming because of its unusually heavy impasto that intensifies its textures of rock and seaweed. All the elements have been consistently enlarged to the same degree as the mussel, both in scale and texture, but the forms are so enormous and there is so much emphasis on shape and pattern, that it takes some time and looking before it becomes clear that it is not just a bold abstract composition, that it is a representation of a very small fragment of the marine world. Hallam's contribution here is her personal vision in seeing the possibilities of taking her subject out of context and presenting it in a greatly enlarged format that alters that subject and recreates it into a pictorial design that has an inescapable presence.

47. IMPROVISATION AND IMAGINATION

CONCEPT Throughout the history of art (and even today) the customary way to develop a picture was to start out with a definite subject in mind, draw several sketches and studies, and finally transfer the composition onto a canvas and paint it. However, in the past forty years or so, partly because of the automatist methods advocated by the Surrealists and the intuitive approaches used by the Abstract Expressionists, many painters of our own time have turned to improvisation as a way of discovering images.

In traditional representational painting, the artist before he begins to paint has a clear idea of what the completed picture will look like. On the other hand, the contemporary improvisational painter purposely clears his mind of any preconceived plan, subject, or image and has no idea at all of where the painting process will lead him. His picture results directly from the manipulation of the medium, from mixing several media, or from the random application and periodic washing off of color. The accidental forms that appear are then further manipulated in a spirit of play, exploration, and discovery until the artist responds to what is happening on the surface and a meaningful subject begins to emerge.

As random paint application stimulates the artist's imagination, memories, and associations, a subject is gradually revealed and identified. That idea then becomes the single control for all decisions affecting the completion of the painting, and at that point the use of accident is discarded in favor of a conscious, orderly organization of all the pictorial elements. It must be understood that accidents are not relied upon solely for the finished product but are carefully controlled and function within the context of a disciplined art. Thus the fortuitous and the accidental are only tools—a method of *starting* the picture. They serve to coax from the picture surface those forms to which the artist brings deep inner responses and which, through selective processes, lead to the development of a painting that, regardless of its beginnings, has meaning, control, order, and structure necessary in a work of art.

It has been said that many painters carry images within themselves and improvisation is a means of stimulating the imagination to release those images, to let them rise to the surface, as it were, and become visible. Thus improvisation offers the painter a chance to bypass the ordinary and the predictable and to capitalize on unexpected effects for creative purposes. Although there is undoubtedly a strong element of risk in using the improvisational approach, which invites imagination and subconscious forces to contribute to the painting process, it is worth that risk for the artist who has stored within himself a wealth of memories and experiences.

PLAN There are those painters who are able to apply improvisational techniques to transparent watercolor, but they are something of a minority. Since the possibilities for continual repainting, overpainting, correcting, and revising are quite limited in a transparent medium, I suggest starting your introduction to improvisational painting in an opaque medium: oil, acrylic, or gouache. Once you are familiar with the method, then you can try it in watercolor.

Your state of mind is important to improvisation. You must empty your mind of any plan or possible subject matter. You must be willing to take risks and not insist on always knowing where you are going. Set up situations in which accidents can occur and then respond instantly and freely to whatever happens. Remember, however, random methods may be used to start a picture, but random methods can't finish it; your route is from intentional chaos back toward order and meaning.

Work very quickly at the start so that you won't have time to think too much, and don't be in too much of a hurry to find an image. Give your imagination free rein, and cut loose with an abandoned attack on your picture. Work in a relaxed manner, but always be on the lookout for a subject, an image that might appear in the midst of all the disorder. Be particularly aware of areas that remind you of rocks and surf, cliffs, trees, harbor forms, tide pools, underwater scenes, sand patterns, or sails, and then build the picture around them.

As your subject emerges, paint out distracting or irrelevant passages and relate colors and shapes more thoughtfully until the design begins to work as a readable organization. Keep it looking loose and casual, not tightly man-made. Retain the accidental effects that help the picture, but ruthlessly eliminate those that don't contribute to either your subject matter or your design.

Use resists and collage; wash off color; lift off paint with newspaper and transfer it to other areas; wipe, swipe, blot, and spatter; do crazy things and see what happens. Later you can slow down and gradually bring to the picture a sense of structure and of recognizable or implied seascape elements.

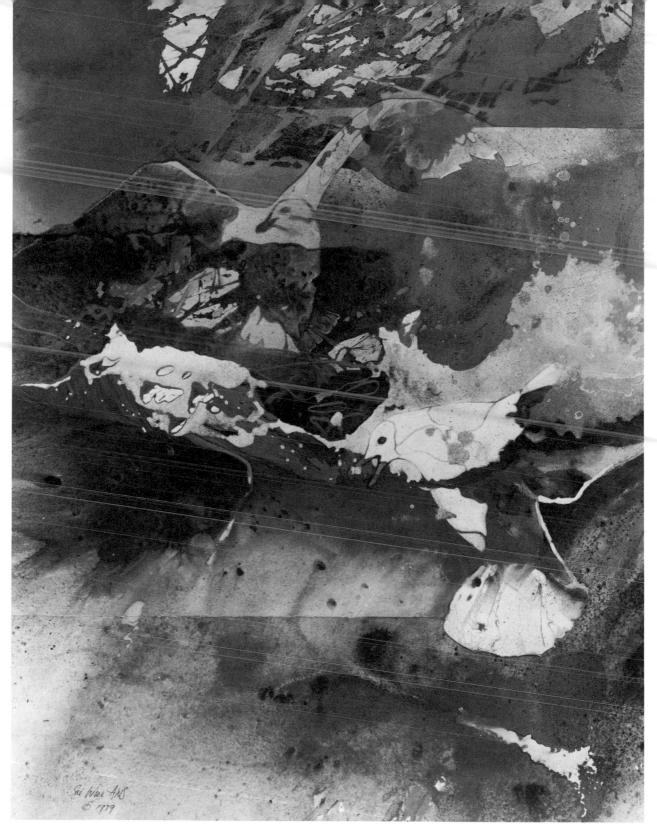

GULLS
by Sue Wise, A.W.S.
Mixed water media on paper,
32½" × 24¾" (83 × 63 cm).

Though Sue Wise is a Colorado painter, this watercolor demonstrates her versatility in handling subjects far from her region. The February 1977 issue of *American Artist* contains a fascinating, detailed account of the technical processes involved in her overlapping multi-sheet constructions, of which *Gulls* is an excellent example. She starts painting improvisationally, preparing several sheets at a time with random applications of watercolor, dry pigments, acrylic, and liquid watercolors. The various sheets are then placed together in various combinations until a subject suggests itself and until continuity is achieved from one sheet to another. Parts of the sheets are torn away and each sheet is then fitted into the context of an adjacent sheet to form a sort of irregular triptych. From there on it is a matter of unifying the forms, colors, and surfaces while maintaining a blend of reality and ambiguity, concealing and then revealing. Accident was used as a means of initiating the development of the painting and its imagery, but the whole is brought together by the artist's sensitive control of shapes and textures that push beyond the accidental to the expressive.

105

48. SURREALISM AND FANTASY

CONCEPT Many painters seem to be still unaware of the fact that Surrealism as an art movement was divided into two groups of artists: the *abstract* or automatist group, such as Joan Miró and Matta (Roberto Sebastian Matta Echaurren), who used free assocation and improvisational techniques to create their images; and the *illusionist* group, represented by such painters as Yves Tanguy and René Magritte, who based their images on fantasy, recall of dreams, and unreal subconscious experiences and rendered them in as convincingly clear and realistic a style as possible. The methods of automatism have been discussed in the previous section, but it is worth considering also what the surrealist illusionists had to offer in the way of a creative viewpoint.

For a seascape painter the most interesting of the surrealists would be Yves Tanguy. Although his paintings are exclusively concerned with an invented, private, interior world, his strange and haunting biomorphic forms are undoubtedly derived—consciously or unconsciously—from the boulders of the Brittany coast, where he was brought up as a child. His pictures depict vast areas that most often suggest the ocean floor, "mindscapes" made up of abstract forms that are described in terms of the most closely observed superrealistic techniques, seascapes where the unreal is made real. In a sense Tanguy can be said to have rejected "real" seascape in favor of an imagined seascape of his own devising. He did not turn in his art to abstractions of objective reality but created a system of new forms out of his interior fantasies. Yet, since these fantasies are traceable to early childhood memories of rocks and beaches, it is immediately apparent that even fantasy has to have some basis in previous experiences or memories, no matter what process is used to bring them into being as paintings.

There must certainly be a mystical relation between man and the sea. Gavin Maxwell has noted that at the edge of the sea, a person "stands at the brink of his own unconscious," and John Steinbeck has written of our "mass of sea-memory." There is also the fact that the human fetus at one stage of its development has vestigial gill slits, indicating man's watery origins and suggesting his psychic connection with sea, moon, and tides. Small wonder, then, that Tanguy and other painters have a strong subconscious attraction to rocks and beaches and use them not only as a source of observed forms that serve as subject matter but also as the basis for evoking subjective seaside fantasies. The sea offers a world of the imagination that is not necessarily a better or worse world, but simply a different and more mysterious one.

PLAN Some painters are completely dependent on direct observation of reality for their subject matter. Others are, to a greater or lesser extent, visionaries who create private worlds in paint, describing their inner seascape or landscape fantasies in uncannily clear, realistic detail. The former possess the outward view of nature and the latter the inward view, and you must decide for yourself which group you feel closest to. The inner world may not be for you after all.

If you are indeed the visionary type, you must realize that before your personal vision of an invented world can take form, you must have acquired over the years a backlog of memories and experiences on which your imagination can feed. Realize also that if you are to make your dream world sufficiently real and convincing to others you must be a master of descriptive painting techniques.

The difference between this kind of painting and conventional realism is that instead of starting with an observed subject and working *from* it, you have no starting point at all but are working *toward* some sort of inner vision of seascape. Use any means that you find helpful to conjure up your subconscious sea world: listen to music, read poetry, recall dreams, look at photographs upside-down, or just doodle idly and let your imagination roam freely. Once the images start to appear, take more pains to clarify the forms, to create their own environment, and to develop your own light sources that will reveal the configurations of the various elements you have assembled. Don't worry about logic. Juxtapose diverse, unexpected forms and unreal spaces. Try for the element of spookiness or surprise. This is a personal fantasy—not the real world, and it's yours to play with as you please.

Your seascape fantasy should have some kind of idea or attitude behind it: mystery, prophecy, magic, anger, fear, humor, or whatever. Such underlying viewpoints will add a more emotional or poetic substance to your painting and increase its expressive forcefulness.

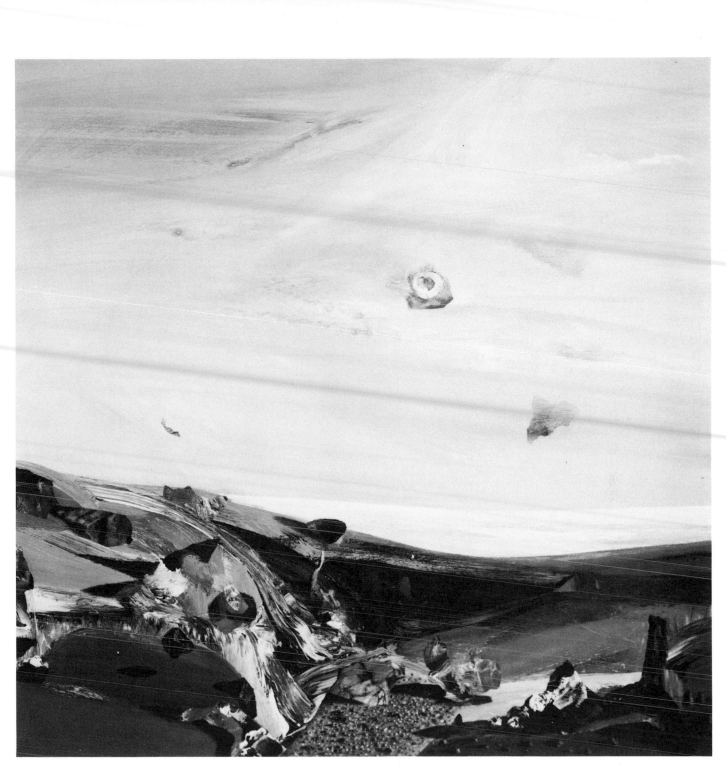

SEA CHANGES
by Richard Gorman Powers.
Acrylic and collage on wood panel,
31½" × 31½" (80 × 80 cm).
Courtesy Deeley Gallery,
Manchester, Vermont.

At first glance this might appear to be a scene on the Oregon coast, with dark, wet sand, flotsam and jetsam, eroded rocks, and weathered driftwood. Then closer inspection discloses the fact that these are not identifiable forms at all but purely imaginary textured forms that exist in their own ambiguous spaces. The open, breezy sky has strange fragmented bits floating about in it, the sea recedes into limitless distances, and the foreground contains a conglomeration of unreal, invented forms evoked by the artist from his private, interior world. Some forms are rendered with unusual clarity and precision, while others flow more casually, jostle each other, and are less literally described. This is a purely mental seascape, a lyrical view of an imagined environment in which the unreal blends with the real. It has been painted with a credibility and a use of detail that, though it initially seems to be realistic description of actual seascape, suddenly plunges us into a world of fantasy. (Technical note: the wood panels on which Powers paints are cut down from flush doors made of Luzon mahogany.)

49. RESOLVING DUALITIES

CONCEPT It has long been known that a major ingredient in most art is the reconciliation of opposites. "The essence of art," W.B. Yeats wrote, "lies in the mingling of contraries," and British author Peter Quennell pointed out that art is an expression of opposing forces and that "the artist is usually a divided man." That everything in art has a counterpart, or complement, can easily be seen, for example, on the color wheel, where opposite or complementary colors balance each other. But these complementary colors intensify each other when placed side by side and neutralize or cancel each other out when mixed or joined. In the same way, everything in nature has its opposite, too. The role of art is the reconciliation or synthesis of these opposing dualities into a fully integrated visual organization.

Such contraries, whether conceptual or technical, break down into an almost endless list: intellectual-emotional, formal-informal, classic-romantic, discipline-spontaneity, clarity-ambiguity, predictability-surprise, order-disorder, seen-unseen. Or on a more technical level, line-mass, straight-curved, hard edge-soft edge, geometric-organic, flat-textured, controlled-loose, simplicity-complexity. The coexistence of such contrary ideas or situations accomplishes two purposes: it provides more visual variety, and it sets up tensions between the opposing extremes. Theoretically they would not ordinarily coexist easily and naturally on the same surface, but it is the function of the artist to balance them and make them work together harmoniously. It might well be that without these underlying tensions, the dualities present in both the painter and his art, that a painting would be rather bland and uninteresting.

The idea, then, is to mingle and coordinate polarities instead of allowing them to remain separate and distinct from each other. This concept is in many ways a close parallel to the Tao principle of Yin and Yang as represented in Oriental painting and philosophy. Yin-Yang has two distinct aspects, yet when written as a symbol it is a single form, continuous and complete in itself, indicating unity. Yin-Yang refers respectively to negative-positive, dark-light, female-male, quiescence-activity, death-life, and so on. Each part complements the other and different aspects of the same thing join together conceptually or symbolically to create perpetual motion, natural order, and harmony. But a contemporary painter is not obliged to be conscious of any Oriental artistic philosophy in order to work toward a reconciliation of contraries as an element of his painting style. Many painters naturally and quite unconsciously play off contraries one against the other while at the same time holding them in perfect balance. The dualities in their art do exist and suggest a conflict of forces, but at the same time they are controlled and unified on the picture surface.

In the long run, the degree of success of a painting as a whole can be determined by the extent to which the artist has successfully blended the various polarized elements involved in the picture.

PLAN Once you agree that a painting is primarily an experience in paint and that it should be a richly varied visual experience (as opposed to a literary one), then your whole urge in evolving a picture is to create a surface, a pictorial statement, that offers the viewer a wealth of visual sensations. You can use thick paint and thin paint, have complex areas set off by simple areas, interweave both line and mass, accent bright colors with neutrals and vice versa, and so forth. You can also set up oppositions where horizontal-vertical elements provide a stable structure to underlie loose, expressive brushwork, and you can create quiet, empty areas that are a welcome change from energetic activity elsewhere in the picture. You may also balance formal passages with informal ones and roughly painted passages with those that are sensitively and delicately applied. The bringing together of such dualities guarantees your audience a varied and constantly intriguing visual journey through your paintings.

Vary the paint application according to the specific needs of individual picture areas so that all textures are not treated alike. Watch constantly for variations of warm and cool colors in differing intensities. Use gestural brushstrokes here: hard-edge, controlled strokes there. But keep in mind that although you may keep the viewer's eye continually engaged with the considerable variety and many contrary dualities you offer, you must be sure they are effectively balanced so that no one aspect is unduly dominant.

Just as semiabstraction requires the artist's ability to merge geometry with reality in a satisfying equilibrium, so the job here demands employing polarized forces or ideas with disciplined order. There should be no feeling of raw, unresolved conflict. It is the way in which one element acts as a foil for others and the way in which the artist creates a unity out of several obvious contraries that give the work of art its harmony, stability, and balance. The artist may indeed be a "divided man," but he sees to it that his painting is not.

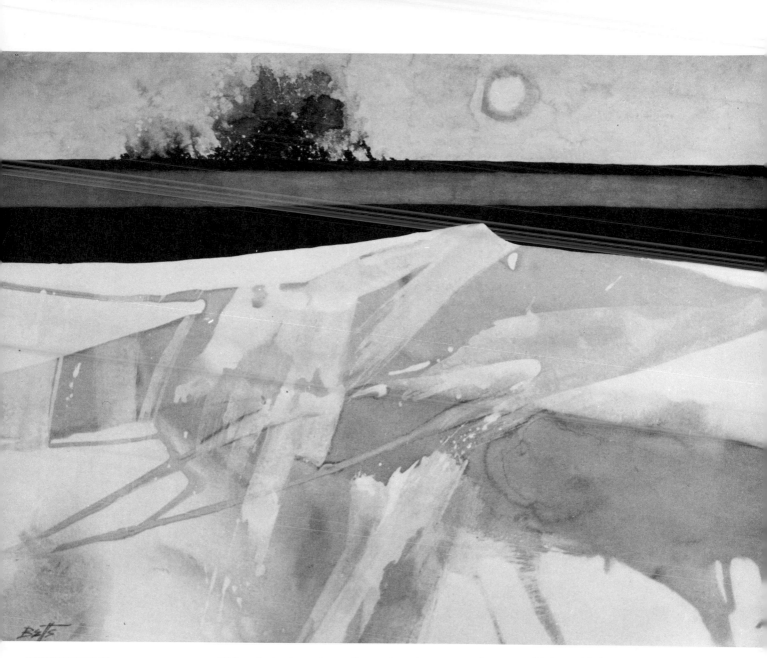

WINTERSHORE
by Edward Betts, N.A., A.W.S.
Casein on synthetic paper,
22" × 30" (56 × 76 cm).
Courtesy Midtown Galleries,
New York City.

This painting is made up of a number of conflicting elements with the aim of adding variety and interest to both treatment and surface. The foreground ice and snow forms are the result of flowing paint combined with gestural brushstrokes—a looseness that is contrasted to the flat, hard-edged treatment of the water. Strong oppositions of hot and cold color are brought into play by dividing the water into bands of a vivid red opposed to a deep blue and a bright blue. The straight geometric forms of water and horizon and the circular sun act as foils for the irregular, organic forms in the rest of the picture. The cold character of the icy blues and whites in the foreground is intensified by the use of a pale yellow in the sky. Also included in the sky is a mass of mottled color created by spraying wet paint with clear water and allowing the paint to spread and blend of its own accord, a technique quite different from that used anywhere else in the painting. The entire picture is a ''mingling of contraries''—plan versus accident, spontaneity versus control, flat versus textured, delicate color versus intense color, and hot versus cold. The result is a richer, more varied visual experience than these would be had the treatment been severely limited to a single method or attitude.

50. DEVELOPING SYMBOLS

CONCEPT If a painter presses beyond realistic and abstract imagery, the next step would be to symbolize nature. An image refers to some fairly specific aspect of nature, but a symbol is a compact universalization of subject matter and is meant to be a richer, more profound emotional or intellectual experience than that offered by realism, semiabstraction, or abstraction. At their best, symbols are a way of affecting the viewer on several levels by gradually revealing each layer of meaning. A symbol is such a condensed treatment of nature that it communicates essences, experiences, associations, ideas, and emotions with greater force and depth than is possible with ordinary methods of visual expression.

There are two kinds of symbols, arrived at by two different processes: the rational and the intuitive. The rational process is based on intellectual analysis of natural forms or forces, and the resulting symbols have a rigor, purity, clarity, and order that express their content with precision and exactitude as a very cerebral experience. The intuitive symbol is just as effective, but it is one that is formed out of feeling and instinct rather than logic. It is a more poetic, often mystical, conception, and for that reason it is less precise or exact than rational symbols. Nevertheless, both kinds of symbols, regardless of origin, are equally creative, and the personality of the artist will attract him to the one he finds most congenial.

Although symbols usually function on several levels at once, some artists use a more private system of symbols that communicate less directly. This is not usually due to any sense of alienation or elitism on their part, but it results from an inner necessity. It is the only way they can express their personal vision of, say, the correspondences or equivalents they feel exist within nature itself or of the relationship between man, art, and the sea. In fact, the poet Robert Frost felt that it was now time for the audience to exert more effort and meet the artist at least halfway, and painter Jack Tworkov put it nicely when he said, "To ask for paintings which are understandable to all people everywhere is to ask of the artist infinitely less than what he is capable of doing."

Withdrawal into a private world must be respected, especially if the artist who does it is sincerely involved in coming to grips with nature in an intensely personal way. If it is his only route toward a profound comprehension of man and nature, and if that sort of search means more to him than public acceptance, then perhaps the public, or at least the informed art public, will have to accept the fact that not all painting is equally accessible and that some symbols are more private than others.

It is quite possible that the painter who deals with symbol and metaphor is working at the highest level of what art can be.

PLAN Developing symbols is not a short-term activity. You will have to face the fact that a symbolic treatment of the coastal environment is very gradually arrived at and cannot be forced. It is the result of prolonged observation, contemplation, meditation, and a very considerable amount of drawing and painting. Don't be self-indulgent. Be prepared to work hard and long at this.

If you plan to use rational symbols, start with analyses of various forms and motifs at the shore. Pare those forms down to their essences; simplify, condense, try variation after variation to get at an intellectual comprehension of the most fundamental, significant aspects of those forms. Work for clarity and order above all, and express your subject in the most carefully controlled terms. Arrive at your symbol through a series of refinements of contour, shape, and color and through the exercise of discipline and pure logic.

Intuitive symbols require you to approach subjects through your feelings and instincts, through inner subconscious responses rather than calm logic.

Explore your motifs through spontaneous impulses, reactions, and insights. Do rapid brush drawings, each one more condensed than the other. Aim to catch the spirit of the subject in the simplest, swiftest gestures. Express the rockyness of rock, the softness of grasses in the wind, the rhythmic lines of water rolling onto a sandy beach and a rocky beach. Neatness is not as important as immediacy—that is, hitting upon a symbol that sums up universals in a single stroke.

Be aware of how others have used symbols pertaining to the sea (Dove, O'Keeffe, Marin), but don't imitate them. Whether your symbols are emotional or intellectual, they should be entirely your own because they originate from your deepest personal responses to nature. If, in spite of yourself, your symbols compulsively tend toward the idiosyncratic or the eccentric, don't worry too much about it. If you don't reach your audience, perhaps they should try harder to reach you. Ultimately, however, the strongest link between you and your audience is the cogency of your symbols.

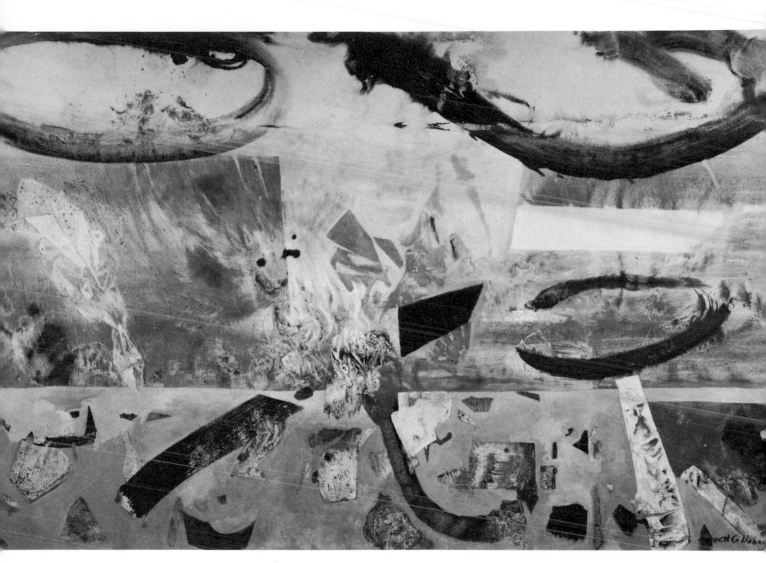

FLOTSAM
by Kenneth Callahan.
Oil on canvas,
50½" × 79" (128 × 201 cm).
Courtesy Kraushaar Galleries,
New York City.

Flotsam, in its literal sense, refers to those parts of a shipwreck that are found floating in the water. Callahan's very personal interpretation of that subject involves seemingly unrelated bits and pieces and debris scattered throughout the picture surface; to suspend all those disparate elements in some kind of equilibrium is no small achievement. Beneath all the casual scattering is a clearly defined asymmetrical structure of geometric planes, a unifying factor that holds the isolated, smaller parts together. Some parts of the flotsam are consciously designed and sharply defined; other parts are made up of phenomenalistic paint handling;

and still others are sweeping calligraphic gestures. There is a constant interplay of soft and hard, straight and curved, and lost and found. This is an excellent example of the intuitively formed symbol: nothing here is recognizable, yet the subject matter can be strongly sensed, even without benefit of a picture title. Although Callahan has evoked his subject by means of an assortment of private symbols, it could be fairly said that this painting can be read not only as symbol but as metaphor—a substitute for nature itself— which is possibly the most affecting and direct method of visual communication.

COLOR GALLERY

Color serves many functions in paintings. It can define light, space, structure, or mood: and provide decoration, design, optical vibration, personal expression or interpretation (intellectual or emotional); or offer even purely sensual delight in it for its own sake. There are so many factors involved in understanding color and they are so complex that few painters feel they have ever truly mastered color as a major element in picture making.

There are indeed artists who seem to have been born colorists—Delacroix, Turner, Gauguin, Van Gogh, Monet, Degas, Vuillard, Bonnard, Braque, Matisse, Avery, Rothko, Louis, Okada, to name a few, but they are a tiny minority if you consider the whole history of painting. Color remains an eternal challenge for most of us. Knowledge of color, mastery of the many ways of using it, comes only through long experience and experimentation. And remember, a colorist is not always the artist who is most at home with vivid, pure, unmixed colors straight from the tube; a colorist can just as well be one who uses beautifully modulated, subtle colors or unexpected offbeat combinations or simply a painter who employs a very personal range of color nuances through which his view of nature is filtered.

As a painter's tool, color is remarkably flexible and versatile—and elusive—and it is a shame that no one book on that subject provides all the answers that painters require. Some books are so scientifically systematic and theoretical that their principles seem to lose usefulness when applied to the particular picture currently on the easel. Other books are so specific or simplistic that they do not seem to be adaptable to a wider range of problems than those covered in the book itself.

Probably the very best way to learn about color is to forget theorizing and just study original paintings and color reproductions of paintings. Toward that end, I have selected seascapes for the Color Gallery that, first of all, struck me above all as being a distinguished group of contemporary marine paintings and that, secondarily, illustrate a wide variety of color strategies. The paintings reproduced in this section range in style from almost photographic realism to the edge of pure abstraction, but their degrees of realism or abstraction were far less important to me than their qualities as paintings and as demonstrations of many individual approaches to color.

These color plates should be mulled over, studied, analyzed, and compared in relation to each other and to your own aesthetic viewpoint. Once you have fully absorbed whatever color ideas can be of use in your treatment of seascape, put this book aside and plunge into the fascinating experience of encouraging color to play an increasingly important role in all your paintings. Think of color not as being merely descriptive but as being a major creative force underlying the development of your seascape images.

BY LATE AFTERNOON
by Ernest Velardi, Jr.
Gouache on board,
36" × 30" (91 × 76 cm).

This particular seascape by Ernest Velardi, Jr., places him as a contemporary painter who continues the American tradition of Luminism, a concern with the study of light and the effects of light on seascape and landscape. Velardi is a romanticist whose images are couched in rigorous, formal terms, in this case through vertically stacked bands of color which refer to the sinking sun reflecting itself in the sky and in the pale waves. His subject is interpreted as a sort of color geometry, with reality and design completely intermixed so that one is inseparable from the other. Note that the extreme brilliance of the sunlight here is the result of intense warm *color* (and some cool color), but not from the overuse of white paint. Velardi has paid careful attention to the spacing of the various horizontal divisions of his picture surface, and to the subtle color transitions that are not often seen in paintings of the hard-edge school. The deep poetry in Velardi's work comes from the eloquent use of color as a major element of his style.

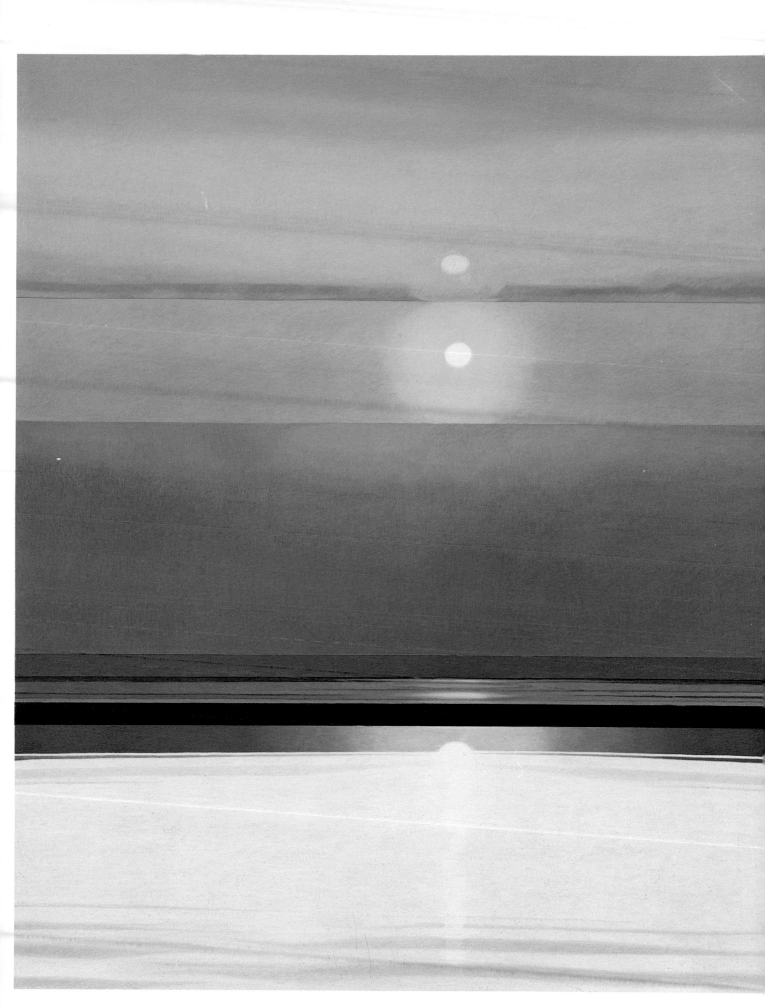

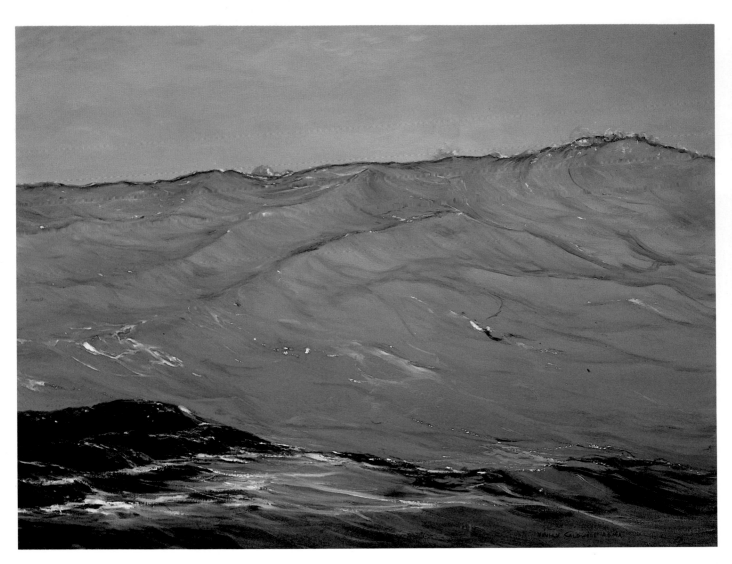

SOFTLY
by Vivian Caldwell.
Oil on canvas, 36" × 48" (91 × 122 cm).
Private collection.
Courtesy The Back Door Gallery,
Laguna Beach, California.

Vivian Caldwell prefers to gather material for her "sea portraits" in the late afternoon, largely because of the quality of light at that time of day. In this instance the light is seen filtered through an ocean swell, which is treated as a gently moving mass rather than a threatening force. The delicately tinted sky is painted as a flat background plane, thus directing the viewer's interest into the wave itself. Her use of color is very economical, restricted to greens, blues, and yellow-greens. Such color economy ensures a unity of the picture surface and a strong sense of mass, and

it reinforces her concern with the wave as being water, not as a vehicle for using a variety of colors that call undue attention to themselves. Every touch, every stroke of color, either captures the shifting movement and watery rhythms of the ocean swell or conveys the brilliant glints of sunlight and reflections of the sky on the water's surface. The translucency of light as seen through the wave is one of the elements contributing to the fact that this painting is a study not just of seascape but of light and motion interpreted with an appropriate and expressive color simplicity.

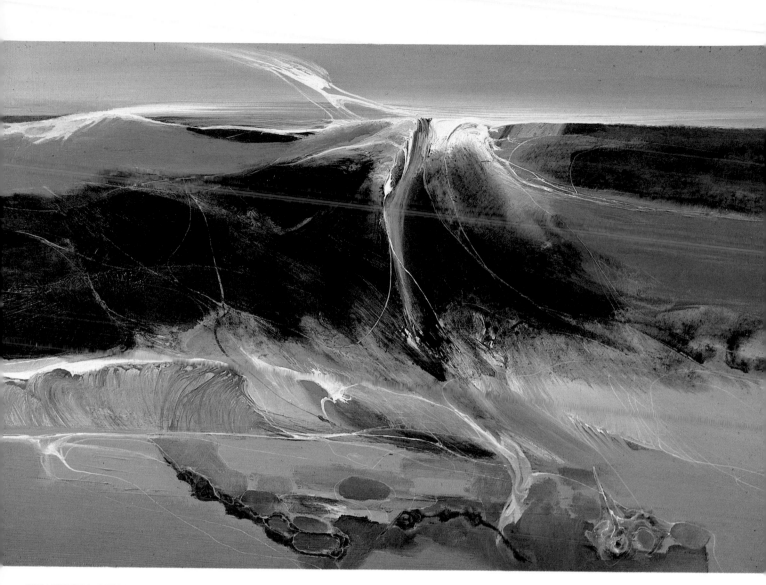

HEAVY SEA, MONHEGAN ISLAND
by Richard Gorman Powers.
Acrylic on wood panel,
32¾" × 43" (83 × 109 cm).
Collection Pratter-Mettey,
Baltimore, Maryland.
Courtesy Rehn Gallery,
New York City.

The weighty mass of breakers approaching the shore has been interpreted here in terms of both flat areas and vigorous brushwork. But what gives this painting its special quality is the way Richard Gorman Powers has incorporated into the composition elegant, flowing, linear arabesques and sweeping rhythmical gestures that not only reinforce the action of the surf but also serve as graceful abstract elements that can be enjoyed purely for their own sake. The spindrift against the sky, a tumbling wave crest, and the wash of white edges of foam playing among beach rocks are handled linearly. But

the wave is almost entirely a monochromatic group of greens, and its irregular moving forms furnish an effective background for the more stylized treatment of the incisive lines. The result is a well-integrated synthesis of the real and the stylized—a sort of formalized realism—a beautiful blend of free-flowing, spontaneous brushiness with a consciously designed personal calligraphy. As standard as the motif might be, Powers never loses sight of the fact that as a seascape it is first and above all else an organization in paint, color, and line.

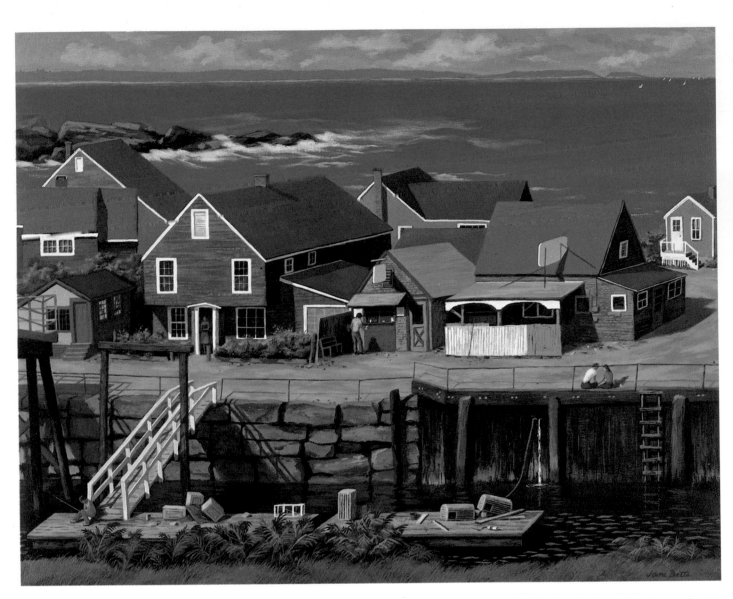

PERKINS COVE
by Jane Betts.
Acrylic on Masonite,
22" × 28" (56 × 147 cm).

Jane Betts's thorough training in abstract painting affects her handling of seascape within a mode of realism, especially through her attention to spatial relationships and because of her sense of natural and pictorial structure and clarity of form. The composition is basically six stratified bands: sky, sea, buildings, road and bulkhead, channel, and foreground greenery. The simple area of water in a saturated blue serves as an ideal background for the varied neutral tones of the roofs and fishing shacks and for the complex interplay of lights, darks, shapes, and patterns. The feeling of strong afternoon sunlight is achieved not by using a

range of light colors but by slightly deepening or intensifying all the colors consistently throughout the surface, with the strongest, brightest colors being reserved for relatively minor areas and accents. Although aerial perspective has been employed in the distant shore and clouds, the central areas of the picture are treated with unusual crispness and a highly personal way of suggesting the abstract qualities that exist in nature. As opposed to sketchy, impressionistic forms of realism, this is an art based on selective decisions—closely observed, thoughtfully controlled, and carefully ordered.

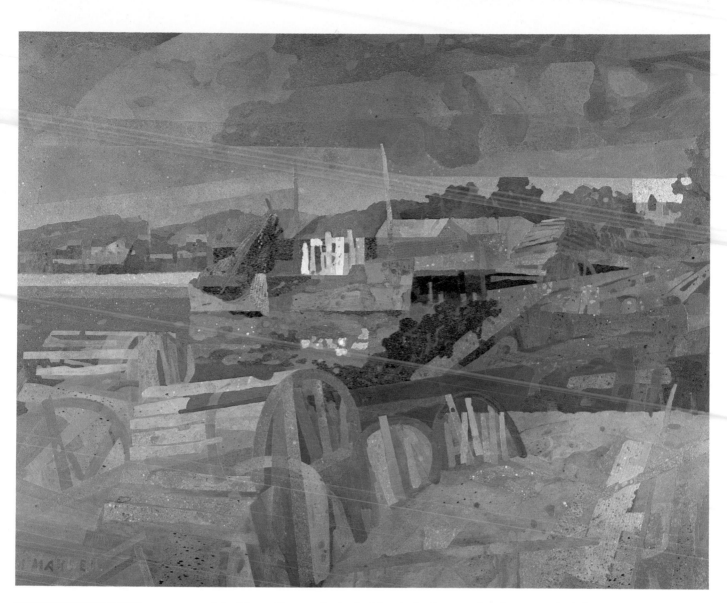

LOBSTERMAN'S COVE
by John Maxwell, N.A., A.W.S.
Acrylic on medium-press
Whatman Board,
27" × 36" (69 × 91 cm).
Courtesy Fontana Gallery,
Narberth (Philadelphia) Pennsylvania.

John Maxwell's use of color in this painting is a fascinating interplay of neutrals and pure colors—of high-keyed pale tints and hues of the richest intensity. In fact, the way these opposing relationships coexist, each group of colors setting off the other, is one of the picture's most satisfying aspects. Working in a kind of color mosaic of dots, spots, patches, and strips, Maxwell creates spatial relationships by progressing from vibrating colors in the foreground to delicate muted tones in the rear planes, yet a few accents of bright color in the central area maintain a sense of the picture plane and prevent too deep a recession into the picture space. Tonal value relationships are subordinate to coloristic relationships, so that even linear elements are never merely lines but are sensitively thought-out color choices. Maxwell is always aware of the great importance of shape, and he sees to it that there is a subtle balance of the organic and the geometric, as well as a complex counterpoint of curved and straight. It is interesting to realize that in terms of drawing this is essentially a very realistic arrangement. Its abstract qualities lie in the daring yet tasteful handling of color—a striking blend of the descriptive and the invented—and in the almost cubistic breakup of various planes and surfaces.

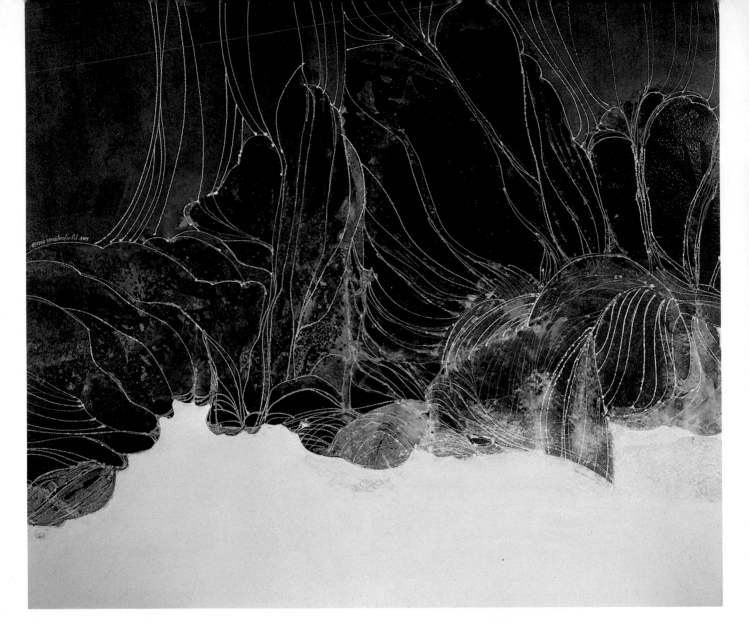

Above
SEA BLOOMS
by Maxine Masterfield, A.W.S.
Watercolor and white ink
on board, 40" × 46" (102 × 117 cm).

Right
SEA SLOT
by Bill H. Armstrong.
Acrylic on paper,
40" × 30" (102 × 76 cm).

Using a basic palette of only blue, black, and white, Maxine Masterfield has produced a painting distinguished by its combination of strength and elegance. It is strong in its bold design, with masses of deep color set against a flat white, and elegant in the assured handling of rhythmic linear gestures and arabesques and in the way it opposes fine white lines to the large, dark areas, in a painting where line and mass perfectly complement each other. Similarly, the stark emptiness or simplicity of the lower section of the picture is a daring foil for the extreme complexity of the upper, major section of the painting where all the visual activity takes place. That is, different parts of the picture are played against each other in various ways, but they are always brought into balance. As strong as the underlying design structure is, it is the skillful use of graceful lines that ultimately ties the composition together, since it is those lines that bring the white of the lower area into the upper mass, thereby unifying the total surface. Like all of Masterfield's paintings, *Sea Blooms* is an example of her ability to mingle opposites: improvisation and control, vigor and delicacy, breadth and intricacy. In the long run, sea forms are less important to Masterfield than the pictorial forms that emerge under her creative guidance.

Bill H. Armstrong's *Sea Slot* is an excellent example of bold, gestural handling and utter simplicity of format, a fresh, direct response to a view of ocean and cliffs. Although the strip of blue water is the smallest area in the painting, it is also the only note of intense, brilliant color, and by virtue of that intensity holds its own against the powerful shapes of the dark rocks and the light of the sky. The gestural approach gives the picture a sense of immediacy, spontaneity, and exuberance that establishes instant communication with the viewer; yet the brushy gesture is used not only for esthetic value, but also to emphasize strongly the verticality of the cliff. Paint textures and application have been differentiated in the rocks at left and at right to avoid a similarity of treatment that might seem repetitive. Armstrong could easily have formed a most conventional image out of this glimpse of the sea, but he preferred to reduce his motif to a symbol presented in a painterly shorthand.

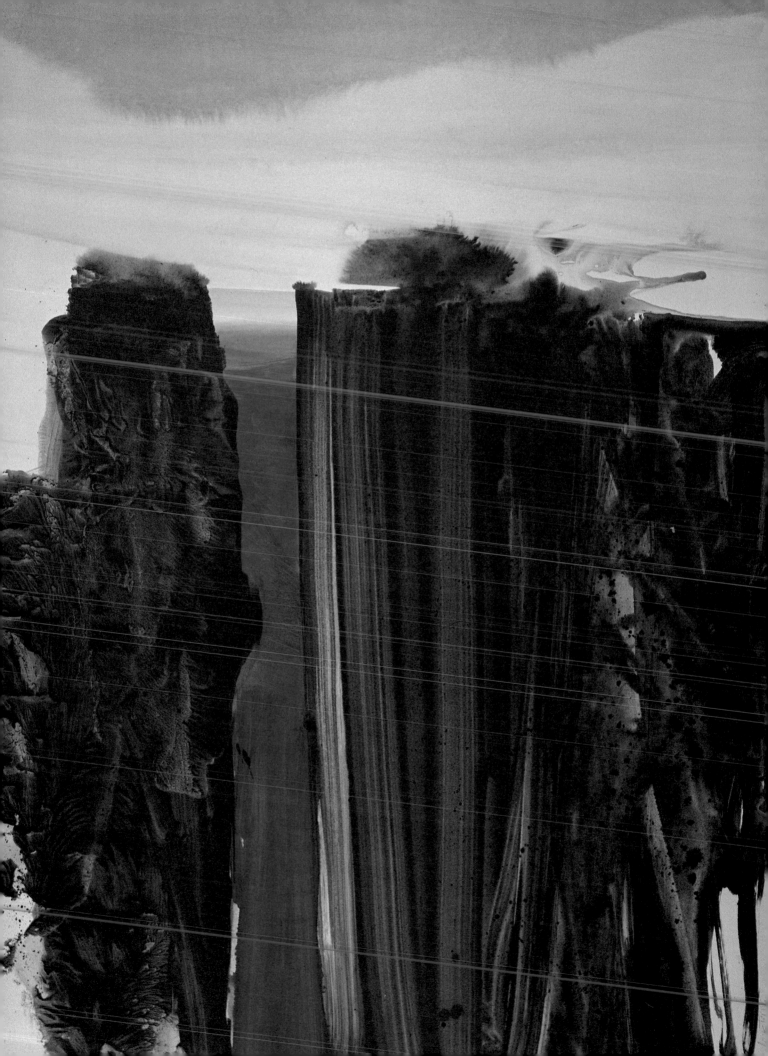

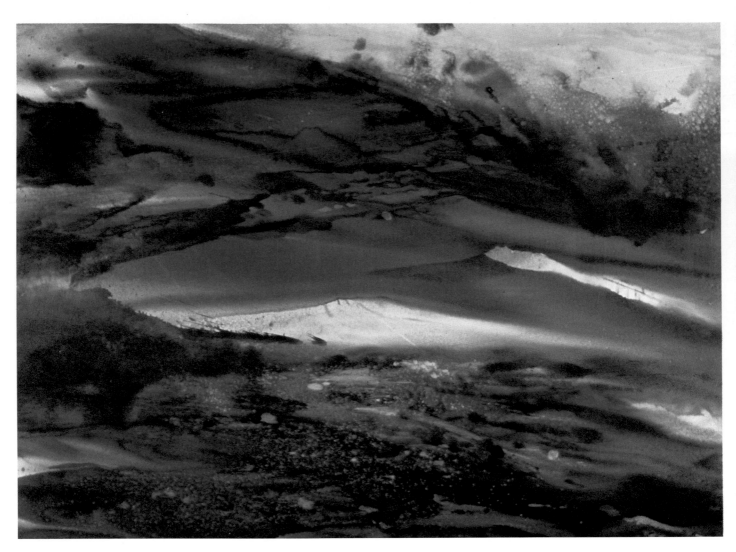

WAVE MOTION II
by Don Carmichael.
Watercolor on cold-press board,
30" × 40" (76 × 102 cm).
Collection The Red Sable,
Memphis, Tennessee.

Don Carmichael uses phenomenalistic flow techniques on very smooth surfaces as a means of expressing the motion and fluidity of ocean waves. The problem of handling such loose runs of color is that extreme care must be taken to preserve several areas of either very pale color or untouched white paper. Failure to preserve those lights would lead to a situation where all colors and values blend together and lose all sense of pattern or contrast. Although the bold freedom of his washes suggests a sort of one-shot immediacy in which the painting is created in a single operation, it is actually built up as a series of

several superimposed washes, combining color flow, direct washes, wet-in-wet, spatters, and stains. In this way, Carmichael uses the fluidity of watercolor drifting across a tilted surface, not only to assist directly in the formation of his sea image, but to serve as a close parallel to the depth and liquid movement—the sense of the ocean as a force—that we feel in the presence of the ocean itself. Carmichael's delicate balance of the controlled and the accidental has been put to unusually expressive use to arouse in the beholder a direct involvement with the power of a wave.

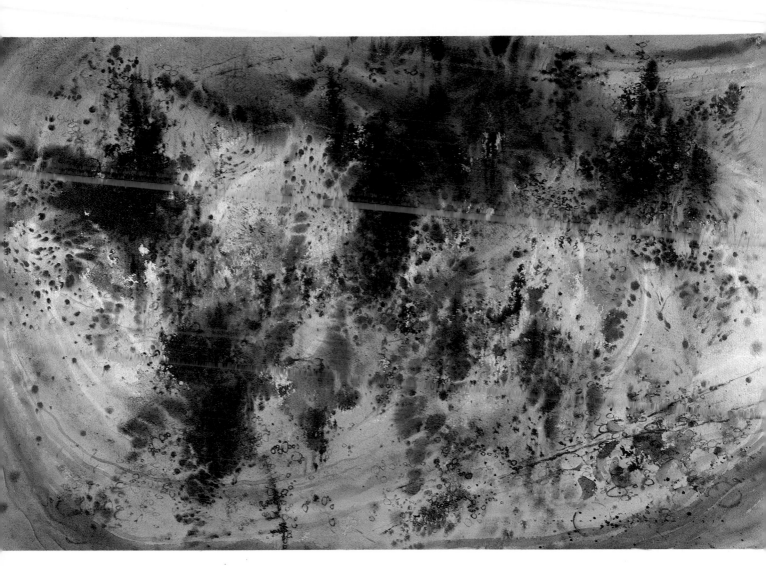

TIDE POOL LANDSCAPE
by Vincent Hartgen, A.W.S.
Watercolor on paper,
24" × 36" (61 × 91 cm).

Vincent Hartgen creates an underwater environment by spattering color onto a thoroughly soaked surface. Washes applied with a brush were kept to a minimum so that the accidents of flung and spattered paint could contribute as much as possible to the development of his image. As easy and random as it may appear, Hartgen's informal approach shows considerable skill and control: in his grouping, spacing, and massing of forms, in his preservation of enough light areas to emphasize darker ones, in his use of dominant blues accented by subordinate warm tones, and in his acute sense of the variety of scale of the paint spatters, which range from tiny blurred dots, to clusters of larger spots of paint, to more

solidly unified major color masses. Obviously, this is not a mere listing of forms observed in a specific tide pool. Hartgen is far less interested in documenting actual marine forms than in creating a painterly surface—and a painterly experience— that uses nature as a reference point but makes no pretense of copying it. The references to the tide pool are all there if one chooses to look for them: rhythmic swirls of water, reflected light, shadowy depths, a variety of underwater organisms, and so on, but Hartgen consciously collaborates with the unpremeditated action of paint and color to produce an art that does not depend on recognizability to satisfy the beholder.

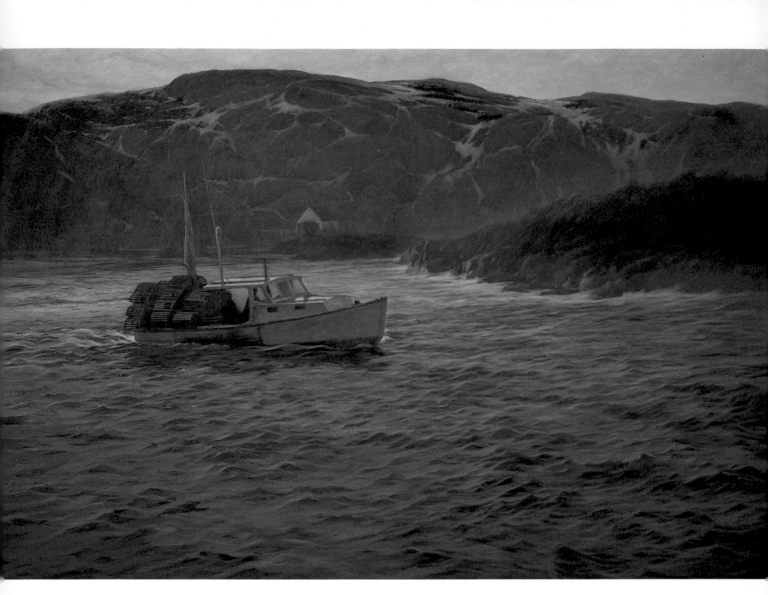

TRAP DAY
by Don Stone, A.N.A., A.W.S.
Egg tempera on gesso panel
(untempered Masonite),
24" × 36" (61 × 91 cm).
Courtesy of Boston Guild of Artists,
Boston, Massachusetts.

Don Stone's subject, with its diffused back-lighting, calls for the use of tonal color— color that is handled within a range of light and dark values. Since the hazy sky eliminates the most extreme tonal contrasts, Stone has restricted himself to a group of middle values that are subtly varied and differentiated from each other. The picture surface is unified by a dominance of cool blues and relieved by occasional passages and accents of warm color. This painting is distinguished by Stone's craftsmanship and by his ability to capture the quality of light and air. His extraordinary

virtuosity in the illusionistic handling of the choppy water is detailed and convincing. It succeeds in sustaining interest in the lower half of the picture without being distracting because it has been so carefully related and adjusted to all other areas throughout the surface. Far surpassing standard types of representational seascape, this picture shows a deep respect for surface appearances but manages to transcend them because of the way in which the subject has been keenly observed, thoughtfully organized, and sensitively wrought.

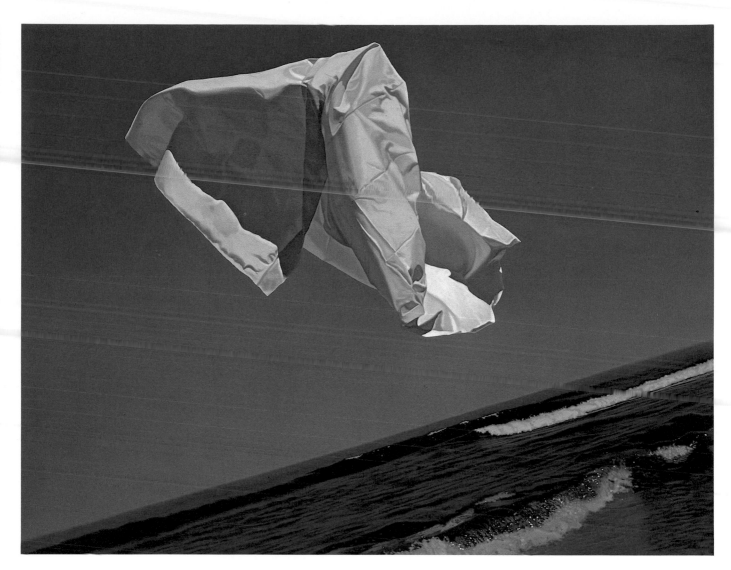

PAROS (THROWN DRAPERY)
by David Ligare.
Oil on canvas, 60" × 78" (152 × 198 cm).
Private collection.
Courtesy Andrew Crispo Gallery,
New York City.

This is one of a series of paintings named after various Greek islands—depicting "thrown draperies" suspended in mid-air (or caught in flight) against a flat, deep blue sky. The image is a startling one, an intriguing mixture of the real and the unreal, in which a photorealist technique is applied to a purely mental conception that stresses the element of surprise or the unexpected. This painting is monochromatic, ranging from bluish off-whites to the deepest of blues, and this predominance of both intense blues and dark blues, coupled with the intense lighting on the drapery,

emphasizes the brilliant, glaring light of the Greek Islands. Like other pictures in this series, the horizon is strongly tilted. Had it remained completely horizontal, the composition would have been far more static, more literal and ordinary, and far less arresting as a division of the picture surface. The surf is masterfully rendered, but the seascape is more of an environment than a center of interest. The crux of the picture is the thrown drapery as a study in shapes, patterns, volumes, contrasting light and shadows, and as an object of mystery and ambiguity.

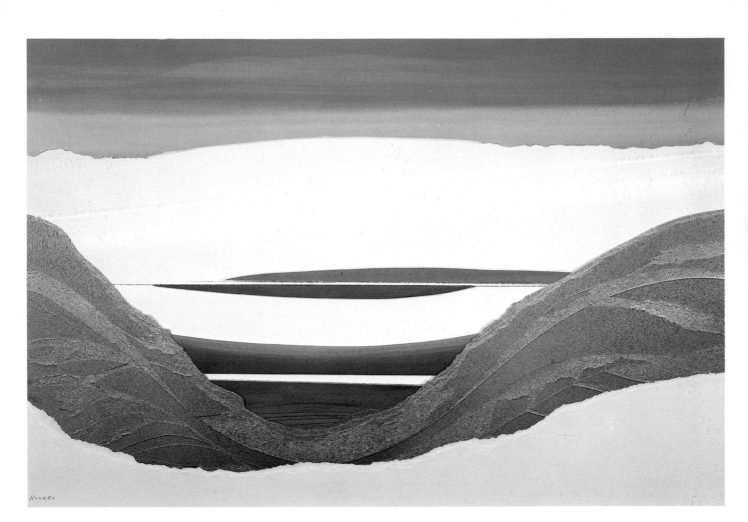

Above
QUIET MORNING, CASCO BAY
by George Kunkel.
Acrylic collage on Masonite,
24" × 36" (61 × 91 cm).

George Kunkel has long been concerned with interpreting the Maine coast in collages of acrylic paint on four-ply 100% rag museum board applied to gessoed Masonite. His work evokes bays, beaches, mountains, islands, rocks, coves, and skies in a variety of cut and torn shapes. Some papers are painted with flat color, some are streaked with wet washes, others are textured with spatter or stippling. By skillful cutting and tearing, a single shape of the heavy museum board can produce two or three different layers of color and texture, and shape upon shape. The final surface is a rich assortment: hard and soft, tight and loose, rugged and refined, lines and masses, organic and geometric, straight and flowing. In this painting the shapes are especially simple and few, yet the play of collage areas against the white of the gesso effectively suggests morning light on placid water, distant islands, and a craggy rock in the foreground. Kunkel's use of color here is particularly effective in that he has used three touches of resonant color as accents in a field dominated by whites and grays.

Right
SEASCAPE
by Helen Lundeberg.
Oil on canvas, 60" × 50" (152 × 127 cm).

The sea paintings of Helen Lundeberg are immaculate and austere. She applies a hard-edged treatment to the most severe simplifications of coastal subjects. In her art nature has been distilled and pared down to bare essentials with an intellectual rigor and clarity that leave nothing to chance. Despite the purity and utter simplicity with which she designs her canvas, seascape subject matter is inescapably present because her abstract forms always refer to such recognizable elements as sky, mountain, waves, and shore—no matter how reductive her design, nature is never lost from sight. Lundeberg's insistence on simplicity of form also extends to her use of color in that large portions of the picture are left as unpainted, white-primed canvas. This strategy makes double use of those areas: they serve as ambiguous sea or land forms and as striking white foils for richly colored shapes and bands. Such whites read as being both positive and negative shapes, and they contribute substantially to the painting's evocation of expansive space and breadth.

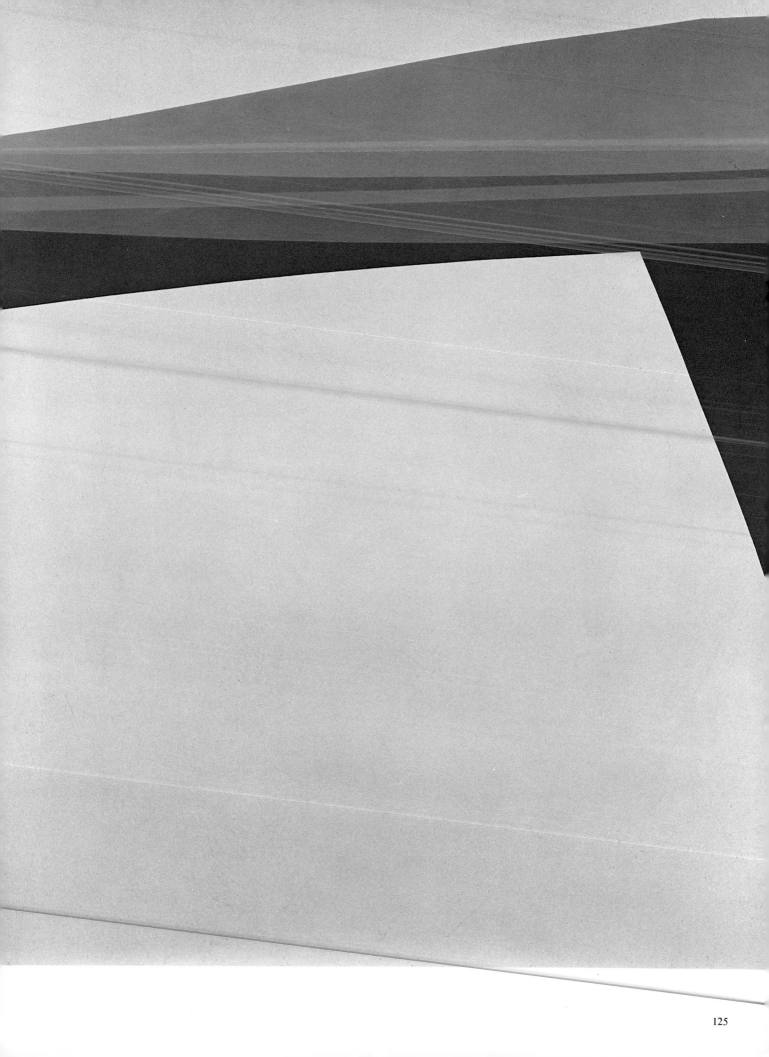

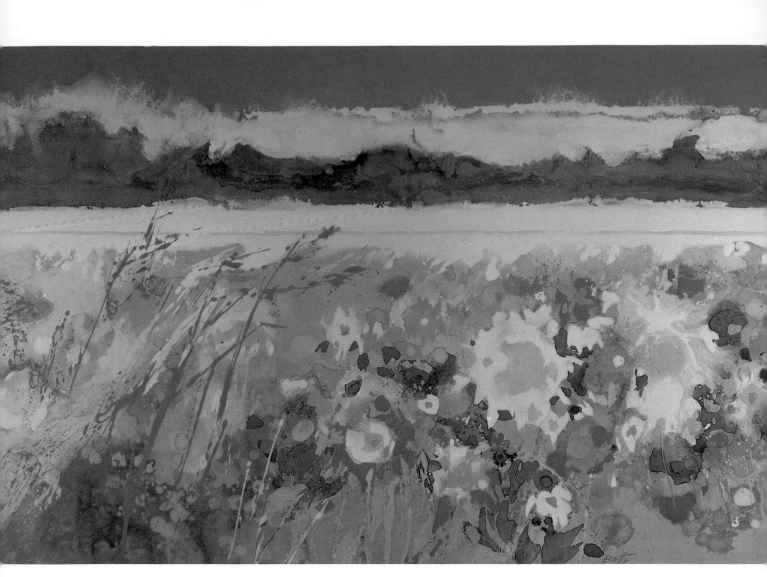

BEACH GARDEN NO. 2
by Edward Betts, N.A., A.W.S.
Acrylic on illustration board,
23″ × 35″ (58 × 89 cm).
Private collection.
Courtesy Midtown Galleries,
New York City.

The basic conception of this painting was as a relatively simple horizontal mass of cold color set against a larger, complex area of hot colors. The crashing wave took several days to paint. It was done by dropping color onto a moistened surface or spraying water onto whites that were still wet. Both processes were repeated and alternated until the wave looked as direct and spontaneous as if it had simply happened into being, and until it looked authentically wavelike, successful both in terms of paint quality and as expressive of the forms and edges of tumbling foam. With the cold blues of the ocean and sky as a backdrop,

the flowers were kept generally in a range of warm colors, some deep and saturated, others bright and intense. Colors of equal value and intensity were occasionally juxtaposed by being placed side by side or superimposing them on one another for the color vibration that would result. Technically, the painting developed out of improvisational methods that ultimately suggested flowers without the least attempt at botanical specifics. At the very end, flung paint, which did indeed refer to sea oats, was used as a linear link between the upper and lower sections of the composition.

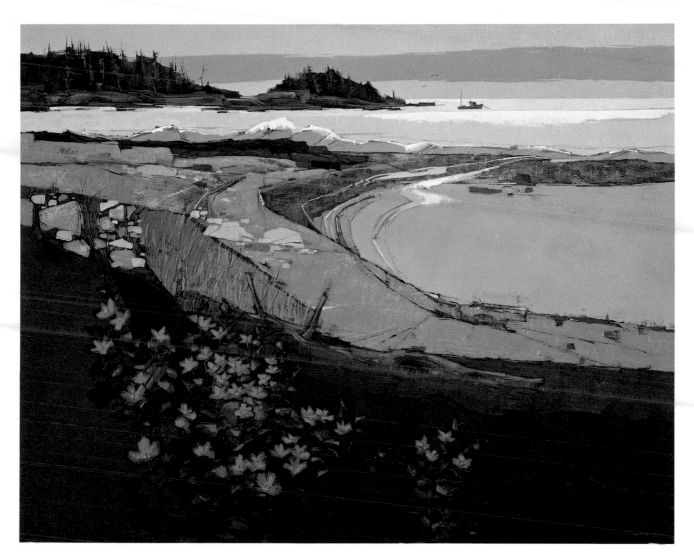

**MALLOWS
ALONG THE COAST**
by Robert Eric Moore, A.W.S.
Acrylic on canvas,
48" × 60" (122 × 152 cm).

Robert Eric Moore's romantic sensibility is nicely balanced by his strong sense of design. Simple description is not enough for him, so he seeks out the abstract qualities already present in his coastal subject matter and uses those qualities to invest his particular brand of realism with a crispness of handling and a formal control of shape and space, especially evident here in the central area of rocks and shore. He also avoids casual or accidental effects in nature, preferring to stress order and organization, a conscious forming of all the elements in his composition. These factors

give his paintings more visual substance and satisfaction than if he had dealt with his themes in a more literal manner. Though his color relationships, usually in a range of earth greens, browns, tans, and ochres, are consistently sensitive and tasteful, he is not afraid to inject an element of surprise by touches of unexpected bright color, in this case the flowers. These color notes suddenly enliven the surface, providing a momentary shock, yet somehow they take their place naturally and convincingly within the total context of this picture.

FAUST MARINA
by Frank Webb, A.W.S.
Watercolor, 22" × 30" (56 × 76 cm).
Courtesy Bird in the Hand Gallery,
Sewickley, Pennsylvania.

The breadth, boldness, and vivacity of *Faust Marina* are due in part to Frank Webb's thorough pre-plan of his pattern and design before setting brush to paper. But it is also due to his generous use of rich, saturated colors, which seem even richer because of his skillful preservation of the white paper. It has been said that the black lines in stained glass help to intensify color richness, but the same is also true of white. With his whites as his strongest lights, Webb establishes shadows as masses of deep colors, vibrant and luminous. Since he is clear in his mind about the patterning of values, he is free to interpret those values purely in terms of color; they relate and contrast essentially as a tonal pattern, yet Webb is actually more concerned with setting one color against another—warm against cool. The middle tones are important to this use of color since they are a vital link between the two extremes of the pure whites and the colorful darks. All the colors have been forced or intensified so uniformly throughout that there is no sense of their being raw or garish. What we do sense is the radiance of sunlight in a dynamic composition structured almost exclusively on a system of diagonals.

NAPLES WHARF
by Robert E. Wood, A.N.A., A.W.S.
Watercolor, 22" × 30" (51 × 76 cm).

By concentrating a wealth of detail in the center of his composition, leaving the top and sides relatively simple and empty, Robert E. Wood makes sure that the viewer's eye remains in one major area to explore the intricacies of the wharf forms. Preserving the whites of his paper in a few judiciously selected areas, Wood throws on color washes that fill the rest of the surface with a wide variety of lights and middle tones, all of which are built on a strong pattern of values, dramatically contrasting lights against darks and darks against lights. The darkest shapes and shadows emphasize the quality of light and give the picture its depth and structure. Vivid color is used only in the form of accents rather than masses—several touches of red here and there, a yellow here, and an intense blue there—but all are carefully related to the underlying light-and-dark pattern. There are oppositions of larger, simple areas (in the background, roofs, and planking) to complex smaller areas (signs, fishing gear, pilings, and flags), but the detail, as overwhelmingly confusing as it at first seems, is obviously controlled and ordered from the very beginning by Wood's innate sense of design. Every stroke, every shape, every accent, has a definite purpose. And best of all, Wood's sheer delight in putting together this imaginative assemblage of forms is everywhere evident.

BEACH AT MAZATLAN
by Stephen Etnier, N.A.
Oil on Masonite,
24" × 36" (61 × 91 cm).
Courtesy Midtown Galleries,
New York City.

Stephen Etnier always works with tonal color because strong contrasts of values are important to his fundamental concern with dramatic patterns of light and dark. The overall tonality in this painting is high in key—very light sky, water, and beach—with the most striking contrasts of bright lights and deep shadows concentrated in the group of boats drawn up on the flat beach. As an additional foil for the pale tints of the foreground and background, Etnier has reserved his richest, most saturated colors for the boats and some of the figures. Since those boats and their shadows contain the

purest color notes as well as the most severe contrasts of values, they immediately catch and hold the viewer's eye. The other areas are of secondary interest: simple, open spaces that don't distract from the arresting shapes and shadows to which Etnier initially responded. Except for the distant point of land at the horizon, everything is treated with exceptional clarity and sharp definition of detail, which of course emphasizes the sense of brilliant sunlight but also happens to suggest an almost surrealist look and mood.

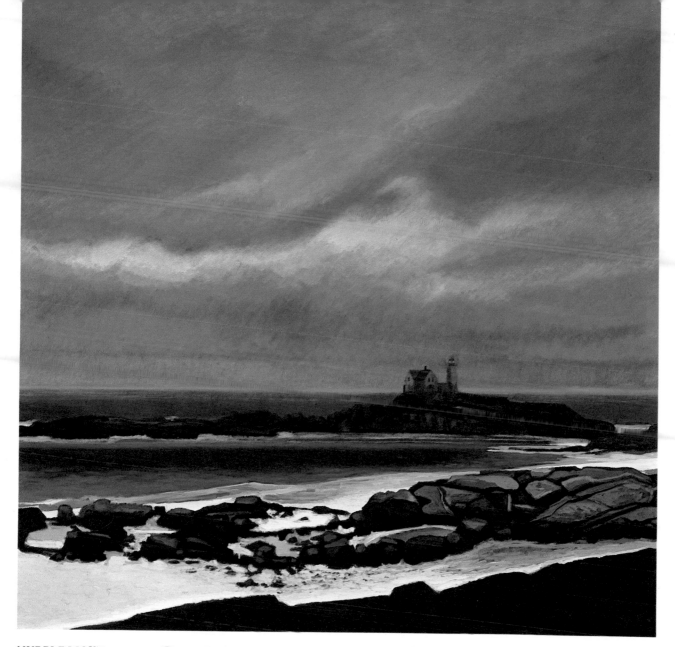

NUBBLE LIGHT— NORTHEAST
by John Laurent.
Acrylic on Masonite,
48" × 48" (122 × 122 cm).

The sea has many moods, and color is a major means of communicating those moods. John Laurent has used a group of grayed blues and greens and stark contrasts of white sea foam against dark rocks to project the bleak, brooding quality of the Maine coast before a storm. Because Laurent limited the picture to a range of muted cold colors, it has become a vivid, intense expression of a mood and condition of nature, an uncompromising statement that purposely avoids any charm or prettiness. *Nubble Light* itself is by no means the principal subject of this composition.

Instead of succumbing to the picturesque aspects of his motif, Laurent has chosen to emphasize the sense of weather, light, and mood. Note, for instance, the juxtaposition of soft forms in the sky with the harsh, rugged rocks in the lower part of the painting. With the sky as the largest area in the picture and the small scale of the lighthouse in relation to sky, ocean, and rocks, there is a spaciousness, a sense of the overwhelming scale of nature and natural forces. Out of a deep emotional involvement with his subject, Laurent has constructed a powerful, dramatic image.

Left
MARINE SERIES: EBB AND FLOW
by Ruth Snyder.
Watercolor and gouache on paper,
24" × 19" (61 × 48 cm).
Courtesy Challis Gallery,
Laguna Beach, California.

Ruth Snyder's watercolor seems almost to have painted itself. The forms are not at all recognizable and there is scarcely any feeling of the presence of a painter consciously forming and controlling the picture; it is simply an evocation of liquid space. The basic color strategy is the use of vast veils of delicate color—drifting, flowing, and blending—accented by applications of blurred wet-in-wet color. A few incisive linear touches reach a color climax through the vibrance of a few notes of orange, red, and yellow. In fact, color is the whole picture, creating a world of watery translucence in which formal design is relinquished in favor of the casual, the effortless, the informal, the spontaneous, and the intuitive. Snyder as used her craft to give expression to ineffable sensations rather than to facts or ideas. Hers is an art of poetic suggestion in which nothing is specific or obvious. She does not merely observe seascape forms and textures and then reorganize or interpret them; she does not paint *from* nature. In her art, nature and paint seem to become one and the same thing—a metaphor in paint.

Above
ISLAND AHEAD
by Lawrence Goldsmith, A.W.S.
Watercolor on paper,
19" × 24" (48 × 61 cm).

Spending his summers as he does on an island nine miles out at sea, Lawrence Goldsmith is familiar with the impressions received during an approach to an island looming ahead across the water. Capitalizing on chance effects of his loose handling of watercolor, Goldsmith conveys the atmospheric blending of clouds, island, and ocean by simultaneously using airy washes of soft color and calligraphic strokes, both painted and scratched out with a blade. The white of his paper functions not only as a background for his seascape forms, but also as an integral part of the light and air out of which those forms emerge. Goldsmith steers clear of particulars, choosing to universalize his imagery, leaving some things unsaid in his poetic treatment of a world of transcience, ephemerality, and ambiguity. Though *Island Ahead* may have certain affinities with Oriental painting, it by no means imitates its superficial aspects, but is a personal, creative use of its most fundamental principles toward contemporary ends.

LEDGE, SEA, AND SKY
by David Lund.
Oil on canvas, 40" × 48"
(102 × 122 cm).
Courtesy Grace Borgenicht Gallery,
New York City.

Over the years, direct experience and observation of nature have provided David Lund with a vast repertoire of forms. It is this mental storehouse of memories combined with the processes of painting that produce his seascape and landscape images. Specific, identifiable motifs are not as important to Lund as creating a pictorial space and then manipulating form, light, color, and mass within that space. This results in a universalization of his shore scenes, a digging beneath outward appearances to get at the essence of nature's forces and processes. This freedom to deal inventively with relationships of rocks, water, and shore leads him to alter shapes, colors, and volumes, treating them more purely as experiences in paint and as personal visions than as imitations of what the eye sees. Lund uses color architectonically to build his forms and control his spaces, but his brushwork and love of painterly surfaces are also crucial to the projection of his inner responses to nature. In this picture he works primarily with relationships of basically warm and cool colors, subtly contrasted and adjusted to each other by a sensibility that is both rigorous and poetic.

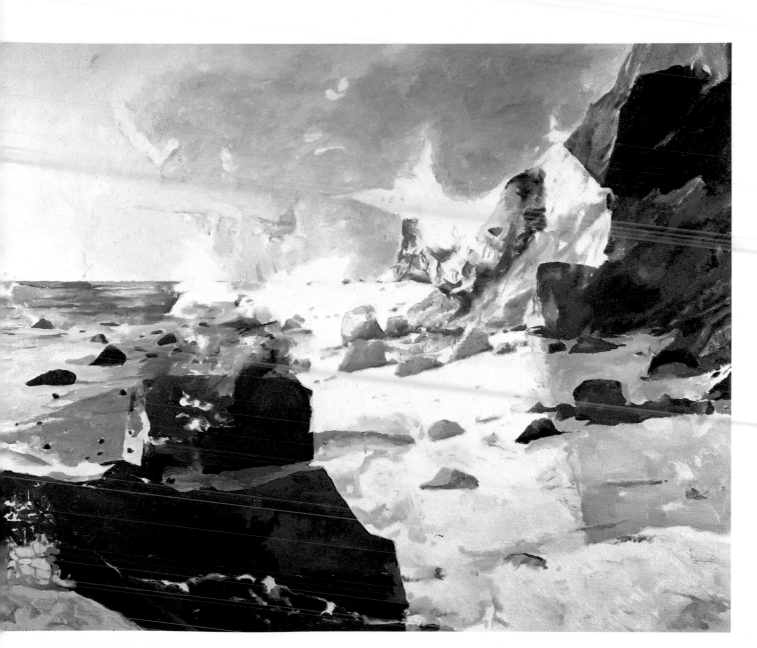

**LIGHT ON THE BEACH
AT MONTAUK POINT**
*by Balcomb Greene.
Oil on canvas,
48" × 60" (122 × 152 cm).
Courtesy of A.C.A. Gallery,
New York City.*

Balcomb Greene works in a vein of what might be called "abstract realism." Earlier in his career he painted in a flat, hard-edged, nonobjective style, and undoubtedly it is that disciplined background in abstraction that still continues to give structure to his current romantic seascapes. Living as he does near Montauk Point, the outermost tip of Long Island, Greene is thoroughly familiar with the coastal forms there. His urge toward abstract design shows in his handling of the steep cliffs at right, the two rock forms at lower left, and in the white that cuts downward through the cliff and continues through the beach and into the foreground. In most other respects, the

painting has been treated quite representationally. The color range is severely restricted to cold blues, blacks, and grays, with only an occasional hint of warmer tones. Realistic description is secondary to suggesting the effect of light passing across rocks and shore; in so doing, Greene is most adept at creating an interplay of edges—hard and soft, lost and found, disappearing and reappearing, clear and unclear. It is largely this quality along with his personal viewpoint that make his work a more interesting visual—and painterly—experience than that obtained from conventional seascapes.

Left
TIDELINE PATTERNS II
by Fran Larsen.
Watercolor, 40" × 30" (102 × 76 cm).

Although clarity of statement, with sharply
defined edges and shapes, is often desirable,
the soft, atmospheric approach to color and
form can be a welcome change. The soft-edged
approach, employing hazy shapes, blurred
color application, and minimal contrast of both
values and colors, is a poetic art of suggestion
and implication that leaves more to the
viewer's imagination than can be achieved
through prosaic description. Although Fran
Larsen has worked here with spray and stipple
techniques, she has nevertheless built the
composition on an abstract structure—an
arrangement of geometric circles and trans-
parent planes—that prevents her design from
becoming a formless mush. Then, too, creative
color need not necessarily be pure color
straight from the tube—it can also be color
characterized by nuance and delicacy.
Larsen's warm colors glow here with so much
subtlety and gentle understatement that their
presence is barely sensed. But it is those
multiple layers of transparent color and the soft
interplay of warm and cool tones that so aptly
suggest sandy patterns and a seashore atmo-
sphere. Larsen's painting is a lyrical combina-
tion of implied marine forms and her private
inner experience of seascape.

Above
WEST SHORE NO. 5
by Stan Brodsky.
Oil on canvas, 48" × 72" (122 × 183 cm).
Private collection. Courtesy Lerner-
Heller Gallery, New York City.

For the past several years Stan Brodsky's
paintings have demonstrated his preoccupa-
tion with shore and low tide. The essence of
his art is what Brodsky calls "color weaving,"
a manipulation of gentle, muted color relation-
ships that are low in contrast—close intervals
of color that are quite similar in both value and
intensity—with their edges deliberately
blurred. Brodsky writes that much of his
approach to color as a field, a fluid force, was
"probably influenced by [his] working with
pastels outdoors. The blending possibilities of
that medium shifted my thinking about oils. I
also began using mineral spirits instead of
turpentine and stopped using linseed oil.
Large brushes were also employed
Overall, I am using color more freely,
spontaneously, allowing it to collide, infiltrate
or slide over preceding passages (dry and wet)
to uncover unexpected possibilities I
want to allow it to vibrate and above all to find
its own extension and boundaries naturally."
Brodsky is skilled at keeping his imagery
vague and slightly ambiguous (although there
is inevitably a sense of water and shore) so that
the subject matter is never allowed to interfere
with his intense interest in exploring both the
formal and lyrical aspects of color,

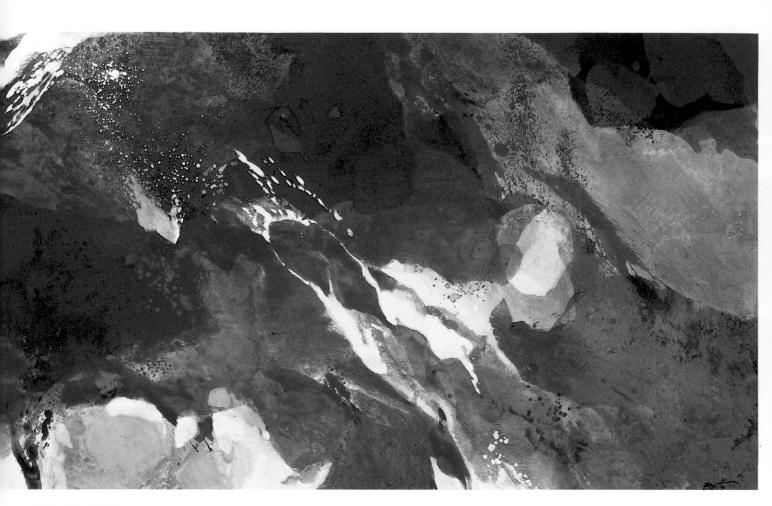

ISLAND REEF
by Edward Betts, N.A., A.W.S.
Acrylic on Masonite,
23" × 29" (58 × 74 cm).
Courtesy Midtown Galleries,
New York City.

This is a view looking directly downward, suggesting both the depth and the shallowness of water as it washes over and around a partially submerged reef. By eliminating any sky or horizon, I was able to restrict undue recession into space. There was no attempt to depict the water flow realistically but rather to create a sense of fluidity and motion through forms that are seemingly casual and spontaneous. The layers of color were applied as a series of superimposed glazes—washes of transparent color over a lighter underpainting—which provided a chance to juxtapose opaque and transparent passages and to achieve a luminosity and depth of color that simply are not possible when only opaque applications of paint are used. Both light and dark spatter was used, not only as a reference to foam and bubbles but to add textural interest to the picture. Some of the spattered areas were later glazed with darker blues, so that all the spatter would not seem to exist on the same plane or surface. Although blues and blue-greens predominate, I felt free to introduce a few intense warm colors not ordinarily associated with water. Many passages were arrived at by flinging on paint or by pouring on color and then tilting the panel momentarily to let the color run or drift.

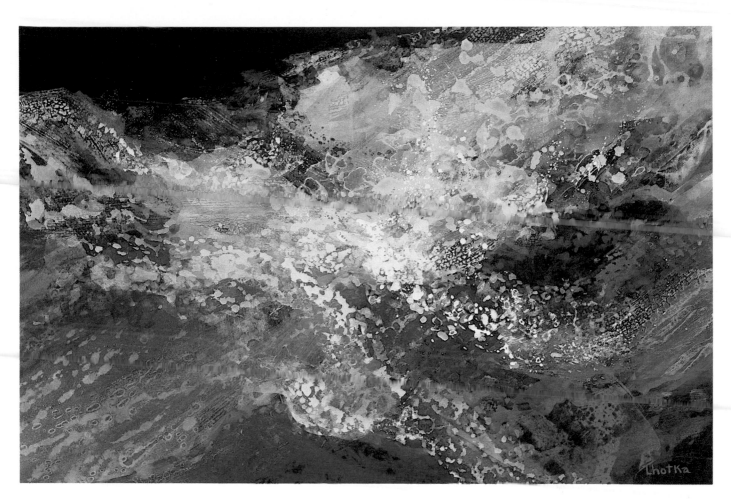

TIDE
by Bonny Lhotka.
Acrylic on board,
20" × 30" (50 × 76 cm).

Many of Bonny Lhotka's recent paintings derive from her continuing study of the coastal waters of Hawaii. *Tide* is an example of her fascination with the force, textures, and elemental rhythms of water in motion, and it illustrates her typical working method, which combines improvisational paint techniques with memory and internal responses to observation of the sea in action. Since textured surfaces are a major element in her paintings, Lhotka enthusiastically resorts to a variety of ways of applying paint, including lifting layers of color to reveal the colors beneath and using resist techniques in what she describes as a "two-handed method, one brush full of alcohol and the other paint" to build up color layers of alcohol resist. Each picture's dominant color is determined in advance, but the beginning undercoats are likely to be the complement of whatever the final colors will be. The sky here is deliberately kept dark to limit pictorial depth and stress the closeup effect. Although the sweeping rhythms of the ocean activate the composition, the real subject of the painting is the variety of color textures, which evokes a watery environment. This is not a literal version of wave and sea form, but it is an interpretation in which the paint, colors, and textures do not copy nature but serve as equivalents to their actual counterparts in the sea itself.

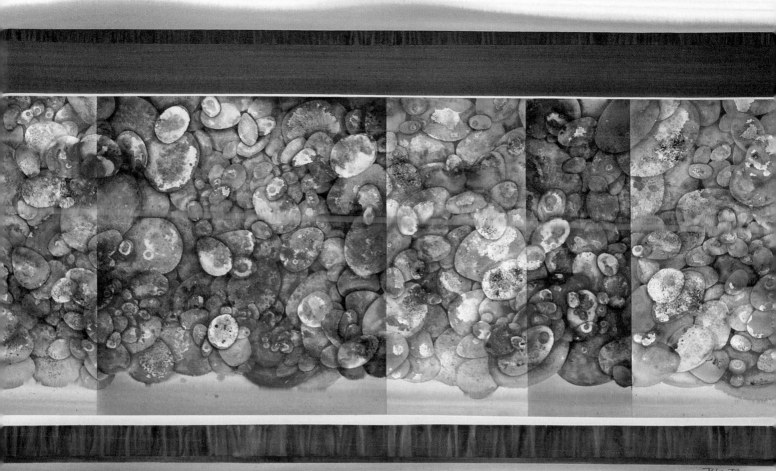

Left
GREEN SEA TRIANGLE
by Miles G. Batt, A.W.S.
Watercolor on paper,
26" × 20" (66 × 51 cm).
Private collection.

Miles G. Batt is dedicated to discovery and invention as
being the core of creativity, and in his work he is
continually, restlessly, trying new and different ideas,
usually with sea themes as the vehicle for his explorations.
Green Sea Triangle, though it is constructed on a complex
geometric plan of overlapping transparent bands, triang-
les, and rectangles, is also a triumph of luminous, opulent
color. Batt has employed a variety of devices for applying
color: staining, blotting, and flowing, along with the use of
airbrush and wax resists. The resulting surface, which is
rich in texture and relaxed in paint handling, is an unusual
combination of free, painterly treatment functioning
within the orderly severity of the geometric design.
Despite the formality of the design, and the fact that he has
pushed toward the limits of total abstraction, there still
remains a feeling of sea and sky, of clouds, and of light on
the water, which gives meaning to the design just as the
design gives form to his seascape motif.

Above
TIDE PEBBLE CARPET
by Pauline Eaton.
Watercolor on cold-press
illustration board,
30" × 40" (76 × 102 cm).

Pauline Eaton has recently done a series of seascapes
dealing with closeup views of specific forms such as kelp or
beach pebbles, handled as an all-over treatment of many
small units which occupy the major part of the surface.
Although the pebbles and stones are painted rather
realistically, with close attention to mottled texture and
subtle modeling, they are set into a firmly structured
format based on stratified bands—of sky, earth, water,
beach—all of which reinforce the notion of her art as being
a geological metaphor. The watercolor handling is precise
and meticulous, with each worn stone observed and
rendered with loving care, yet the arbitrary vertical
divisions or panels are purely a design concept that ties in
naturally with the narrow strips of color above and below
the main image. What might otherwise be a busy and
confusing surface is unified by the use of color—mostly
greens, blues, and siennas—which flows from panel to
panel in a free yet controlled manner. The complexity of
compacted detail, both realistic and abstract, is set off by
the spacious, simple areas of white at top and bottom, both
of which are connected to the ''carpet'' by undulating
soft-edged wet-in-wet grays.

141

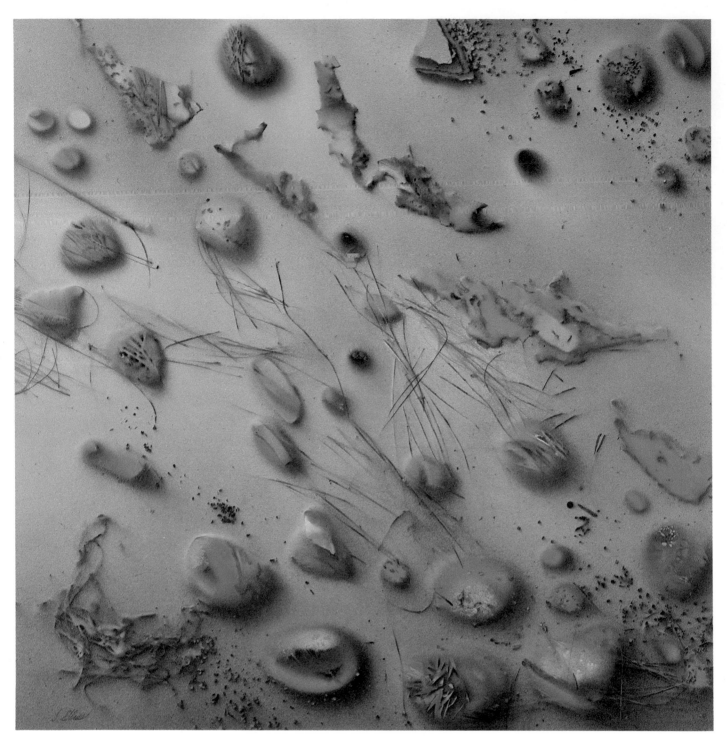

FRAGMENTED SEA
by Sylvia Glass.
Water media on 300-lb Arches paper
mounted on illustration board,
35" × 35" (89 × 89 cm).
Courtesy Orlando Gallery,
Encino, California.

The paintings of Sylvia Glass represent a highly personal blend of realism and fantasy—of forms and textures which at first look like scattered elements on the ocean floor, but on further examination prove to be purely imaginative inventions. Glass uses several types of aqueous media, both transparent and opaque, in a single painting. Occasionally she uses conventional methods and applies paint with a brush, but the greater part of her painting is done with a spray gun. Sprayed color is used for the cast shadows to create a kind of diffused, eerie light, and also

to create the strange fragmented forms which, because of their blurred edges, seem to possess a peculiar glow of their own. The spray effects also contribute to the sensation of seeing things in an imagined underwater world. Subtle color is handled with delicacy and restraint, accented by effectively placed flecks of intense color. This painting goes beyond a mere depiction of actual underwater forms to offer above all a sensitive, poetic exploration of textures, surfaces, and edges, a most intriguing reconciliation of the real with the unreal.

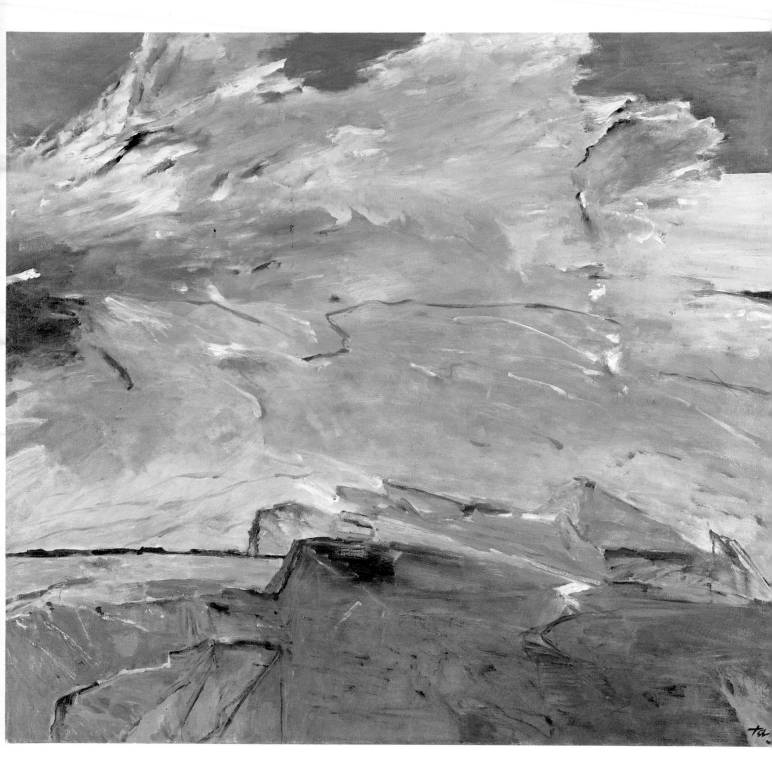

OCTOBER SEA
by Reuben Tam.
Oil on canvas, 40" × 44"
(102 × 112 cm).
Courtesy Coe Kerr Gallery, Inc.
New York City.

Although *October Sea* has the look of an Abstract Expressionist painting, there is one important difference: where the New York School insisted on eliminating any direct references to nature, Reuben Tam insists that an intimate experiencing of nature must underly each of his pictures, all of which invariably spring from his almost mystical response to the sea. Yet Tam has never succumbed to the picturesque or the anecdotal. We are always kept aware that in his paintings, it is paint and gesture that are his principal means of giving form to inner visions of a primordial geological world. His gestural color strokes are used in two quite different

ways here: the ocean splash is treated with energetic, brushy strokes that eloquently convey the thrust and directional sweep of the heavy foam, while the rocks are handled in a more contained manner, smaller in scale, stressing angularity of planes and the most subtle relations of warm and cool color. In both surf and rocks there are various linear or explosive gestures that pertain to the action of the surf on one hand, and to the edges and textures of rocks on the other. The hard, straight, distant horizon is only a minor accent in a picture based on the grand conflict of the ocean and the rocky coast.

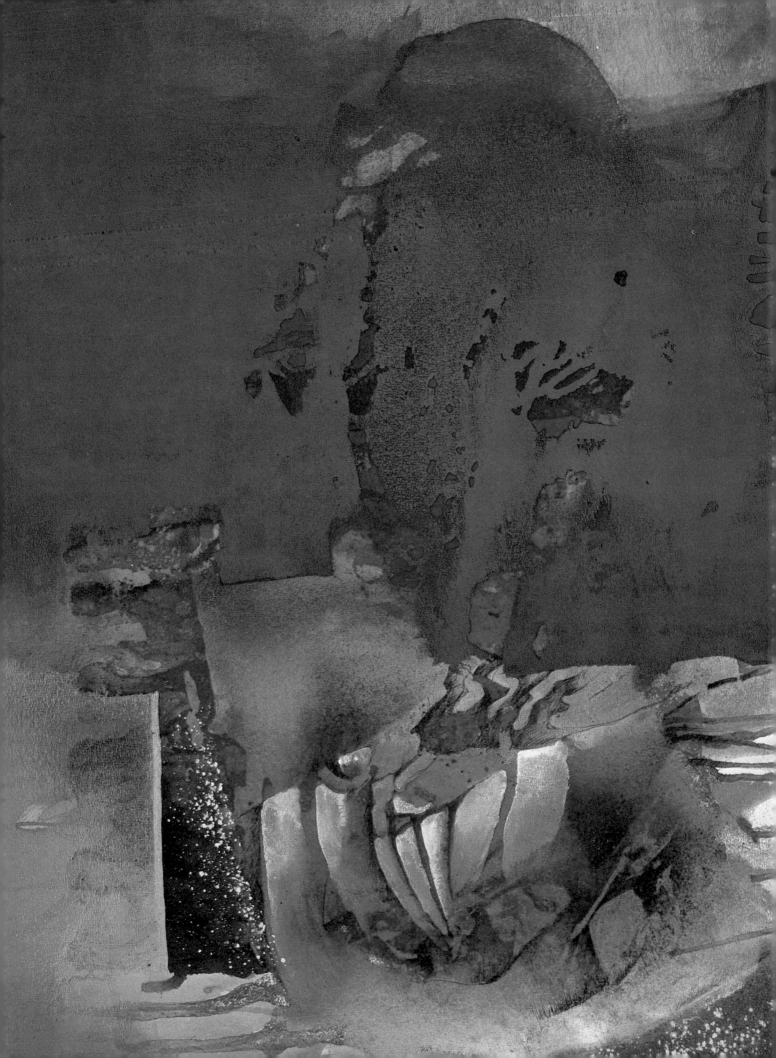

SEA FORM
by Sister Barbara Cervenka.
Mixed media on paper,
28" × 22" (71 × 56 cm).
Courtesy Habatut Gallery,
Dearborn, Michigan.

Sister Barbara Cervenka's series of "Sea
Form" paintings are rich in color and varied in
texture. They deal with undersea subject
matter that is implied rather than described,
giving a far more poetic view of the marine
world than that offered, for instance, in
scientific underwater photography. Beginning
her paintings with an improvisational use of
watermedia, Sister Barbara Cervenka's forms
develop partly as a result of the behavior and
interaction of opaque and transparent paints,
India inks, and oil and water resists, and partly
as a result of her own instantaneous, intuitive
responses to what is happening on the picture
surface as the paints. Where most artists might
be inclined to keep an undersea painting
exclusively in a range of cool greens and blues,
she is not afraid to introduce a large mass of
red, which vibrates in relation to the blues
beneath or adjacent to it, affording a reminder
that this is an experience in paint and color,
not scientific documentation. By permitting
color to drift and run, and by letting rivulets of
color remain visible through overpainted
glazes, she produces surfaces that have
considerable depth and sensuousness. This is
a most sensitive use of abstraction to suggest
an undersea environment.

STUDIO NOTES

TECHNIQUE
Technique is the easiest part of painting.

You don't learn to paint by watching demonstrations; you learn to paint by painting. Demonstrations may be fun to watch, but they lead to imitation. I prefer that you develop as a painter by thinking for yourself and painting in your own way.

Technical facility is a curse. Such virtuosity should be put to work, not exploited.

Technique alone cannot save a painting or make it great. There must be some substance—thought, idea, concept—beneath that technique, which is the servant, not the star, of the painting.

In the early stages of your career, learn to paint both tightly and loosely, with equal skill and assurance. Later on you can decide which way is most natural to you and which manner comes closest to expressing your view of nature.

Pay more attention to edges and to transitions from one area to another. Play with those that are hard and soft, ragged and blurred, precise and sloppy.

Your paintings are becoming a little stale. Why not change to another medium for a while? Try some ink or wash drawings. Or draw with a stick instead of a pen or brush. Or switch from an opaque to a transparent technique.

I *assume* technique and craftsmanship; I take all that for granted. Now, what are you going to do with it?

COLOR
Nobody is born a colorist. You become a colorist only after many years of looking, experimenting, and painting. And painting and painting.

Make more sensitive, more exact, color choices.

If you employ inventive ideas in painting seascapes, then make sure your use of color is equally imaginative or daring so that it reinforces those creative ideas. Don't betray your conception by using ordinary color.

Sometimes a painting has areas of both tonal color and bright color. The bright colors make the tonal colors look dirty and dull, or the tonal colors may cause the bright color to seem garish or not a part of the same surface. So decide which range of color you want to stay with—either tonal or intense—and then keep the use of color consistent throughout the picture.

If you must use a camera, take black-and-white pictures rather than color slides. Because most of us are too strongly influenced by the colors we see in a slide, black-and-white photographs offer us more opportunity to invent our own color relationships.

SEASCAPES
Watch out for that raw blue water. The ocean is usually not as pure a blue as many people think. Look for the variety of blues and the greens, grays, purples, and lavenders.

This surf is too frozen, too static. Don't strain just for visual accuracy of a single moment in the flow of water. Paint water so that it *feels* right to you. Study the ocean as long as you can. But when it comes to painting it, rely more on your memory, knowledge, and experience and not quite so much on snapshots.

Don't assume you know the color of sand. It varies from beach to beach and according to tides, time of day, light, weather, sky, and wetness or dryness. Sand is not necessarily a light yellow; it can be off-white, tan, beige, gray, lavender, brown, or pink. Look at it more carefully, and don't mix only the obvious color.

Surf: Use your white paint more sparingly. This looks more like a confection than a seascape.

Don't be so eager to paint. Allow time to sit and observe the sea. Familiarize yourself with your subject through daily contact whenever possible. Get to know the surface aspects, but also dig into the deeper aspects and build your art out of that kind of knowledge.

When in doubt about how to handle an area, look to nature for suggestions—it's all there.

PAINTING PROCESS
During the development of a painting, your role should be that of a discoverer, not a mechanic.

Don't force yourself on your picture. Flow with it a little more.

Even when the going gets tough, don't ever lose your enthusiasm. If you aren't interested in your picture, how are you going to interest someone else?

I find my painting suffers most when I am trying too hard to make a picture—that is, some kind of finished product. Most of my best things seem to have grown out of a mood of play or curiosity, a relaxed standing-around-and-watching-what-develops attitude. It's a matter of responding to the unpredictable, not stamping out picture after picture with the same old cookie cutter. I'm a great believer in serendipity: stumbling onto something that is better than what I had set out to find.

I know your painting looks awful at this point, but cheer up. It's only going through that awkward adolescent stage. It'll get better later on.

As an antidote to becoming too finicky, try a little recklessness.

Don't keep on with the painting if you don't know what you're doing. Instead of making foolish mistakes, put the picture away for a while, and come back to it later when your purpose and direction are clearer to you.

A painting should look as though it had been allowed to grow naturally into being rather than coldly planned and executed.

The mind has as much to do with painting as the hand and paintbrush do. Do your most serious thinking *before* you begin a picture and, again, *after* you feel that the picture is almost finished.

This is too safe. Mess it up a bit—take some risks—test your limits.

Composition begins with selectivity.

I'm not one for checking the progress of a painting by viewing it in a frame. It makes it too easy to fool yourself into thinking the picture is better than it really is. Wait until the picture has been completed to the best of your ability, and only then let a frame show it off to fullest advantage.

Our pictorial ideas are usually far ahead of our ability to give them form on canvas or paper. Sometimes we're simply not yet ready to bring them to realization. Wait a few months or a few years before giving them another try.

Don't be depressed by a painting that is going really badly. Accept the fact that it probably can't get much worse, and try to do something to it that will be absolutely disastrous. Try something crazy—get mad at it. Then see if you can save it.

As a painting nears completion, take time out to look it over with a sharp eye. Ask yourself how it might be successfully finished—not with how *many* additions or changes but with how *few*. Such careful decisions are worth hours of "finishing."

Decide what areas in the painting you are particularly pleased with or which ones are most important to you and to the painting. Then, as much as possible, eliminate any lesser passages that might distract from them. Compress and consolidate so that your principal image is clearly visible. Your job is to control the eye of the spectator and to make the picture readable.

GENERAL

It's the painters who don't take risks who do the dullest pictures.

Too much self-analysis lets the air out of one's creative balloon.

Simplicity leads to clarity.

Don't paint nature according to what art teachers tell you it looks like. Rely only on your own eyes and let them tell you what is really there. Don't paint strictly by rules; paint according to what you see and know and feel.

You'll never paint a picture that matches your expectations. There will always be some small part of it that you wish you had handled better.

To look at a painting is to have a sensual experience. Accurate description is no substitute for that kind of experience.

The basis of all drawing and painting is establishing and controlling relationships: relations of color, of values, and of shapes in space. It's largely a matter of emphasis and suppression, too.

Use your sketchbook as a sort of experimental laboratory. It's a more private, informal place to try out visual ideas than when you are *painting a picture*.

Stay free to follow your impulses. A little too much thought and introspection could immobilize you if you're not careful.

Be harder on yourself than you have been up to now. No serious painter can afford the luxury of self-deception when it comes to judging the quality of his own work.

Don't skimp so much on your art materials. Since you usually get what you pay for in that area, buy the very best. One good-priced picture sale or substantial award could take care of all your materials for a year or more.

Before sending a picture out into the world, ask yourself what justification there is for this painting. Why should a jury or anyone at all be expected to spend time looking at it?

The great thing about skies, rocks, water, and tide pools is that they are abstract to begin with. All you have to do is to intensify those abstract qualities.

Your pictures might sell better if you didn't try so hard to make them saleable.

Stay unknown as long as you can; you'll never be as free again.

SUGGESTED READING

Baur, John I. H. *Nature in Abstraction*. New York: The Macmillan Co., 1958.

Betts, Edward. *Creative Landscape Painting*. New York: Watson-Guptill Publications, 1978.

——. *Master Class in Watercolor*. New York: Watson-Guptill Publications, 1975.

Braun, Ernest. *Tideline*. New York: Viking Press, 1975.

Goldsmith, Lawrence. *Watercolor Bold and Free*. New York: Watson-Guptill Publications, 1980.

Gray, Cleve, ed. *Marin on Marin*. New York: Holt, Rinehart and Winston, n.d.

Groschwitz, Gustave von. *The Seashore Paintings of the 19th and 20th Centuries*. Pittsburgh: Carnegie Institute, 1965.

Hale, Nathan Cabot. *Abstraction in Art and Nature*. New York: Watson-Guptill Publications, 1972.

McShine, Kynaston, ed. *The Natural Paradise: Painting in America, 1800–1950*. New York: Museum of Modern Art, 1976.

Raynes, John. *Painting Seascapes: A Creative Approach*. New York: Watson-Guptill Publications, 1971.

Shimizu, Yoshiaki, and Carolyn Wheelwright, eds. *Japanese Ink Paintings*. Princeton, N.J.: Princeton University Press, 1976.

Snead, Stella. *Beach Patterns: The World of Sea and Sand*. Barre, Mass.: Barre Publishing, 1975.

Stebbins, Theodore E., Jr. *Close Observation: Selected Oil Sketches by Frederick E. Church*. Washington: Smithsonian Institution Press, 1978.

Sutton, Ann, and Myron Sutton. *The Wild Shores of North America*. New York: Alfred A. Knopf, 1977.

Weng, Wan-Go. *Chinese Painting and Calligraphy: A Pictorial Survey*. New York: Dover Publications, 1978.

INDEX

Edited by Bonnie Silverstein
Designed by Bob Fillie
Graphic production by Hector Campbell
Set in 10-point Times Roman